CLAIRE BINGHAM

A BEAUTIFUL MESS

teNeues

CONTENTS
INHALT

A New Vintage | Das neue Vintage .. 004

Bohemian Rhapsody | Über den Dächern von Paris 020

Ahead of the Curve | Neue Lösungen für eine neue Zeit 038

Studio Moves | Kreatives Chaos .. 054

Color Vision | Fabelhafte Fliesen .. 072

Dans le Salon | Der magische Garten .. 086

Couture Revival | Upcycling ist Trumpf ... 104

House of Fun | Spaß und Spiel .. 120

Pretty Cool | Ganz in Weiß ... 138

Living to the Max | Maximales Wohnen ... 154

Escape to the Château | Château der Träume ..172

Credits & Imprint | Bildnachweise & Impressum192

INTRODUCTION / EINLEITUNG

Beautiful homes come in many shapes and forms. Each home has a look and feel that is integral to its identity—and the best ones exude an atmosphere that make you want to hang out and stay.

One of the biggest kicks I get from checking out people's homes for a living is having a window into their eclectic, well-traveled, and characterful lives. The houses that linger the most are the living spaces that aren't curated or produced by identikit. They are the "follow-your-own-path" interiors, where a house becomes a home through participation, not perfection. They are far from precious. They are about having fun.

In this book, we take a tour around some of the most unique living spaces that showcase a collage of personality and décor styles. From highly decorative interiors that are overflowing with objects, embellishment, sequins and fringing to cool, creative spaces that move like a Ouija board, forever changing—the thread that ties all these together is their originality. Be inspired by the intuitive nature of homeowners' who mix pattern and collectibles with flair. Free from decoration faux pas, these interiors don't hold back.

Marie Kondo would no doubt remind that there's a point where you need to stop accumulating and throw things out or store them. Does something spark joy? While this is a philosophy I wholeheartedly respect, there's a lot to be said for a degree of disunity in a home, too. The most enviable abodes that I've ever been in are an extension of their owners' character and feel as though they have never been "dressed" at all (this is always never the case).

For me, a home is a place to cherish where there is no separation from everyday life and a love of objects and design. Ornately furnished or beautifully unkempt, in filling your house with mementoes and things that you love, you create a house that tells a story, an original and truly personal space.

Besides, orderliness is overrated. Scuffed, stuffed, or full-throttle pattern clash, repeat after me, "Bless this mess."

Schöne Interieurs kommen in allen möglichen Formen und Stilen daher. Jedes Zuhause hat einen Look der seine Identität ausmacht – und die besten verströmen eine Atmosphäre, in der man sich einfach wohlfühlt.

Eine der schönsten Seiten an meinem Beruf ist, dass ich, wenn ich die Häuser und Wohnungen von spannenden Menschen betrachte, Einblick in ihr buntes, interessantes, weitgereistes Leben bekomme. Die Interieurs, die dabei den bleibendsten Eindruck hinterlassen, sind diejenigen, die nicht nach Schema F eingerichtet wurden. Es sind die eigenwilligen Dekors, die ein Haus nicht durch Perfektion sondern durch die Persönlichkeit seiner Bewohner zu einem Zuhause machen. Sie sind nicht besonders kostbar oder glamourös, sondern machen einfach Spaß.

In diesem Buch nehmen wir Sie mit auf eine Tour durch einige außergewöhnliche Behausungen, die ein breites Spektrum an Persönlichkeiten und Einrichtungsstilen präsentieren. Von üppig ausstaffierten Interieurs, die vor lauter Objekten, Verzierungen, Pailletten und Zierleisten geradezu überfließen, bis hin zu kühlen, kreativen Räumen, die sich permanent verändern: Der rote Faden, der sich durch alle Beispiele zieht, ist Originalität. Lassen Sie sich inspirieren von der Intuition der Besitzer und Bewohner, die Muster und Designobjekte mit Flair kombinieren. Von strengen Dekoregeln befreit, lassen diese Kreativen der Fantasie freien Lauf.

Marie Kondo würde sicherlich darauf hinweisen, dass man an irgendeinem Punkt aufhören muss, Dinge zu sammeln, und anfangen sollte auszumisten oder einzulagern. Obwohl ich diese Einstellung durchaus respektiere, spricht auch viel für ein gewisses Maß an Ungeordnetheit und Uneinheitlichkeit. Die beneidenswertesten Domizile, die ich je besuchte, waren Spiegelbilder der Charaktere ihrer Besitzer und fühlten sich so an, als wären sie gar nicht bewusst eingerichtet worden (was allerdings fast nie wirklich der Fall war).

Für mich ist ein Zuhause ein Ort, der nicht zwischen Alltag und der Liebe zu Objekten und Design unterscheidet. Ob elegisch elegant oder herrlich wild: Indem Sie Ihr Haus oder Ihre Wohnung mit Erinnerungen und geliebten Gegenständen füllen, erschaffen Sie ein Heim, das eine Geschichte erzählt. Einen originellen und wirklich persönlichen Raum.

Außerdem wird Ordnung überbewertet. Sagen Sie also ja zum Abgewetzten, zum Vollgestopften und zu Farb- und Musterkombis auf Kollisionskurs und sprechen Sie mir nach: „Chaos ist cool."

A NEW
VINTAGE

From Union Jack cushions to a cool crew of portraits on the wall,
this vintage style seeker has a home that's as chilled out,
open, and diverse as her personal style.

"How would I describe my style?" exclaims Ashley Tell. "Bipolar? I'm joking. Erratic? My friend says it is disheveled, which is a really appropriate word. It is orderly disheveled if that makes sense. Everything has a place. The place just happens to be out and seen. It doesn't look untidy but it does look like life is happening here."

The inherent clash between the past and present speaks volumes about the fashion-forward vintage clothes retailer's attitude to life. Owner of the fashion store, Global Vintage Collective, her passion for vintage is palpable. Enter and your eyes are drawn to the collection of portrait paintings on the living room wall. The massive street poster from a secondhand shop lists old train stops. It is rare for Ashley to come back from a buying trip without a suitcase full of things for her home.

Dividing time between Melbourne and her native California, where Ashley casts a magpie's eye over Americana T-shirts, street wear, and cool denim. "Basically mum clothes," she smiles. "It's a dichotomy of the 18-year-old hipster girl in Australia, but where I'm from, they've never stopped wearing them." It is from her background where she gets her taste for old Navajo blankets and kitsch horse figurines.

Ashley's home in the hip Melbourne suburb of Richmond is decorated simply: in white and earthy colors with textures ranging from the velvety cowhide on the floor to butter-soft leather. Centered on the stylish living room, it is designed with comfort in mind. From the deep-sinking 1970s chair that reminded Ashley of a huge baseball glove to the fabulous mix of things on display, the vibe is warm and inviting. It also indulges Ashley's passion for sourcing vintage finds. "For my job I go to flea markets," she explains. "I just like finding stuff, bringing it home, and making it work."

Previously owned by the 1970s Australian fashion designer Norma Tullo, Ashley's two-bedroom apartment is on the ground floor of an old converted factory. The bright, open-plan layout features the original loft-style windows and a low ceiling, which is beautifully ornate. "It is such a charming building," says Ashley. "When you enter through the cobbled courtyard with its big water fountain, it feels like an oasis in the city. It's breathtaking."

Ashley describes the interior as an eclectic-slash-rustic mix with a color palette of orange and green. A skillful juxtaposition of old and new, it is in part industrial (with some Ikea thrown in). In the living room, a vintage floral rug is paired with a cowhide. A streamlined modern sofa sits adjacent to a retro squidgy chair. In the kitchen, all the dishes aren't neatly stowed away, but are out on display. "It's not the kind of house where life is kept behind the clean cupboard," she says. "It's quite the contrary. In my world, if I don't see it, I don't use it." At home with her objects on show all around her, the fancy-free interior perfectly matches her off-grid sense of style.

For instance, the art on the walls is an example of Ashley's desire to "play" with the styling of her home. "I'm naturally drawn to portrait paintings," she says. "I started with one, and I thought, 'Oh he needs a friend.' And so, I found another that I happened to like the face of. Now I have lots of portraits, and they all have conversations with each other." Independent, full of humor, modern, and vintage—this welcoming home is everything but ordinary.

DAS NEUE VINTAGE

Von Kissen mit Union-Jack-Design bis hin zu coolen Ölporträts:
Die Wohnung dieser Vintage-Style-Liebhaberin ist genauso entspannt,
offen und facettenreich wie ihre Persönlichkeit.

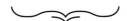

„Wie ich meinen Stil beschreiben würde?", grübelt Ashley Tell. „Bipolar? Nur ein Scherz. Unberechenbar? Ein Freund nennt ihn zerzaust, was die Sache ganz gut beschreibt. Mein Stil ist zerzaust und trotzdem ordentlich, falls das irgendeinen Sinn ergibt. Alles hat seinen festen Platz. Es sieht nicht unordentlich aus, aber doch so, als würde hier gelebt."

Die hier vorherrschende Spannung zwischen Vergangenheit und Gegenwart reflektiert die Lebenseinstellung der modebewussten Besitzerin des Global Vintage Collective, einer Boutique für Vintage-Kleidung. Ashleys Leidenschaft für Vintage ist überall spürbar. Wer die Wohnung betritt, dessen Blick fällt sofort auf die Porträts an der Wohnzimmerwand. Auf dem riesigen Straßenplakat, das sie in einem Trödelladen fand, sind alte Bahnhaltestellen gelistet. Ashley kommt selten von einer beruflichen Einkaufstour zurück, ohne auch für ihr eigenes Zuhause einen ganzen Koffer voller Sachen mitzubringen.

Ashley pendelt zwischen Melbourne und Kalifornien, wo sie ursprünglich herkommt. Dort hält sie vor allem nach Americana-T-Shirts, Streetwear und cooler Jeanskleidung Ausschau. „Im Grunde genommen die Klamotten meiner Mutter", sagt sie grinsend. „Für ein achtzehnjähriges Hipster-Girl in Australien ist das vielleicht ein Stilbruch, aber wo ich herkomme, hat man nie aufgehört, solche Sachen zu tragen." Ihrer Westküsten-Herkunft ist auch

ihre große Vorliebe für alte Navajo-Decken und kitschige Pferdefiguren geschuldet.

Das Dekor von Ashleys Zuhause in Richmond, einem hippen Stadtteil von Melbourne, ist eher schlicht gehalten: Erdtöne und Weiß dominieren, während die Texturen von samtigem Kuhfell bis zu butterweichem Leder reichen. Alles hier ist auf Komfort ausgerichtet, der Vibe warm und einladend. Der Sessel aus den 1970er-Jahren, in den man tief einsinkt, erinnerte Ashley an einen riesigen Baseballhandschuh. Mittelpunkt der Wohnung ist das stylische Wohnzimmer, wo ein fantastischer Mix unterschiedlichster Objekte präsentiert wird. Ashley ist immer auf der Suche nach alten Schätzen. „Für meine Arbeit besuche ich oft Flohmärkte", erklärt sie. „Ich liebe es, Besonderes aufzustöbern, es mit nach Hause zu bringen und dort dafür den perfekten Platz zu finden."

Ashleys Vier-Zimmer-Wohnung gehörte früher der australischen Modeschöpferin Norma Tullo und befindet sich im Erdgeschoss eines alten Fabrikgebäudes. Der lichtdurchflutete offene Wohnraum wird durch die Originalfenster im Loft-Style sowie einer wunderbar verzierten niedrigen Decke geprägt. „Es ist ein charmantes Haus", sagt Ashley. „Wenn man den Hof mit seinen Pflastersteinen und dem großen Springbrunnen betritt, fühlt man sich wie in einer Oase mitten in der Stadt. Es ist atemberaubend."

Ashley beschreibt das Interieur als einen eklektisch/rustikalen Mix in Orange- und Grüntönen. Der gekonnte Gegensatz von Alt und Neu ist zum Teil Industrial (mit einem Schuss Ikea). Im Wohnzimmer wird ein floraler Vintage-Teppich mit einem Kuhfell kombiniert. Ein stromlinienförmiges modernes Sofa steht neben einem zerknautschten Retro-Sessel. In der Küche ist das Geschirr nicht ordentlich verstaut, sondern zur Schau gestellt. „Bei mir wird das Leben nicht hinter sterilen Schrankfronten versteckt", sagt Ashley. „Das Gegenteil ist der Fall. Denn, wenn ich etwas nicht sehe, dann benutze ich es auch nicht." Dieses Wohnen umringt von Objekten passt zu ihrem ungewöhnlichen Style.

Die Kunst an den Wänden ist ein Beispiel dafür, wie Ashley mit der Einrichtung ihrer Wohnung „spielt". „Ich finde Porträtgemälde besonders faszinierend", sagt sie. „Ich fing mit einem an und dachte dann: „Oh, es braucht einen Freund." Und so fand ich ein weiteres, dessen Gesicht mir gefiel. Inzwischen besitze ich viele Porträts und sie unterhalten sich alle miteinander." Unabhängig, humorvoll, modern und Vintage – dieses einladende Zuhause ist alles andere als gewöhnlich.

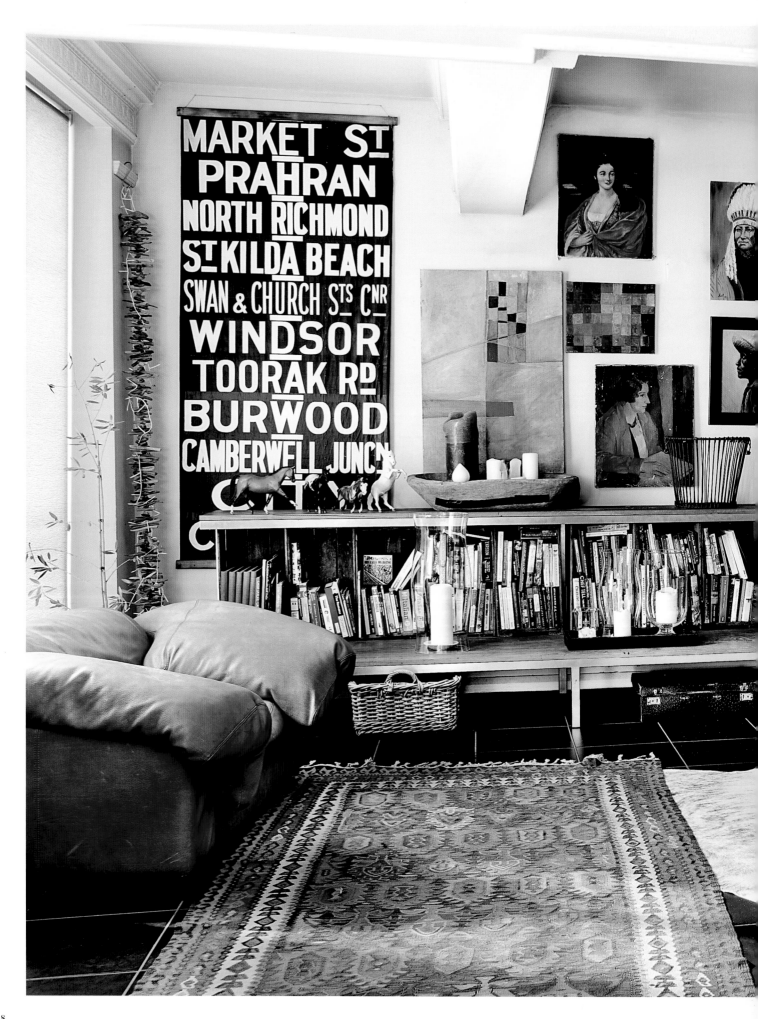

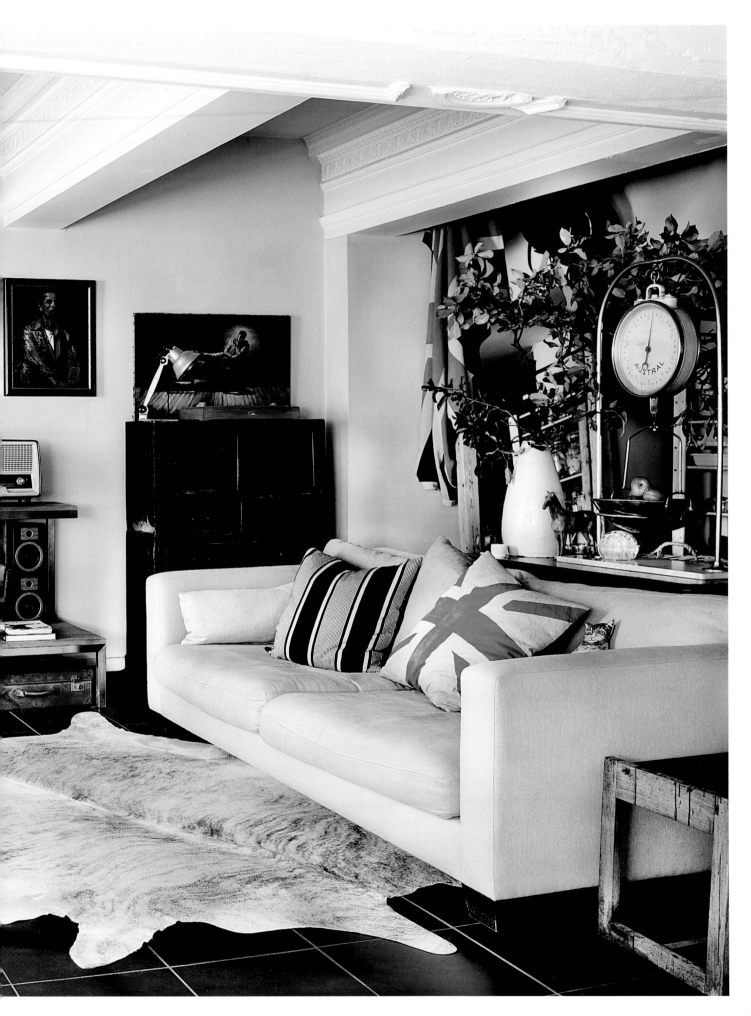

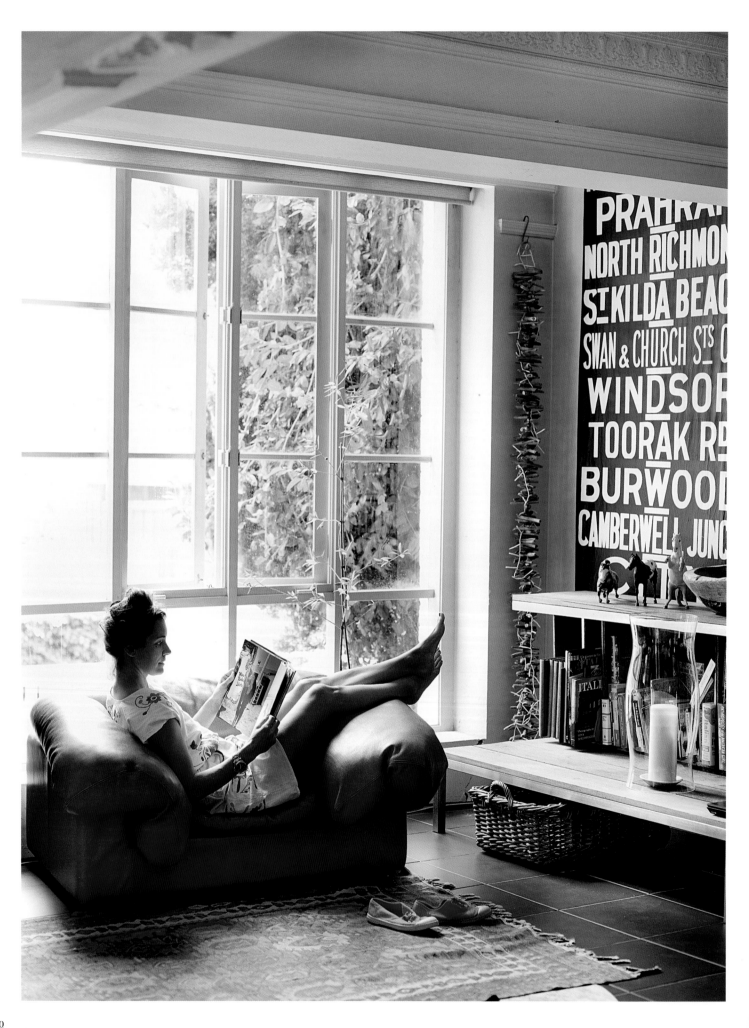

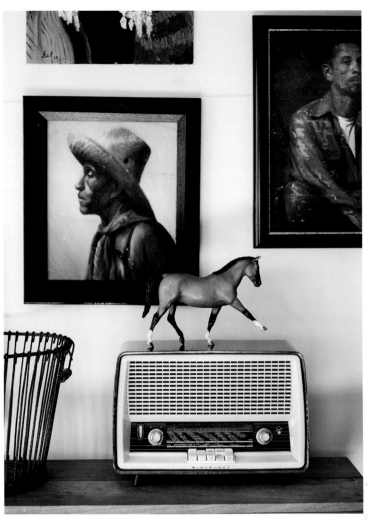

Living Room

"I found the leather chair at a market in Melbourne. I didn't know if it would work in the room but I liked the tan color and the texture. The seventies thing isn't really what I'm about, but one piece here and there is okay. My sister lives in England and the Union Jack cushions reminded me of her. Now I have a Californian flag draped on my sofa as well. On the wall, the old train sign was from a secondhand store. I fell in love with the colors and thought that if I ever moved back to California it would be a really nice souvenir."

Wohnzimmer

„Den Ledersessel habe ich auf einem Markt in Melbourne gefunden. Ich wusste nicht, ob er ins Zimmer passen würde, aber mir gefielen der Braunton und die Textur. Die Siebziger sind eigentlich gar nicht so mein Ding, aber hier und da mal ein Teil ist in Ordnung. Meine Schwester lebt in England und die Kissen mit der britischen Fahne erinnern mich an sie. Jetzt habe ich auch eine kalifornische Flagge auf meinem Sofa drapiert. Das alte Haltestellenposter an der Wand stammt aus einem Trödelladen. Ich verliebte mich in die Farben und dachte, es wäre ein schönes Andenken, wenn ich jemals nach Kalifornien zurückziehe."

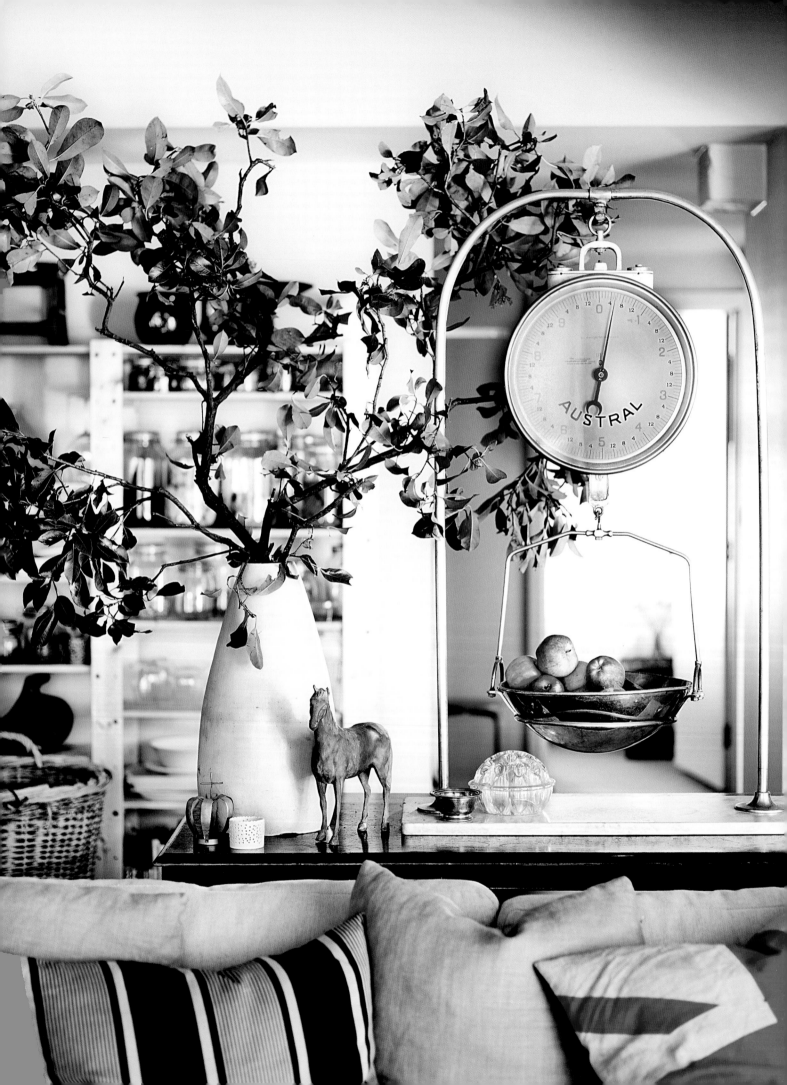

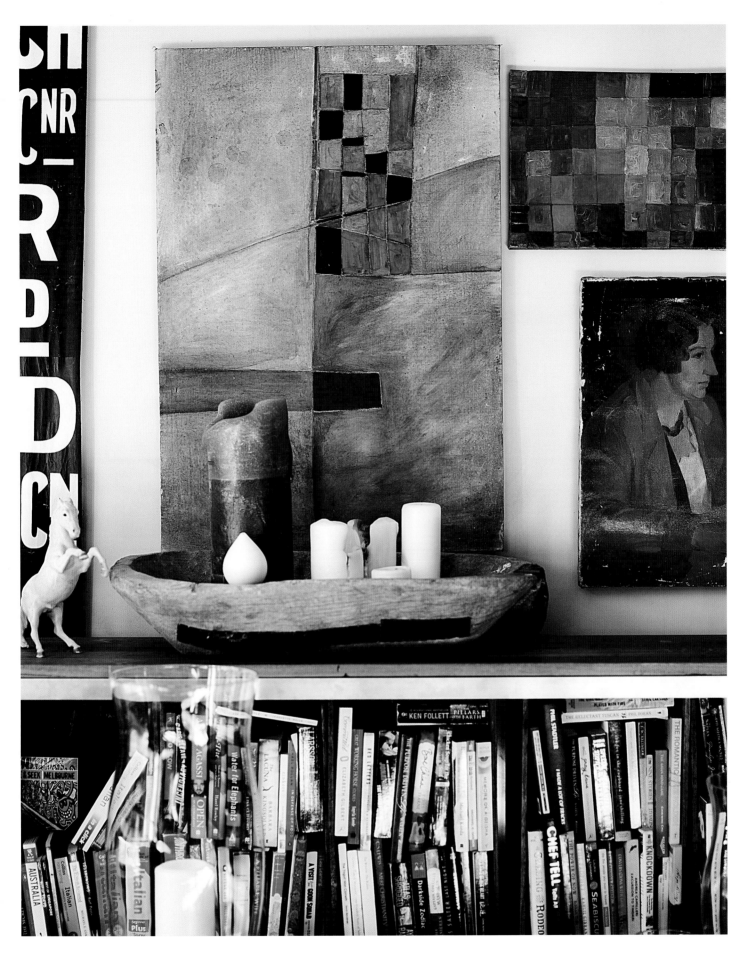

In the living room, the earthy red and green colors mix with industrial-style furniture finds.
--
Im Wohnzimmer harmonieren die erdigen Rot- und Grüntöne mit Möbeln im Industrial Style.

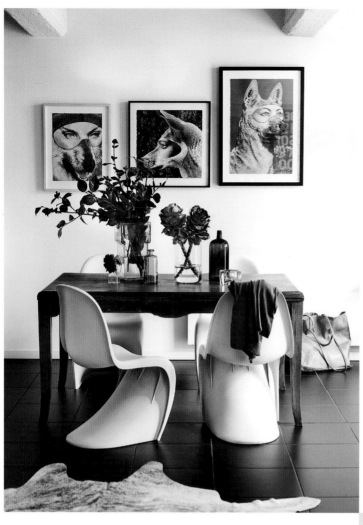

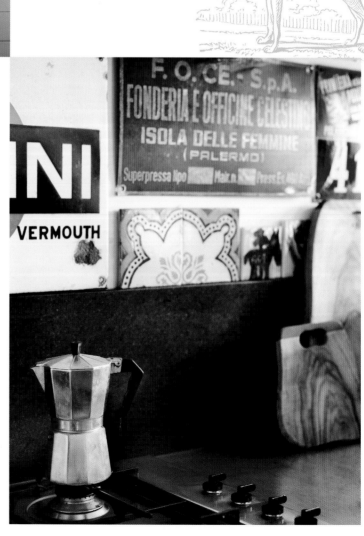

Dining Area

"This room shares a space with the living room. It is pretty much open-plan. I like having an older table with modern chairs. I think it's a nice mix, and I've always liked the style of the Verner Panton chairs. I just wish I could say they were comfortable. Above the dining table are lithographs by a Lithuanian artist who lives in Australia. These were presents from a friend."

Essbereich

„Dieser offene Bereich geht ins Wohnzimmer über. Mir gefällt die Kombination aus einem alten Tisch und modernen Stühlen. Das ist ein schöner Mix. Den Stil der Stühle von Verner Panton habe ich schon immer gemocht. Ich wünschte, ich könnte behaupten, dass sie bequem sind. Über dem Esstisch hängen Lithografien von einem litauischen Künstler, der in Australien lebt. Ein Freund hat sie mir geschenkt."

Bedroom

"I find it really soothing to have a bedroom that is sparse and where everything is white. It's very simple. Basically, there's a bed, a bedside table, and very little artwork. I wanted it to be almost contrary to everything else that is going on in the house."

Schlafzimmer

„Ein spärlich eingerichtetes Schlafzimmer ganz in Weiß finde ich beruhigend. In diesem gibt es ein Bett, ein Nachttisch und nur wenig Kunst. Ich wollte, dass das Zimmer fast einen Kontrast zu dem bildet, was sich sonst so in der Wohnung tut."

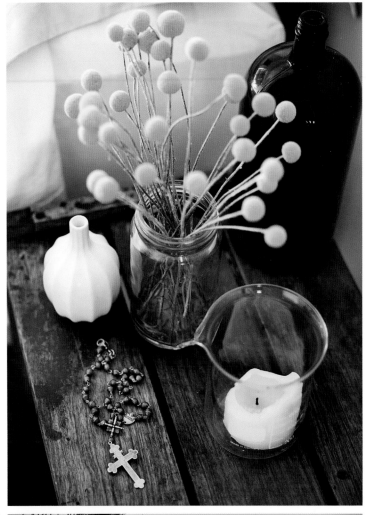

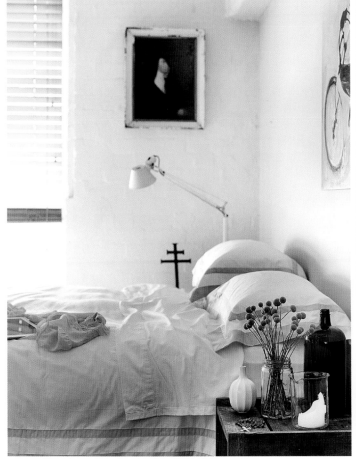

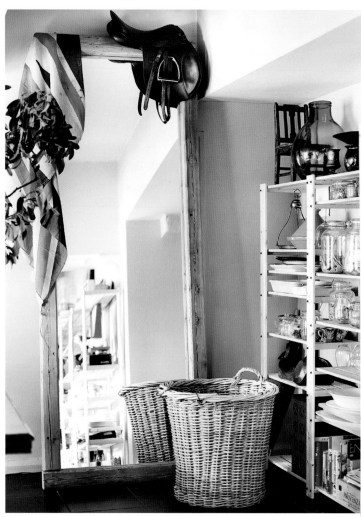

Kitchen

"When we moved in, there were only two small cupboards in the kitchen so we needed something else. I bought the Ikea shelving units so that items used on a daily basis could be stored at shoulder height. The look is informal. The great thing about the shelves is that you can build them as you go. We customized them to what we needed. The Martini sign is from Italy—I collect street signs whenever I travel. I don't normally use red in decoration but it works when items are color blocked together in a smaller space."

Küche

„Als wir einzogen, gab es in der Küche nur zwei kleine Schränke. Wir brauchten also noch mehr Stauraum. Ich kaufte die Regale von Ikea, um Dinge, die wir täglich benutzen, auf Schulterhöhe unterzubringen. Der Look ist informell. Das tolle an den Regalen ist, dass man immer anbauen kann. Wir haben sie an unsere Bedürfnisse angepasst. Das Martini-Schild kommt aus Italien – ich sammle von überall, wohin ich reise, alte Schilder. Rot verwende ich normalerweise nicht, aber es funktioniert, wenn Gegenstände in verschiedenen Rottönen auf engem Raum zusammenstehen."

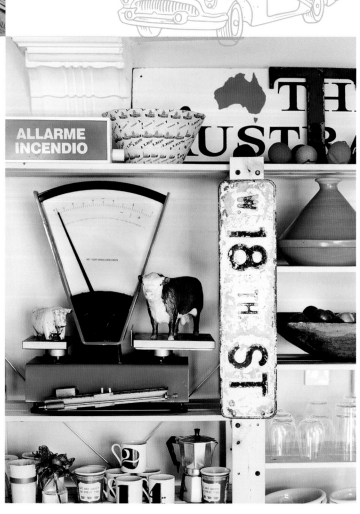

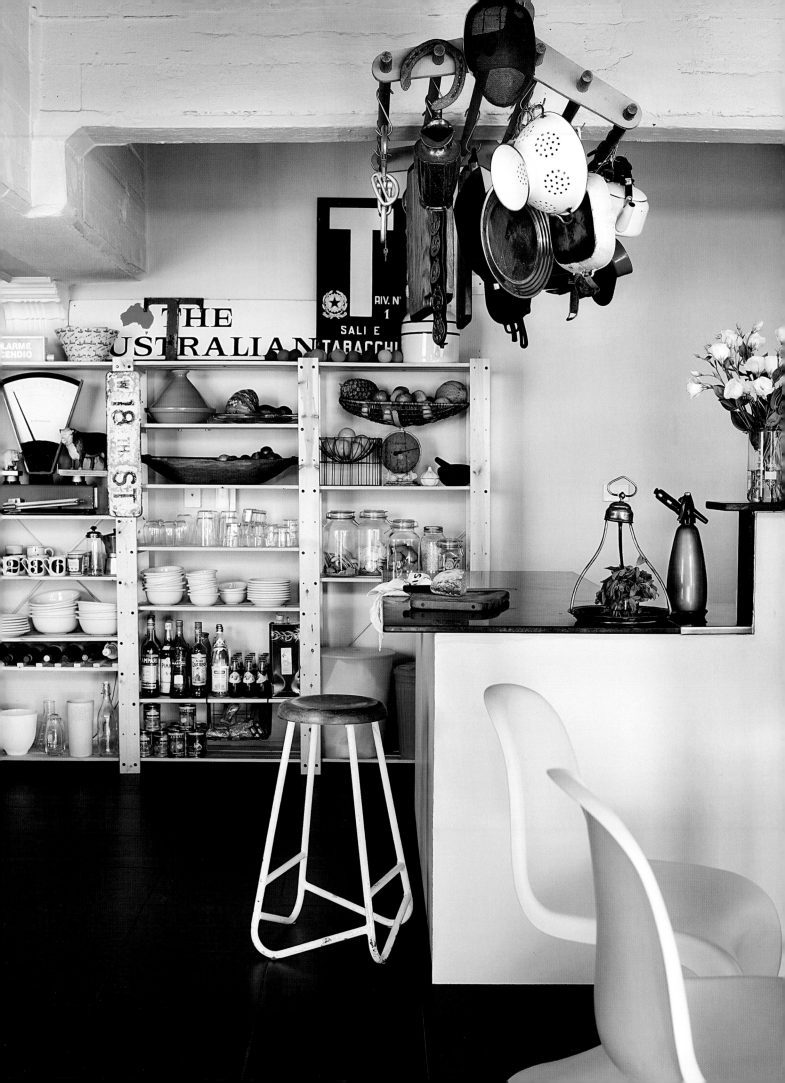

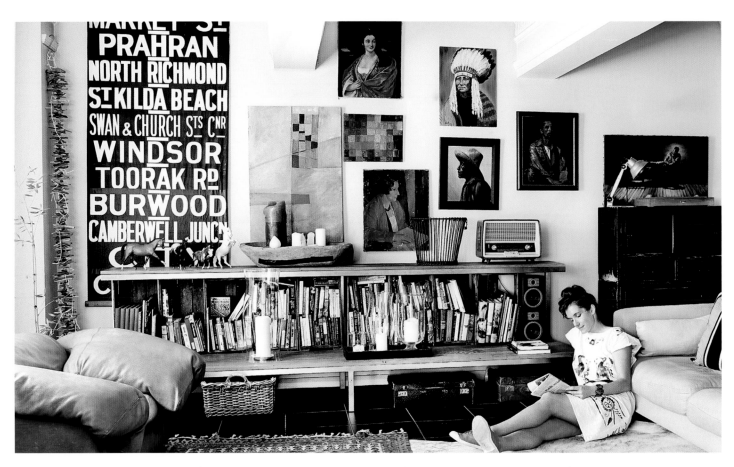

Ashley's golden rules of
CREATING A GALLERY WALL

1. Find a painting that you love regardless of the subject matter and build on it from that.

2. Either stick to a theme or concentrate on a color palette, so you have some continuity. It makes the end result easy on the eye.

3. Start with a painting that you love the most—or the largest one that might be difficult to place. See what proportions are working and whether you need to raise it above eye level.

4. I don't have any particular rules on framing. I leave them as I find them. As long as the colors and subjects go together, you can mix up everything else. Black tape at the corners of a canvas can also be fun.

5. My life motto is to be self-deprecating. It does me good. With the framing, I literally nail them on the wall and off I go. It's good to start backwards sometimes.

Ashleys goldene Regeln für eine
GALERIEWAND

1. Finden Sie ein Bild, das Sie lieben (ganz gleich, welches Motiv es hat), und bauen Sie Ihre Galerie darauf auf.

2. Halten Sie sich entweder an ein Thema oder eine Farbpalette, um eine gewisse Kontinuität zu erzeugen. Das verhindert zu viel visuelle Unruhe.

3. Hängen Sie zuerst ein Lieblingsbild auf — oder das größte, das vielleicht schwer zu platzieren ist. Achten Sie darauf, wie die Proportionen wirken und ob Sie es eventuell höher als Augenhöhe hängen müssen.

4. Beim Rahmen habe ich eigentlich keine Regeln. Ich nehme es, wie's gerade kommt. Wenn die Farben und Motive zusammenpassen, kann man alles andere bunt mischen. Eine mit schwarzem Klebeband gerahmte Leinwand kann auch lustig sein.

5. Mein Lebensmotto ist Bescheidenheit. Das tut mir gut. Was die Rahmen anbelangt, nagele ich einfach erst einmal alles an die Wand und denke nicht groß darüber nach. Manchmal ist es gut, von hinten anzufangen.

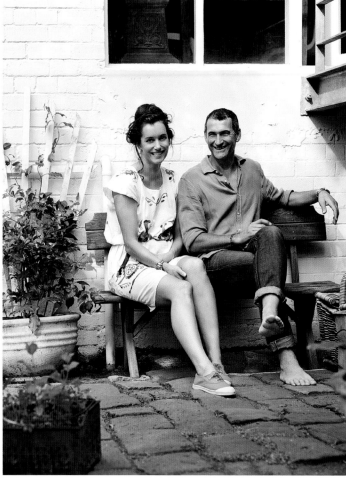

MY
HOME
TRUTHS

<u>My style is in constant rotation.</u> What I love about Australia is that there's a freedom to be a little bit nutty in your dress sense. I can basically wear whatever I want here and I feel fine. At the moment, Gucci has brought together granny-style, streetwear, and 1970s — it's hideously fabulous. I'm embracing that right now.

<u>My ambition is to supply vintage</u> to a major store and be on the front line seven days a week looking for it. That is the dream. I go home to California for four months of the year to source product for the store, hand selecting pieces. This is the favorite part of my business. It gives me the grit that I need.

MEINE
WOHN-
WEISHEITEN

<u>Mein Stil verändert sich ständig.</u> An Australien liebe ich, dass man hier die Freiheit hat, ein bisschen gaga in seinem Kleidungsstil zu sein. Hier kann ich im Grunde genommen anziehen, was ich will. Gerade hat Gucci den Oma-Style, Streetwear und die 1970er-Jahre zusammengebracht — scheußlich schön. Diesen Stil liebe ich gerade.

<u>Mein Ziel ist es,</u> ein großes Geschäft mit Vintage-Sachen zu versorgen und sieben Tage pro Woche an vorderster Front danach zu suchen. Das ist mein Traum. Ich bin vier Monate im Jahr in Kalifornien, um Produkte für meinen Laden zu finden. Ich selektiere jedes Stück einzeln. Das ist der Teil meiner Arbeit, den ich am meisten liebe. Es gibt mir den nötigen Drive.

BOHEMIAN
RHAPSODY

Zinging color, midcentury furniture,
and a riot of character turns this Parisian apartment
into a beautiful box of tricks.

Behold the madcap and colorful Paris home of Victoire de Taillac and her husband the DJ, art director, and brand Renaissance man, Ramdane Touhami—the French-Moroccan creative behind the resurgence of the beauty brand Buly 1803, and before that, the 17th-century French candle maker Cire Trudon.

Home for this globetrotting couple and their three children has been many places. They have moved—usually for work reasons—eight times since having children, including stints in New York, Tangier, and most recently, Tokyo, where they are planning to open a Buly store. "Nothing quite compares to Tokyo," says Victoire. "It's another planet. Our house in Tokyo is from the 1960s. It's colorful, but quite empty—so not at all like the Paris flat, which is full of things. Usually when we move, all our things come with us, but this time it was a different story."

Living in a very beautiful 18th-century hôtel particulier on Saint Germain's Rue du Bac, this lofty, two-story apartment is every bit as colorful as the family of five. The living room's airy, floor-to-ceiling windows offer rooftop views over the Parisian skyline taking in Les Invalides to the Eiffel Tower along the way. "It was unlike most Parisian flats," says Victoire. "Apartments in Paris tend to be classical but this one was different. It is like a penthouse on the top of the city."

The layout is the reverse of a typical Parisian home, with the bedrooms, bathroom, and kitchen on the first floor and the wide, expansive living and dining rooms above. The look inside, though, is anything but streamlined. Instead, it is a happy jumble, a collection of individual passions crisscrossing the worlds of art, design, and fashion. "It's an unexpected mix, because things come from different houses and styles; different stages in your life," says Victoire. There is an eclectic mix of art, midcentury furniture, and flea market finds that Ramdane has picked up around the world. "My husband loves to collect things," Victoire continues. "He goes to the flea market in Clignancourt, and he loves the antique fairs in Aix-en-Provence. These are the things that he likes. There are so many books and records. Things tend to pile up."

The finished result is a joyful mix that captures the personality of the family and their wanderlust ways. It is relaxed, easy-going, and full of color. There's the purple and gold dining room, for example, with its enormous refectory table that the couple shipped over from their apartment in New York and craned in through the window here. That's the only way it would fit. The turquoise kitchen is wallpapered with a Moroccan-inspired tile, and the living room features a fabulous multicolored wall.

"We never know how long we are going to be in one place, so we are quick to try things out," explains Victoire. "There's no 'should I; should I not?' We never have these kinds of questions. If it's a mistake, it's a mistake. We can always paint over it."

"The decoration is a constant work-in-progress," says Victoire. "Ramdane designed the bold, bright wall mural in the living room to perk up a gray sofa, because gray is too sad,"—unlike Ramdane and Victoire. Wherever they travel, whatever they take with them, things always find their place.

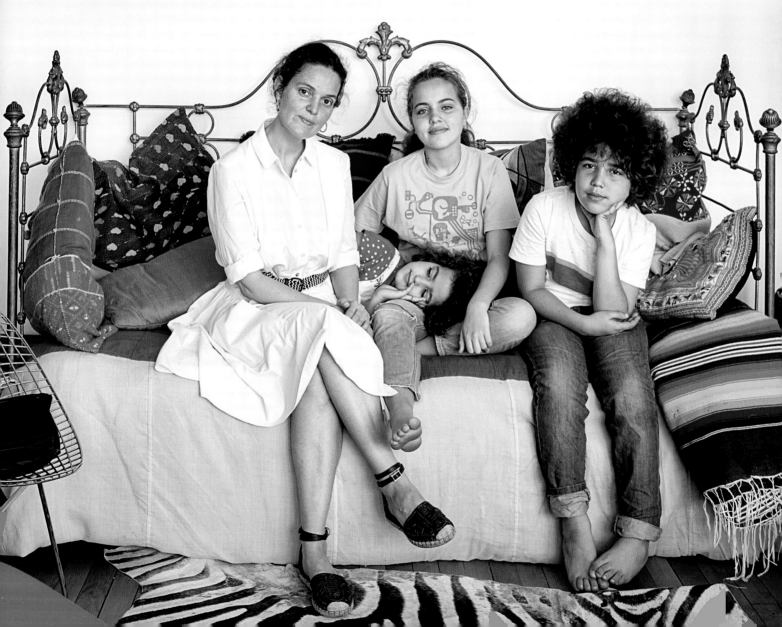

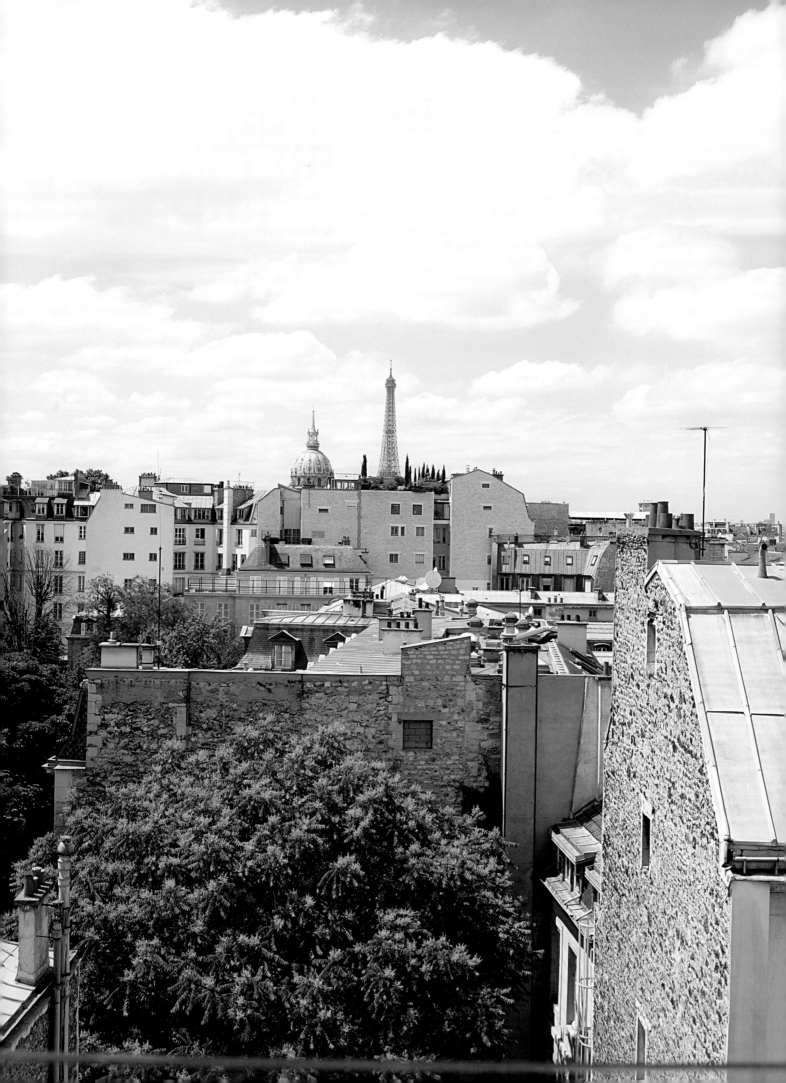

ÜBER DEN DÄCHERN VON PARIS

Knallige Farben, Möbel aus der Mitte des 20. Jahrhunderts und jede Menge Charakter machen dieses Pariser Appartement zu einem wunderschönen Überraschungspaket.

Willkommen in der bunten, verrückten Pariser Bleibe von Victoire de Taillac und ihrem Mann, dem DJ, Art Director und Produktdesigner Ramdane Touhami. Der französisch-marokkanische Kreative Touhami führte unter anderem zwei Traditionsunternehmen – die Parfüm- und Kosmetikmarke Buly 1803 und die im 17. Jahrhundert gegründete französische Kerzenmacherei Cire Trudon – zu neuer Blüte.

Das Globetrotter-Paar und ihre drei Kinder waren schon an vielen Orten zu Hause. Seit sie Kinder haben, sind sie – meistens der Arbeit wegen – bereits achtmal umgezogen und lebten unter anderem in New York, Tanger und jüngst Tokio, wo sie einen Buly-Store eröffnen wollen. „Nichts lässt sich mit Tokio vergleichen", sagt Victoire. „Es ist wie ein anderer Planet. Unser Haus in Tokio stammt aus den 1960er-Jahren. Es ist bunt, aber ziemlich leer – so gar nicht wie die Pariser Wohnung, die mit Dingen vollgestopft ist. Normalerweise nehmen wir alle unsere Sachen mit, wenn wir umziehen, aber dieses Mal war es anders."

Das zweistöckige, loftartige Pariser Appartement befindet sich in einem sehr schönen Hôtel particulier aus dem 18. Jahrhundert in Saint Germaines Rue du Bac und ist genauso bunt wie die fünfköpfige Familie, die es bewohnt. Die riesigen raumhohen Fenster des Wohnzimmers bieten einen Blick über die Dächer von Paris, Invalidendom und Eiffelturm inklusive. „Die Immobilie hob sich von den meisten Wohnungen hier ab", erzählt Victoire. „In Paris sind die Wohnungen meist klassisch, aber diese thront eher wie ein Penthaus über der Stadt."

Der Grundriss stellt die typische Raumverteilung auf den Kopf: Schlafzimmer, Bad und Küche befinden sich im ersten Stock, die weitläufigen Wohn- und Essbereiche eine Etage höher. Und auch das Interieur ist alles andere als stromlinienförmig – eine wilde Sammlung individueller Leidenschaften aus den Bereichen Kunst, Design und Mode. „Es ist eine überraschende Mischung, weil die Sachen aus unterschiedlichen Häusern und Stilen kommen, aus unterschiedlichen Lebensabschnitten", sagt Victoire. Den eklektischen Mix aus Kunst, klassischen Designermöbeln und Flohmarktfunden hat Ramdane auf der ganzen Welt zusammengeklaubt. „Mein Mann sammelt gern Dinge", fährt Victoire fort. „Er besucht den Flohmarkt in Clignancourt und liebt die Antikmärkte in Aix-en-Provence. Wir haben so viele Bücher und Schallplatten. Die Sachen stapeln sich schon."

Das Endresultat ist ein fröhliches Durcheinander, das die Persönlichkeit der Familie und ihre Reiselust einfängt. Das Interieur ist entspannt, locker und farbenfroh. Das Esszimmer ist zum Beispiel in Gold und Lila gehalten und beherbergt einen riesigen Refektoriumstisch, den das Paar von New York nach Paris verschiffen ließ und der per Kran durchs Fenster gehoben werden musste, da er nicht durch die Tür gepasst hätte. Das Tapetenmuster der türkisfarbenen Küche ist von marokkanischen Fliesen inspiriert und im Wohnzimmer leuchtet eine fantastische quietschbunte Wand.

„Wir wissen nie, wie lang wir an einem Ort bleiben", erklärt Victoire. „Deshalb probieren wir immer schnell neue Ideen aus. Es gibt kein langes: Soll ich oder soll ich nicht? Solche Fragen stellen wir uns nicht. Wenn es ein Fehler war, dann war es eben ein Fehler. Wir können es ja jederzeit überstreichen."

„Unsere Einrichtung ist ein permanentes Projekt", sagt Victoire. Ramdane hat das aufregende bunte Wandmuster im Wohnzimmer entworfen, um ein ursprünglich graues Sofa aufzupeppen, weil Grau einfach zu traurig ist". Im Umfeld von Ramdane und Victoire wird kein Trübsal geblasen. Und wo immer es sie auch hinzieht: Die Dinge finden überall ihren Platz.

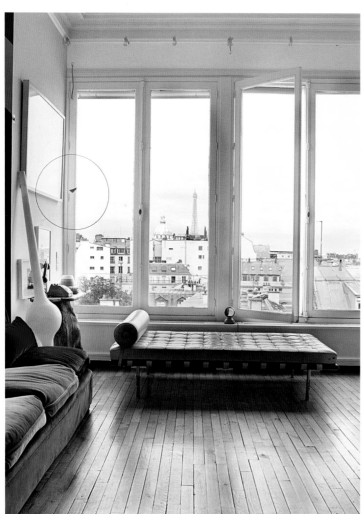

Living Room

"The living room is huge. We use it to entertain and watch TV—
and because we are on the top floor, the light is very nice.
The bookcases on either side of the fireplace are about 13 feet
(four meters) high and hold Ramdane's collection of art and
fashion books. He also designed the bright mural wall, which
corresponds with the colors of the sofa cushions. We first chose
the velvet of the sofa and then worked out the colors for the wall
behind. I would say that the furniture is a combination of eclectic
with vintage flea-market pieces such as the Mies van der Rohe
Barcelona daybed, Eames chairs, and 1950s Scandinavian chairs."

Wohnzimmer

„Das Wohnzimmer ist riesig. Wir empfangen darin Gäste und
gucken fern – und weil wir auf der obersten Etage sind, ist das
Licht wunderbar. Die Bücherregale beiderseits des Kamins sind
etwa vier Meter hoch und beherbergen Ramdanes Sammlung an
Kunstbänden und Büchern über Mode. Er hat auch die leuchtend
bunte Wand entworfen, die mit den Farben der Sofakissen
korrespondiert. Zuerst wählten wir den Samtstoff für das Sofa
aus und dann die Farben für die Wand. Ich würde die Möbel
als sehr durchmischt bezeichnen, mit Vintage-Flohmarktfunden
wie Mies van der Rohes Liege Barcelona, Eames-Sesseln und
skandinavischen Stühlen aus den 1950er-Jahren.

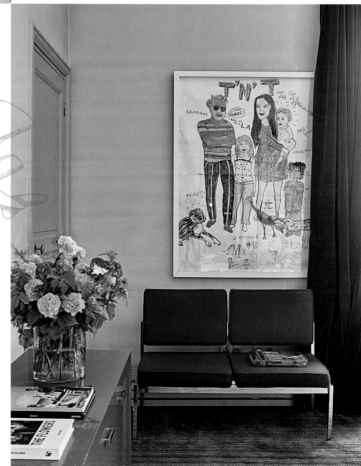

The family created a fun self-portrait with artist
friend Artus de Lavilléon.
--
Das lustige Familienporträt kreierten die Touhamis
zusammen mit ihrem Künstlerfreund Artus de Lavilléon.

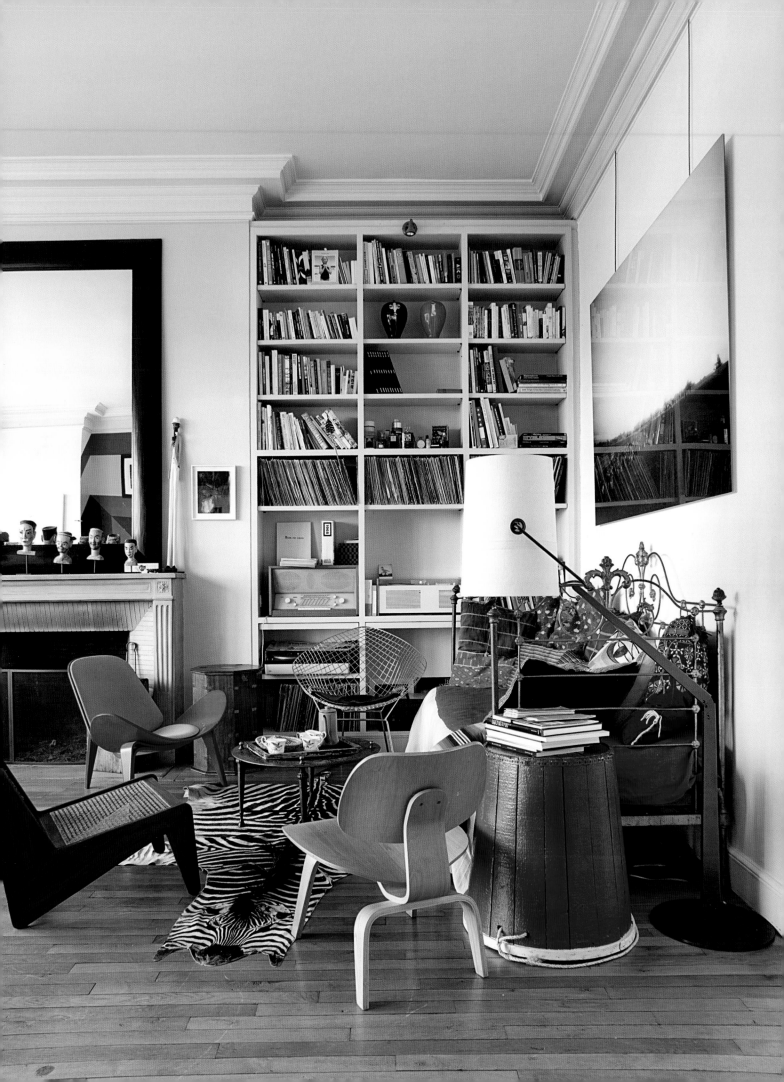

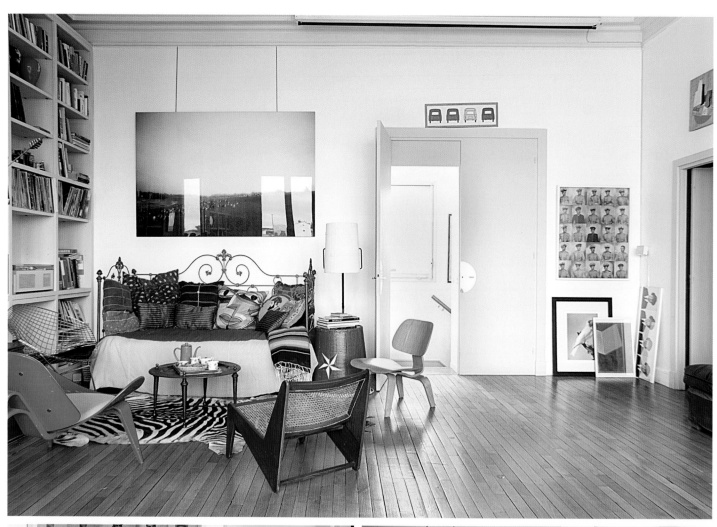

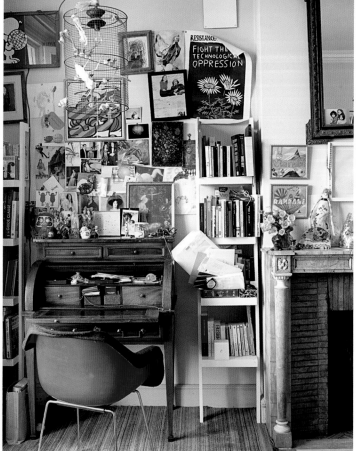

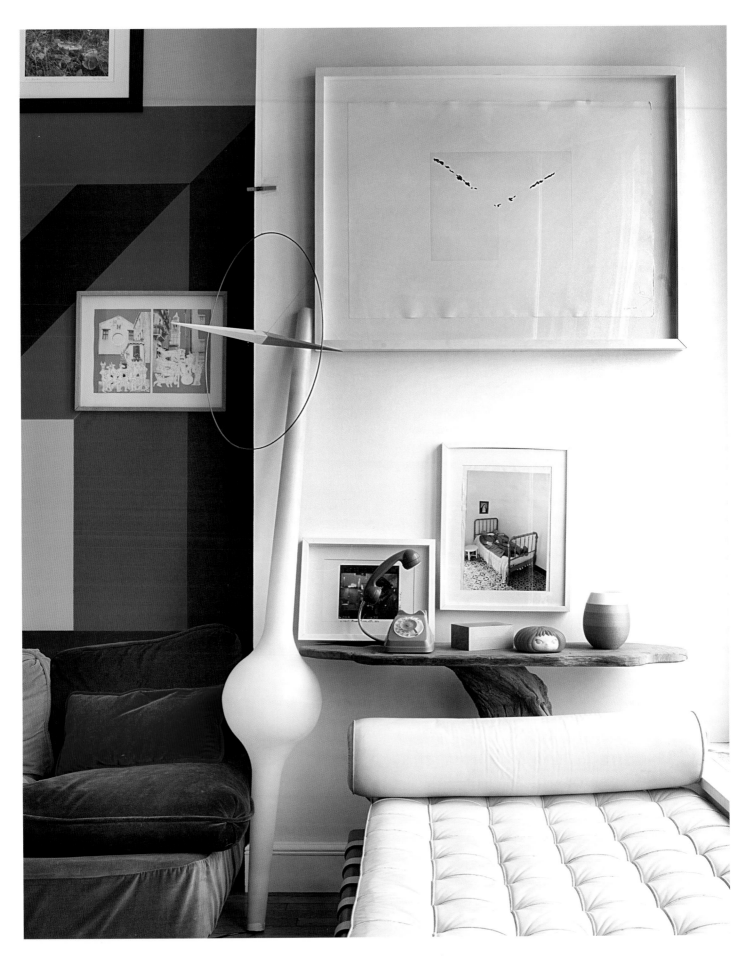

The living room contrasts kitsch knick-knacks with vintage pieces and modern buys.
--
Im Wohnzimmer sind kitschige Erinnerungsstücke mit Vintage-Möbeln und modernen Teilen kontrastiert.

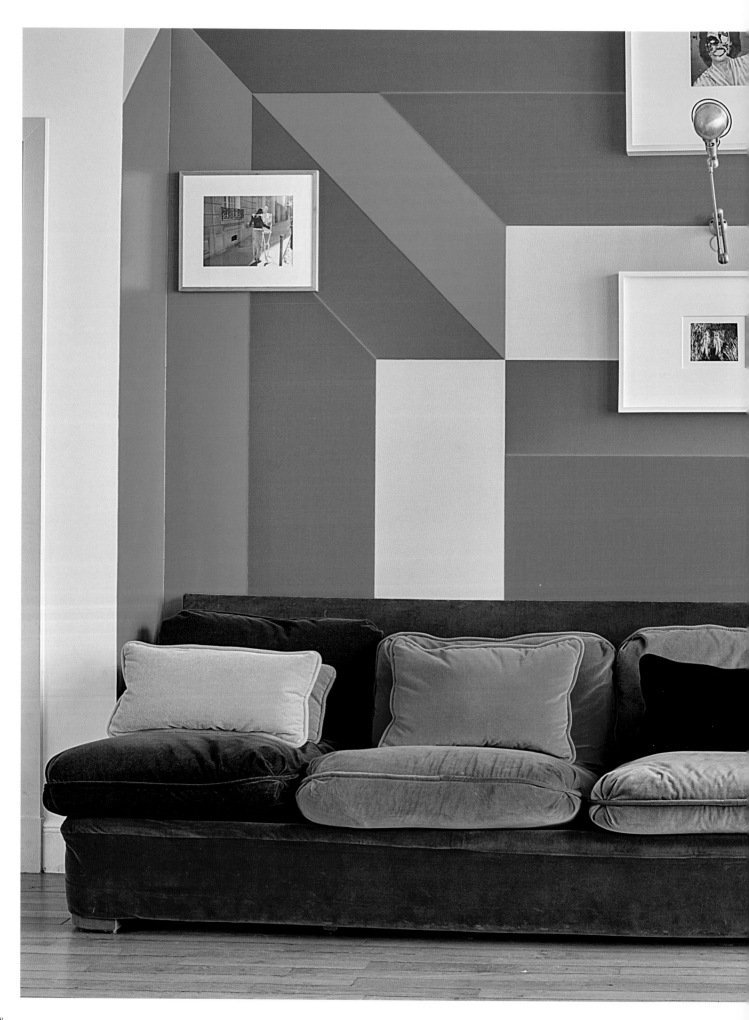

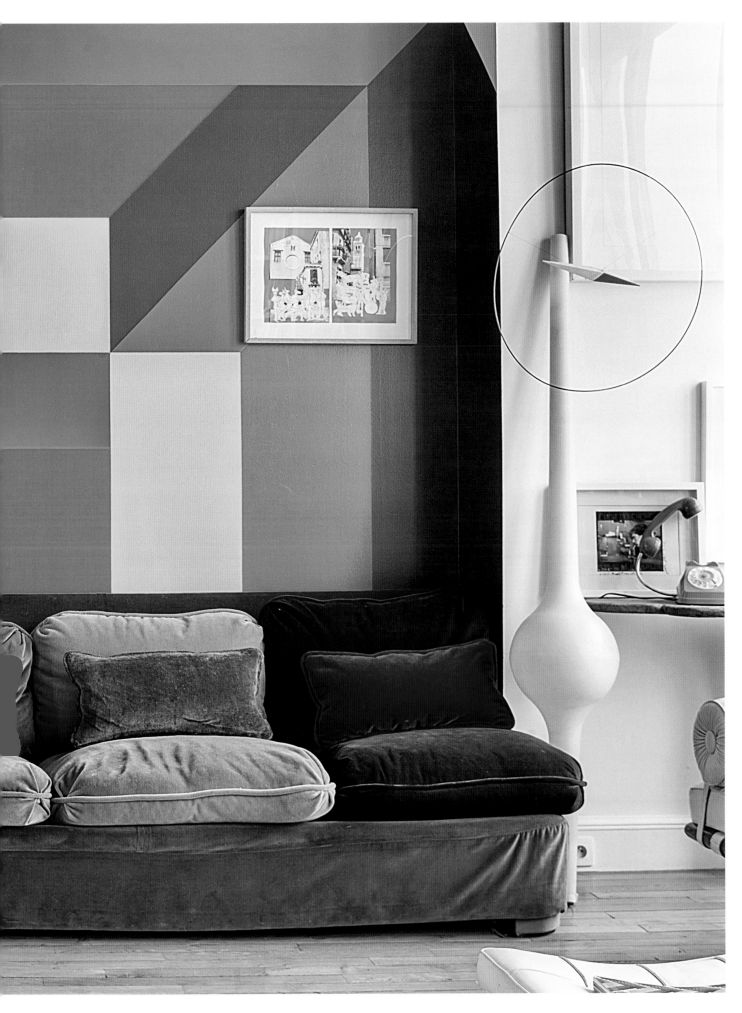

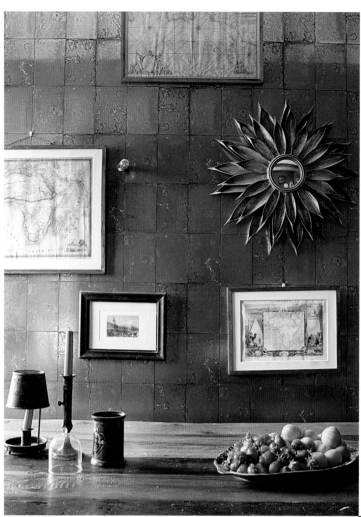

Dining Room

"This was the first room we decorated when we arrived. The enormous wooden farm table came from our first house in Brooklyn and is long enough for 15 or 20 people to gather around. The walls are painted dark purple and are paired with gold wallpaper from Cole & Son. We were in the mood for something more dramatic in this space."

Esszimmer

„Das war das erste Zimmer, was wir einrichteten. Der gigantische Bauerntisch stammt aus unserem ersten Haus in Brooklyn und bietet 15 bis 20 Personen Platz. Die Wände haben einen Anstrich in Dunkellila, der mit einer goldenen Tapete von Cole & Son kombiniert wurde. Wir hatten hier Lust auf etwas Dramatisches."

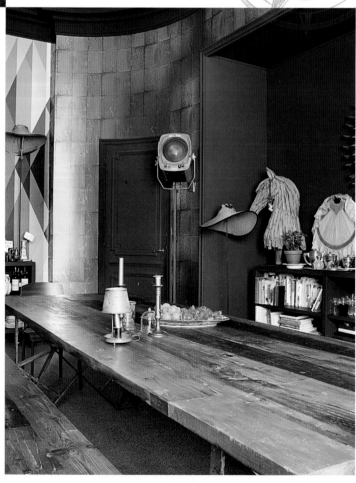

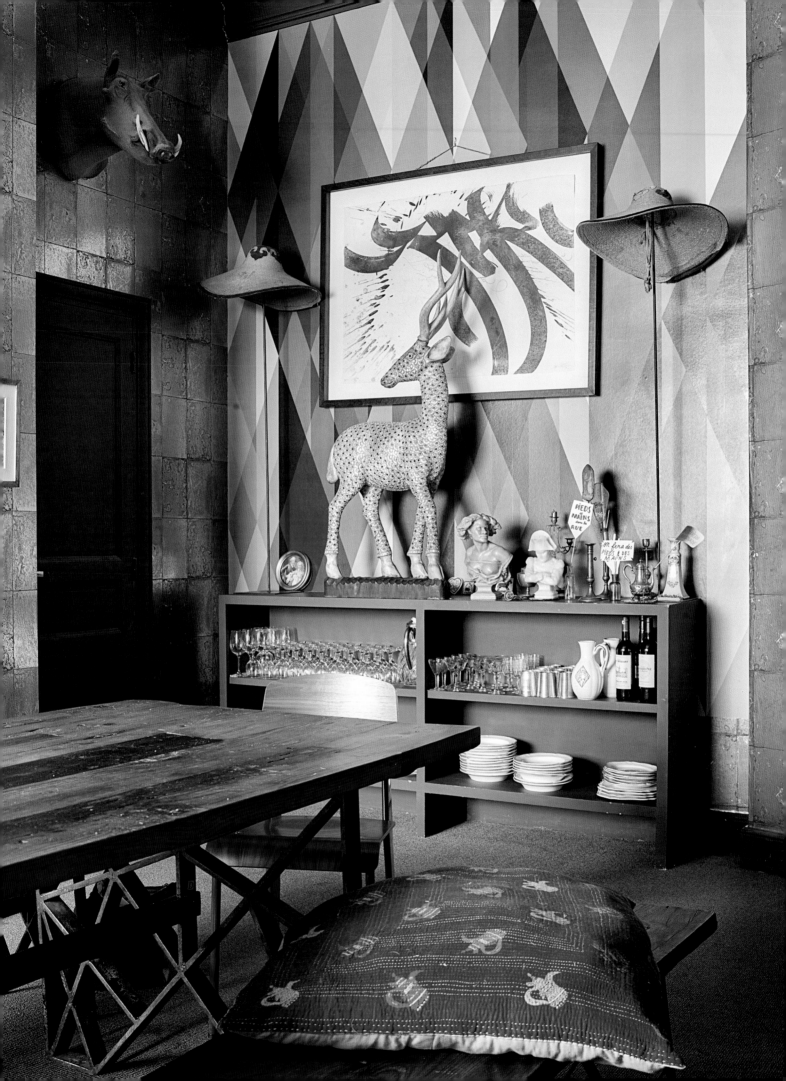

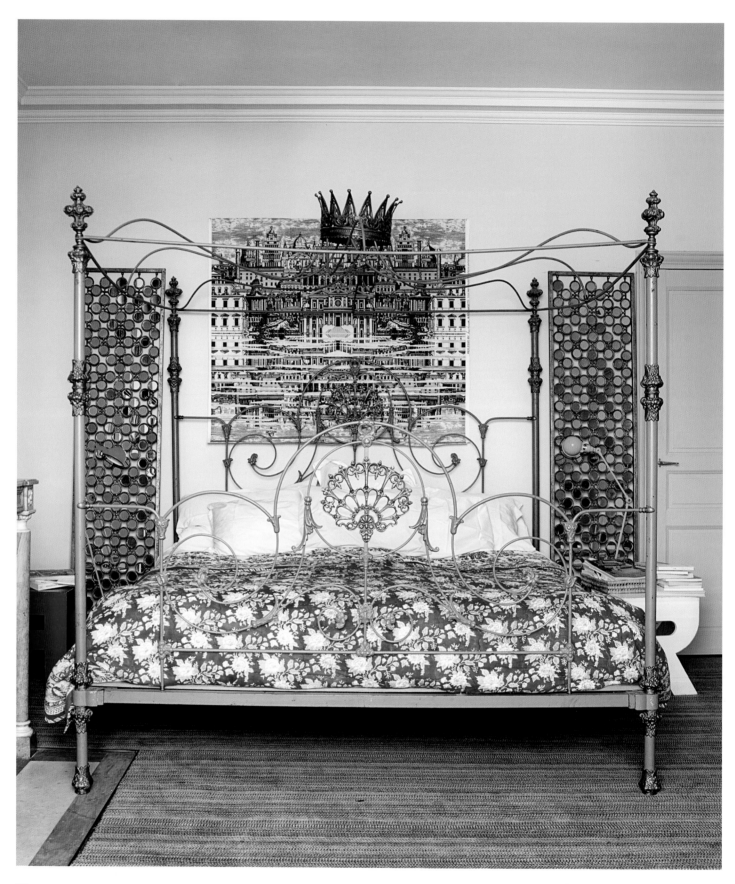

"The ornate 19ᵗʰ-century baldachin bed came from our house in Tangier, which had seven bedrooms that we needed to fill. It is big enough for the whole family to tumble into. The Indian mirror-work screens on either side of the bed came from a store in Paris."

--

"Das verzierte Bett aus dem 19. Jahrhundert mit Baldachin stammt aus unserem Haus in Tanger, das sieben Zimmer hatte, die alle gefüllt werden mussten. Darin kann die ganze Familie sich tummeln. Die indischen Spiegeltrennwände an beiden Seiten haben wir aus einem Geschäft in Paris."

Kitchen

"In Paris, traditionally the kitchens are tiny. So this room felt depressing, and it had no view. It is a shame as we spend a lot of time cooking. To cheer things up, we painted it turquoise, added the teapot light from Anthropologie, and wallpapered in a Moroccan tile. For us Tangier was about colors, tiles, and outdoor living. The turquoise reminded Ramdane of a kitchen we had before. We repeat ideas that we have tried in previous apartments, so we know whether we like them or not."

Küche

„In Paris sind die Küchen traditionell winzig. Dieser Raum wirkte deprimierend und hatte keine schöne Aussicht, was schade ist, weil wir viel Zeit mit Kochen verbringen. Um die Stimmung aufzuhellen, strichen wir die Decken in Türkis, klebten Tapeten mit marokkanischem Fliesenmuster an die Wände und setzten mit der Teekannen-Lampe von Anthropologie einen fröhlichen Akzent. Mit Tanger verbinden wir Farben, schöne Fliesen und ein Leben im Freien. Das Türkis erinnerte Ramdane an eine unserer früheren Küchen. Wir übernehmen manchmal Ideen aus früheren Wohnungen, weil diese bereits erprobt sind."

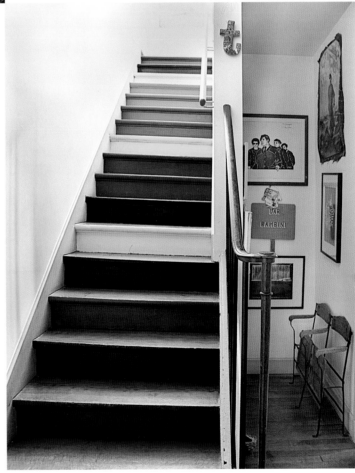

The rainbow-painted staircase is the first thing you see as you enter the home—it gives a colorful greeting as you walk in.
--
Die bunte Treppe ist das Erste, was man sieht, wenn man das Haus betritt — eine farbenfrohe Begrüßung.

Bathroom

Victoire's bathroom may be classic and white
but decorative touches such as the pink rag rug,
ceramic sconces, and Japanese souvenirs add character.
Silver accessories deliver on the elegance and
the double basin is practical for the Touhami clan.

Badezimmer

Victoires Badezimmer ist zwar klassisch weiß gehalten,
aber dekorative Akzente wie der bunte Flickenteppich,
Wandleuchten aus Keramik und japanische Souvenirs
geben dem Raum Charakter. Silberne Accessoires
sorgen für Eleganz und der Doppelwaschtisch hat
praktischen Nutzen für die Touhamis.

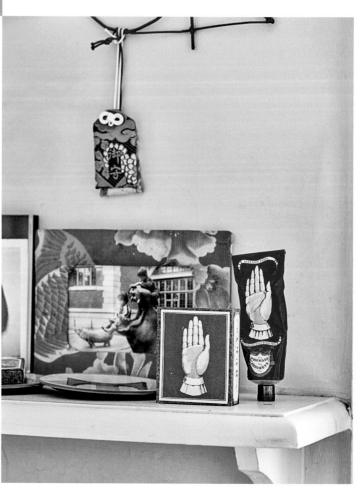

"I love my white 1930s bathroom," says Victoire.
"It has a balcony, which opens out to the view."
Victoire is a keen gardener, so the balcony is full
of plants.
--
Ich liebe mein weißes 1930er-Jahre Badezimmer",
sagt Victoire. Es hat einen Balkon mit Ausblick."
Victoire ist eine passionierte Gärtnerin, der
Balkon entsprechend voll mit Pflanzen.

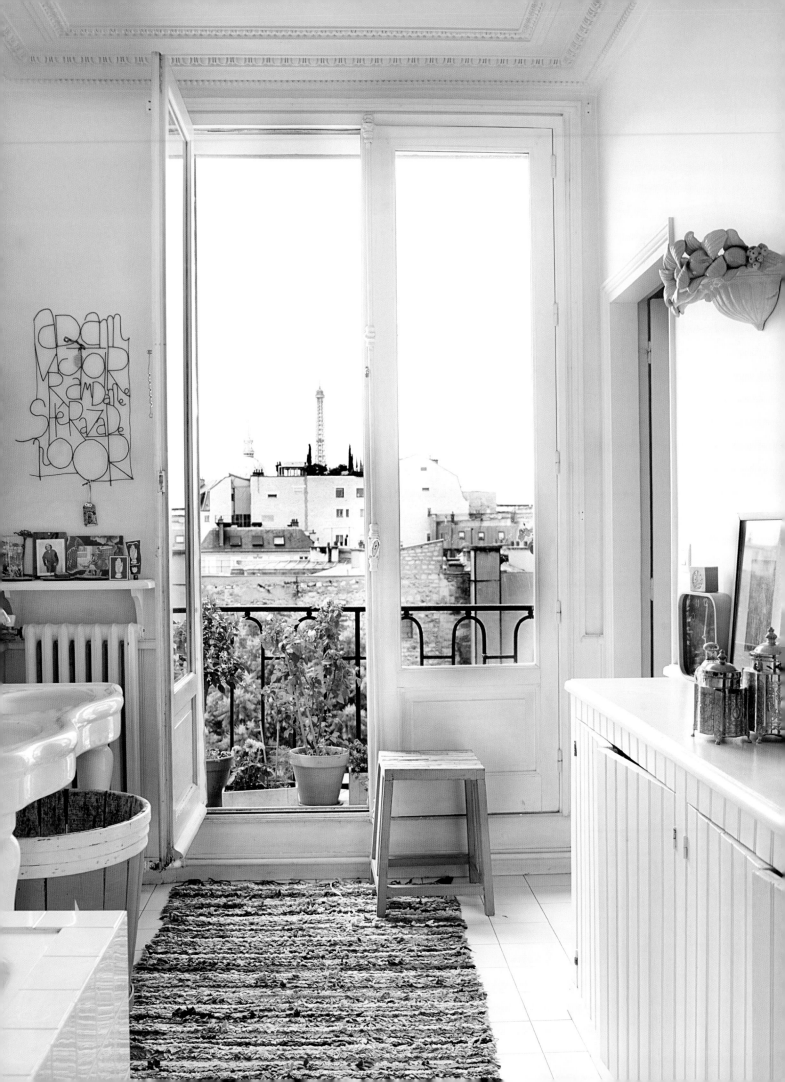

Victoire's top tips for
GLOBE-TROTTING STYLE

1. Be open-minded. A new house means you will find a place for everything. We don't expect our living room to always look the same.

2. The first thing we do when we move is to fill any furniture gaps. Decoration comes before utilities for us.

3. With a lot of things to move, things get broken, things get lost—but the more order you have, the easier everything will be.

4. Before moving, get rid of as many things as possible—not when you get into the new place.

5. My design philosophy is to experiment. Don't take home decoration too seriously and make do with what you have.

Victoires Top-Tipps für einen
GLOBETROTTER-STIL

1. Seien Sie offen. In einem neuen Haus werden Sie Platz für alles finden. Wir erwarten nicht, dass unser Wohnzimmer immer gleich aussieht.

2. Das Erste, was wir beim Einzug machen, ist, Möblierungslücken zu füllen. Bei uns hat die Dekoration Vorrang vor dem Praktischen.

3. Bei einem Umzug gehen Dinge kaputt oder verloren — je organisierter Sie sind, desto leichter wird alles.

4. Misten Sie aus, bevor Sie umziehen — nicht erst beim Einzug in die neue Bleibe.

5. Meine Designphilosophie heißt: experimentieren. Nehmen Sie das Einrichten nicht zu ernst und begnügen Sie sich mit den Mitteln, die Ihnen zur Verfügung stehen.

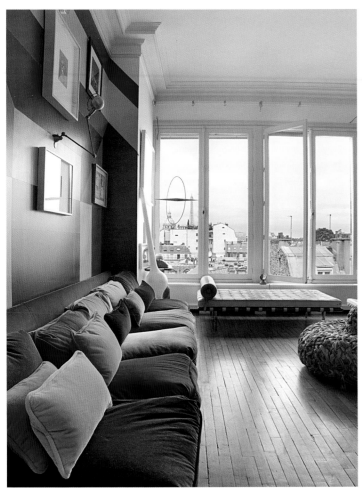

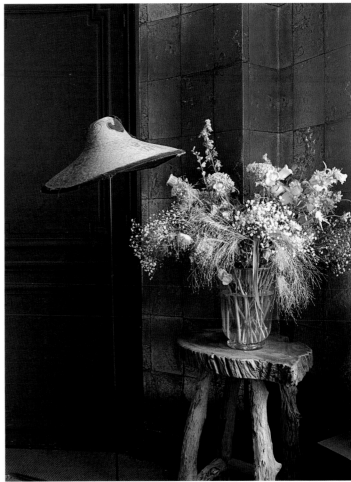

MY HOME TRUTHS

Our style is difficult to define. We have things from all over the world since we travel so much. It's a big mix of furniture that follows us from home to home.

I would love our next move to be to a house in the countryside with lots of rooms to store all of our things. For now, we are enjoying Tokyo, but it's not the same lifestyle as in France.

MEINE WOHNWEISHEITEN

Unser Stil ist schwer zu definieren. Da wir so viel reisen, besitzen wir Gegenstände aus allen Ecken der Welt. Ein großer Möbelmix folgt uns von Haus zu Haus.

Ich fände es toll, wenn wir als Nächstes in ein Haus auf dem Lande ziehen würden, das viele Zimmer für unser ganzes Zeug hat. Im Moment genießen wir noch Tokio, aber der Lebensstil dort ist ganz anders als in Frankreich.

AHEAD OF
THE CURVE

Pops of bright color, futuristic design, and unabashed
open-plan living rule in this extraordinary Parisian home.

The Parisian apartment of Moustache design studio founders, Stéphane Arriubergé and Massimiliano Iorio is a far cry from shy. From the achingly hip furniture to the open-plan layout—the peek-a-boo bathroom is in clear view of the living room scene—this contemporary interior is a lesson in how to do fearless decoration. For instance, there are not many spaces that can pull off the Cloud textile partition designed by the Bouroullec brothers. Similarly, the Aim ceiling lights (also by the Bouroullec boys) are effortlessly draped from the ceiling. The installation no doubt easier imagined, than done.

The key to this apartment's killer style is in part down to Stéphane and Massimiliano's daring ways. Inside, design pieces and art are crucial to its personality; the couple are avid collectors. The offbeat interior is also thanks to the artistic vision of their friend, neighbor, and designer Matali Crasset, whom the couple enlisted to help realize their plans.

It was Matali that first tipped off the duo about what is now their standout home in Goncourt, close to the Saint-Martin canal. "We had been searching for an apartment for about two years when we came across this disused mechanic's garage on the ground floor of an early 20th-century building," says Stéphane. "We could see that, chaotic as it was, the space had the potential we had been desperately looking for. We literally fell under its spell."

"The ground floor was bathed in light the day we went to see it," Stéphane adds, "and we knew in an instant that we had our dream space." By demolishing everything, including all the interior walls, the couple created a single, entirely open living area; they even added a garden. The objective was to show off the space's vast scale and to offer uninterrupted views from all angles. Today, the ground floor apartment is a standout 1,400 square feet (130 square meters) with a 20-foot (six-meter) high ceiling. The entire space flows from one area to the next, uninterrupted by walls of any kind.

The instructions for Matali were very clear, "Do not build internal walls, and instead organize this space by using light solutions and zones. We asked her to create furniture to complement the scale of the architecture." Matali came up with the idea of designing a cabin-like space for the bedroom and office—and everything else was organized around that. "It is like a house within a house," Stéphane adds.

The first floor houses the bedroom and a balcony office; below it at ground level is a bathroom. "The apartment shows how we think about new solutions for modern living," Stéphane says. The avant-garde space also speaks volumes about their forward-thinking approach. "We have an irresistible need to be part of our time," Stéphane explains. "With Moustache, we give a political and social view of the world through the production of objects. This apartment depicts our willingness to propose new solutions for living today and our need to look ahead."

Color is an important aspect in the apartment's interior decoration. Bright, mismatched dining chairs or a royal blue sofa provide shots of color; strong shades offset by soft pastels balance each other out. "We don't use color as an afterthought. We treat it as a material. It always comes first. We also like to play with the symbolism of colors and try to free ourselves from constraints," explains Stéphane. "The pink resin floor is far from its typical feminine and childish connotations. Used on the floor and in combination with bold colors, it becomes something else."

NEUE LÖSUNGEN FÜR EINE NEUE ZEIT

Knallbunte Farbtupfer, ein futuristisches Design und offene Wohnbereiche prägen dieses außergewöhnliche Pariser Appartement.

Das Zuhause von Stéphane Arriubergé und Massimiliano Iorio, den Gründern des Designstudios Moustache, ist alles andere als zurückhaltend. Vom auffallend hippen Mobiliar bis hin zur offenen Raumaufteilung – vom Wohnzimmer hat man einen freien Blick aufs Bad – demonstriert das zeitgenössische Interieur, wie man angstfrei und hemmungslos ausstattet und dekoriert. So gibt es zum Beispiel nicht viele Räumlichkeiten, die den von den Brüdern Bouroullec entworfenen textilen Raumteiler in Wolkenform vertragen könnten. Gleiches gilt für die (ebenfalls von den Bouroullecs entworfenen) Aim-Lampen, die wie scheinbar zufällig und provisorisch von der Decke hängen.

Der Killer-Style der Wohnung ist zum Teil Stéphanes und Massimilianos Unerschrockenheit und Abenteuerlust geschuldet. Designerstücke und Kunstobjekte machen einen Großteil des Charakters aus, denn beide sind leidenschaftliche Sammler. Das ungewöhnliche Interieur wurde aber auch von der künstlerischen Vision der Designerin Matali Crasset bestimmt, einer Nachbarin und Freundin, die die Pläne des Paares realisiert hat.

Matali war es auch, die die beiden auf das Objekt in Goncourt, in der Nähe des Canal St-Martin, aufmerksam machte. „Wir suchten bereits zwei Jahre nach einer Wohnung, als wir auf diese ehemalige KFZ-Werkstatt im Erdgeschoss eines Gebäudes aus dem frühen 20. Jahrhundert stießen", erzählt Stéphane. „So chaotisch es auch war: Wir erkannten in dem Raum das Potenzial, nach dem wir verzweifelt gesucht hatten. Wir waren verzaubert."

„Das Erdgeschoss war lichtdurchflutet, als wir es besichtigten", fügt Stéphane hinzu. „Wir wussten sofort, dass wir unser Traumobjekt gefunden hatten." Das Paar riss sämtliche Innenwände raus und schuf eine einzige, völlig offene Wohnfläche; außerdem fügten sie einen Garten hinzu. Ziel des Designs war es, die Weite des Wohnraums zu betonen und von überall freie Sicht zu haben. Heute weist das Erdgeschoss eine Fläche von beeindruckenden 130 Quadratmetern und eine Deckenhöhe von sechs Metern auf. Die Wohnbereiche fließen ohne Wände nahtlos ineinander.

Die Vorgaben für Matali waren sehr klar: „Errichte keine Innenwände, sondern unterteile den Raum durch Licht und verschiedene Zonen. „Wir baten sie, Möbel zu entwerfen, die zur weitläufigen Architektur passen." Matali hatte die Idee, eine Art separate Kabine für das Schlaf- und Arbeitszimmer zu bauen – alles andere wurde darum herum organisiert. „Das ist wie ein Haus in einem Haus", erklärt Stéphane.

Im ersten Stock dieser Kabine befinden sich das Schlafzimmer und – auf einer Empore – das Arbeitszimmer; darunter im Erdgeschoss liegt das Bad. „Die Wohnung demonstriert, was wir unter zeitgemäßem Wohnen verstehen", sagt Stéphane. Das avantgardistische Interieur stellt ihren innovativen Ansatz unter Beweis. „Wir haben das unwiderstehliche Bedürfnis, Teil unserer Zeit zu sein", erklärt Stéphane. „Mit Moustache setzen wir durch die Produktion von Objekten ein politisches und soziales Statement. Dieses Appartement zeigt unsere Bereitschaft, für das Wohnen in der heutigen Zeit neue Lösungen zu finden."

Farbe ist ein wichtiges Gestaltungsmerkmal der Wohnung. Bunte, wild zusammengewürfelte Esszimmerstühle oder ein leuchtend blaues Sofa setzen Farbakzente; kräftige Farbschattierungen werden mit sanften Pastellfarben ausbalanciert. „Für uns ist Farbe kein nachträglicher Einfall, sondern wir behandeln sie wie ein Material", erklärt Stéphane. Sie steht immer an erster Stelle. Wir spielen auch gerne mit Farbsymbolismus und versuchen, uns von vorgefassten Vorstellungen zu befreien. Das Rosa des Harzbodens wirkt keineswegs typisch feminin oder kindlich. Auf dem Boden und in Kombination mit kräftigen Farben hat es einen völlig anderen Effekt.

Living Area

Long-time admirers of the Bouroullec brothers' work (the designers' studio is just up the road), the Cloud partition was used to create a distinct space. It is a focal point that separates the living room from the library that runs along the stairs. "We have surrounded ourselves with objects that we produce at Moustache," says Stéphane. "This is one way of trying things out before they go in the store. It is also a way of testing prototypes before they go into production. Living with these objects allows us to perfect our knowledge of them and to judge how they benefit our daily lives."

Wohnbereich

Stéphane und Massimiliano sind schon seit Langem Bewunderer der Brüder Bouroullec (deren Studio ganz in der Nähe liegt) und verwendeten deren Wolken-Trenn-„Wand", um einen bestimmten Wohnbereich abzugrenzen. „Die Wolke steht im Blickpunkt und trennt das Wohnzimmer von der Bibliothek ab, die an der Treppe entlangführt. „Wir haben uns mit Objekten eingerichtet, die wir bei Moustache herstellen", sagt Stéphane. „Auf diese Weise können wir Dinge ausprobieren, bevor wir sie im Laden anbieten. Außerdem können wir so Prototypen testen, bevor sie in Produktion gehen. Indem wir mit diesen Objekten leben, erfahren wir mehr über sie und können besser beurteilen, wie sie unseren Alltag bereichern."

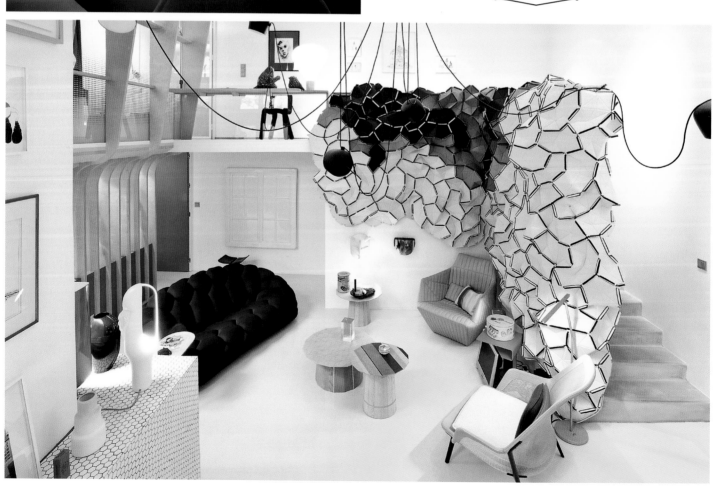

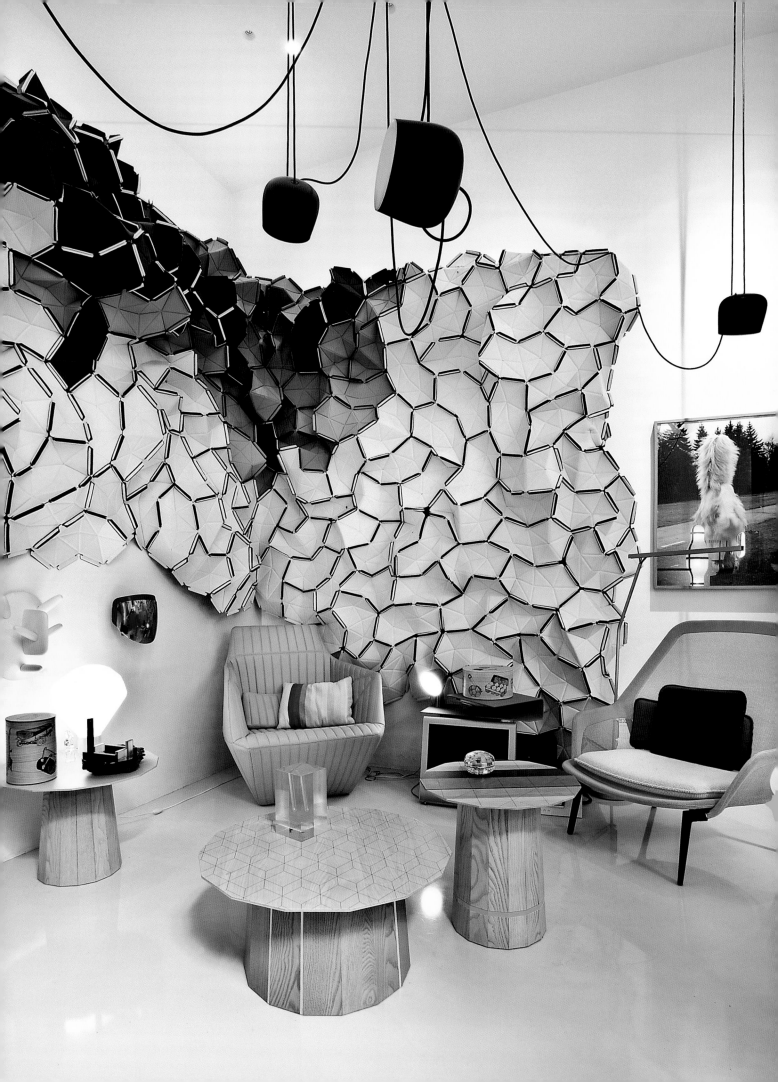

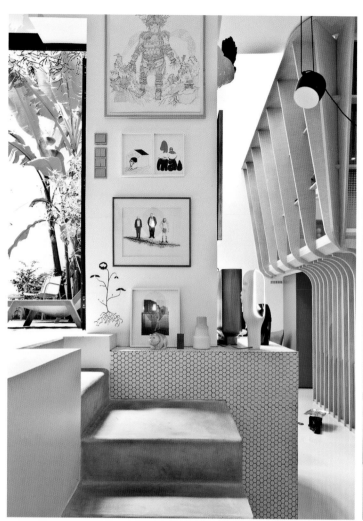
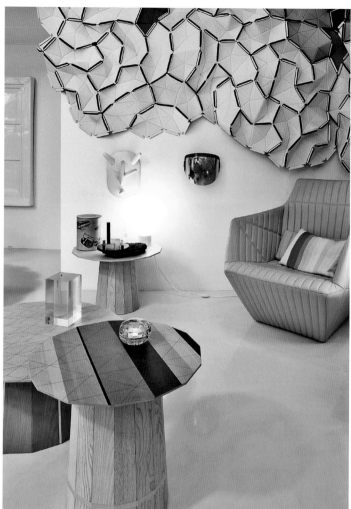
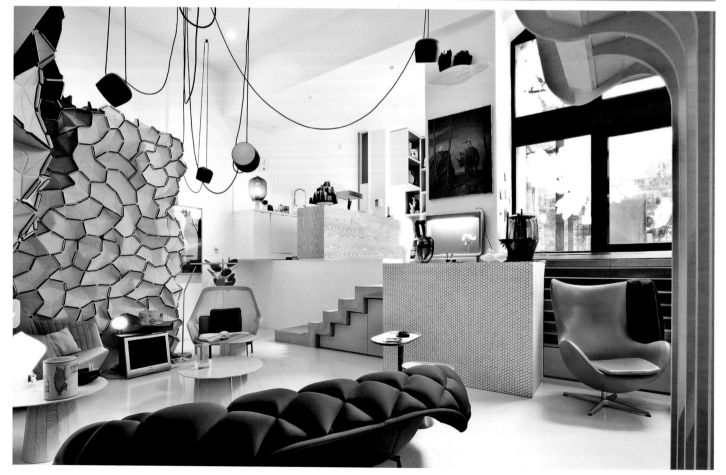

Bedroom

"Soft materials give a homely feel in our bedroom. For privacy, a curtain can be pulled around the space. Created by Ronan and Erwan Bouroullec for Danish textile company Kvadrat, it creeps along the wall between the office and sleeping area and acts as a fluid partition. The wallpaper is by Australian artist Dylan Martorell for Moustache."

Schlafzimmer

„Weiche Materialien machen unser Schlafzimmer gemütlich. Um Privatsphäre zu schaffen, kann rund um den Bereich ein Vorhang gezogen werden. Dieser von Ronan und Erwan Bouroullec für die dänische Textilfirma Kvadrat entworfene Vorhang führt an der Glaswand zwischen Arbeitsbereich und Schlafzimmer entlang und dient als fließende Abtrennung. Die Tapete hat der australische Künstler Dylan Martorell für Moustache entworfen."

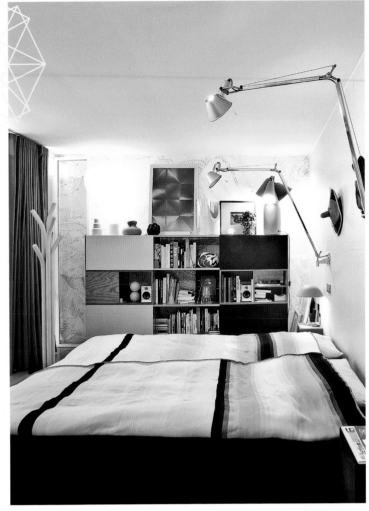

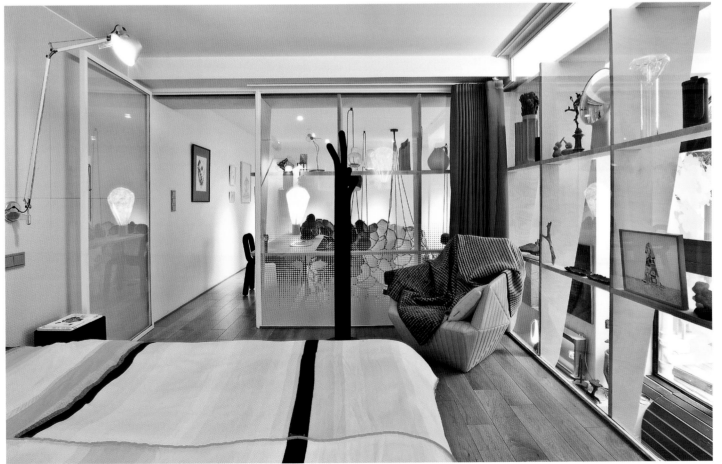

Kitchen

"The kitchen and dining area blends natural wood with textiles and polished concrete stairs. The Douglas fir island is balanced by a Corian countertop, and the space opens onto the garden via large, full-height windows. These can be fully folded back in summer. By keeping the terrace on the same level as the interior there is no distinction between the inside and outdoors."

Küche

„In Küche und Essbereich wird Naturholz mit Textilien und Treppen aus poliertem Beton kombiniert. Die Kochinsel aus Douglasienholz wird durch eine Arbeitsfläche aus Corian-Stein schön abgesetzt. Der Küchenbereich ist vom Garten durch raumhohe Fenster abgetrennt, die im Sommer komplett ineinander geschoben werden können. Dadurch, dass sich die Terrasse auf derselben Ebene wie der Innenbereich befindet, gibt es keine Abgrenzung von innen und außen."

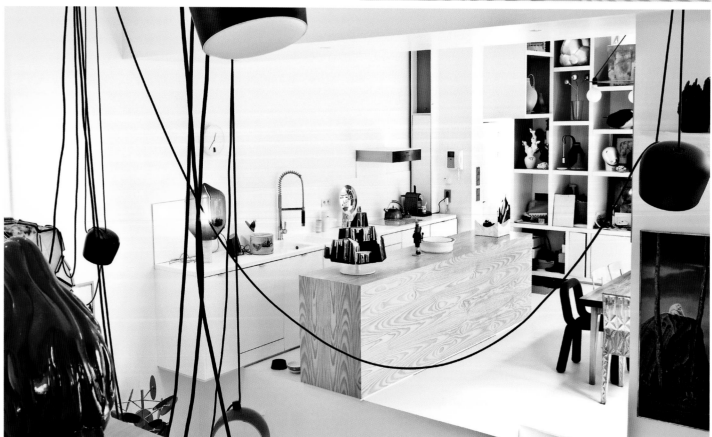

Stéphane and Massimiliano are avid collectors of contemporary design, favoring objects that say something about the era and push boundaries in the use of materials and technological innovations.
--
Stéphane und Massimiliano sind leidenschaftliche Sammler von zeitgenössischem Design — von Objekten, die etwas über die Ära aussagen und im Hinblick auf Material und Technologie die Grenzen verschieben.

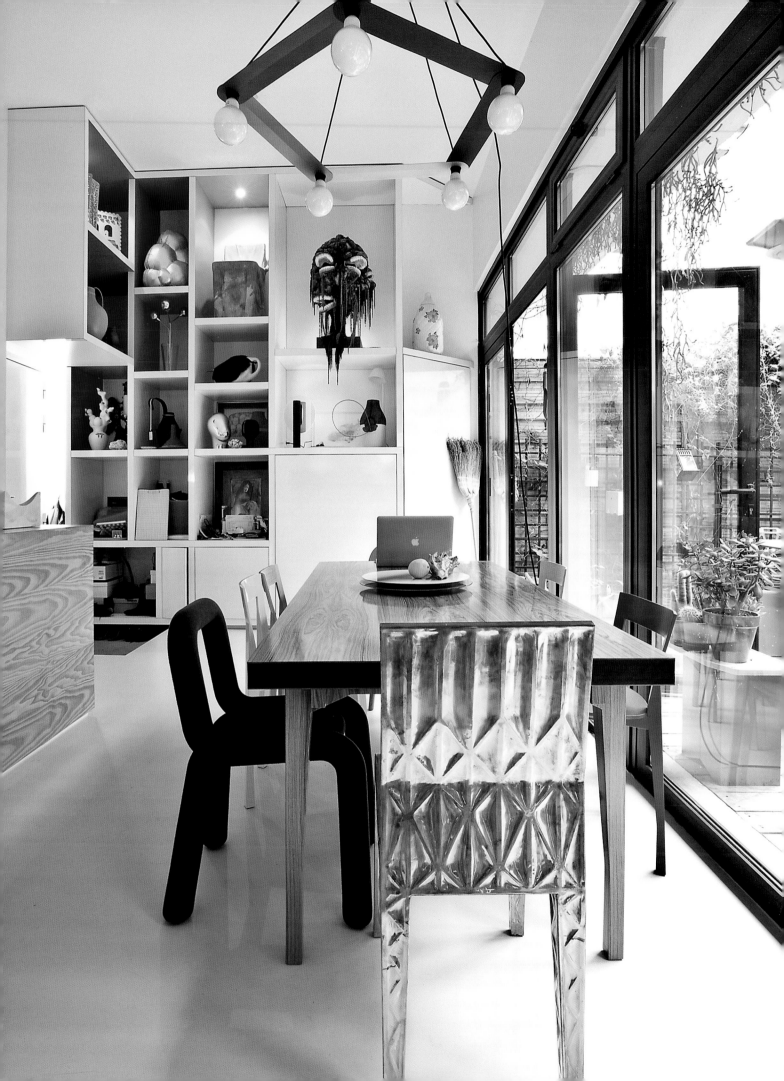

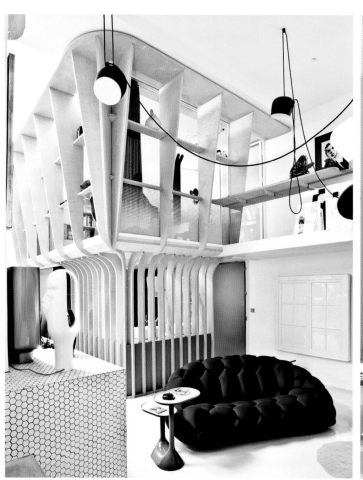

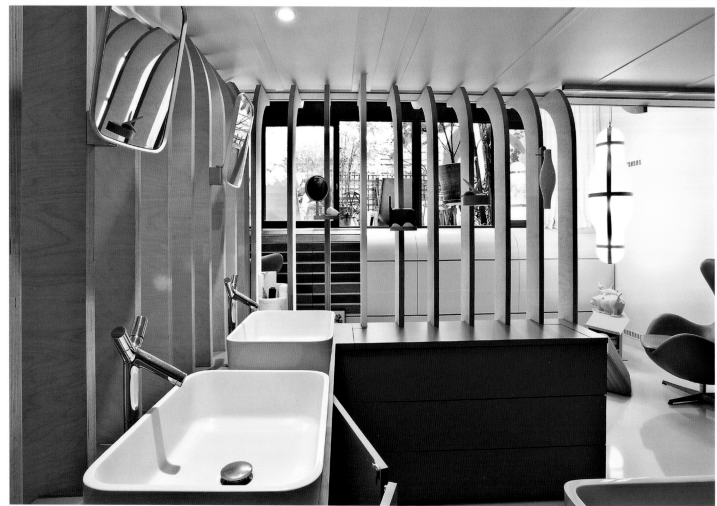

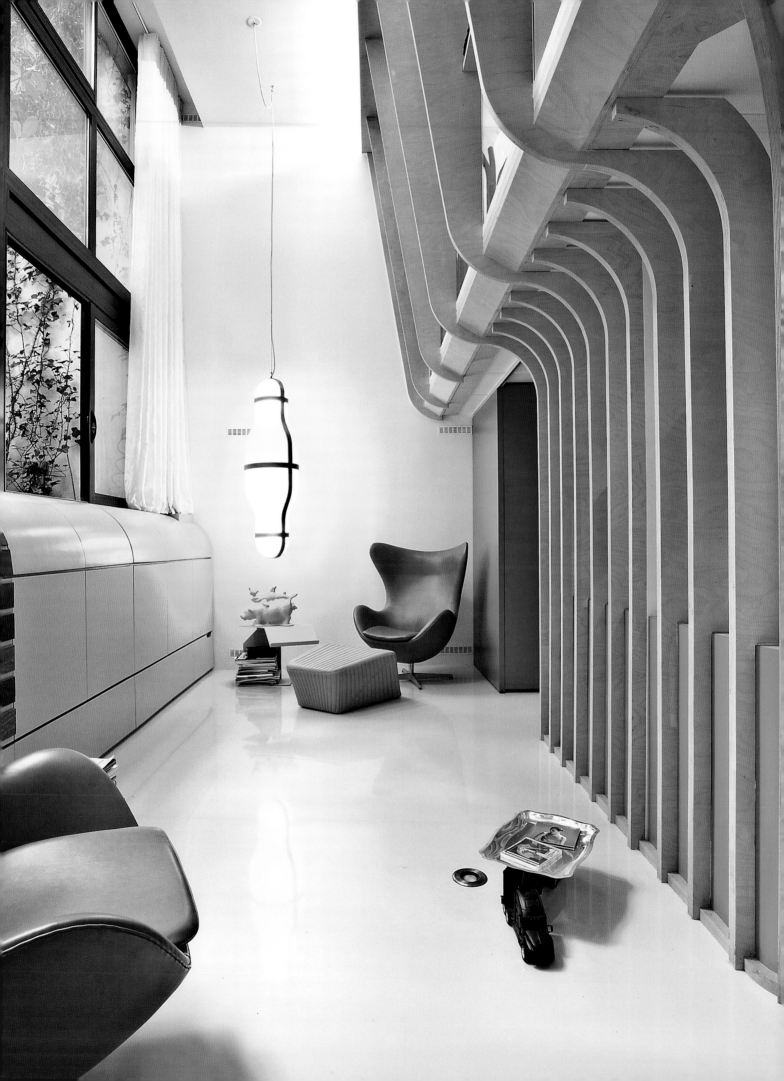

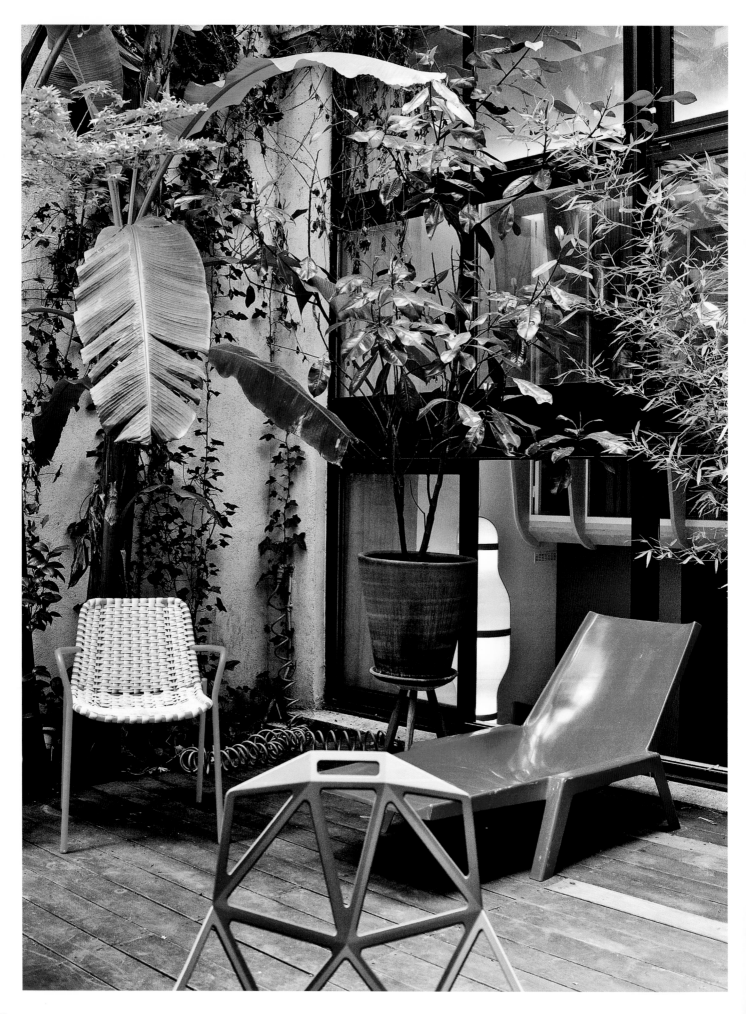

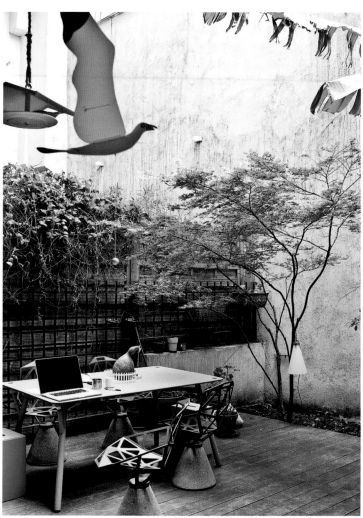

Garden

"The apartment surrounds a small garden and is entirely oriented towards it. In the garden we have a banana tree, as well as a Japanese maple, a Californian lilac, and Spanish beans. There are few restrictions and the plants are allowed to grow quite freely. Furniture includes the Chair_One by Konstantin Grcic for Magis and the red loungers are old prototypes found at a flea market in the South of France."

Garten

„Das Appartement umfasst einen kleinen Garten und ist komplett auf diesen ausgerichtet. In unserem Garten wachsen ein Bananenbaum, ein japanischer Ahornbaum, kalifornischer Flieder und spanische Bohnen. Die Pflanzen dürfen sich ziemlich frei ausbreiten. Zum Mobiliar gehört der Stuhl Chair_One von Konstantin Grcic für Magis. Die roten Liegestühle sind alte Prototypen, die wir auf einem Flohmarkt in Südfrankreich entdeckten."

Decking, potted plants of varying sizes, and creeping foliage to disguise a concrete wall combine to turn the garden into something of a hidden treasure.
--
Holzdielen, Topfpflanzen verschiedener Größen und Kletterpflanzen, die sich an einer Betonwand entlangranken, machen den Garten zum kleinen Paradies.

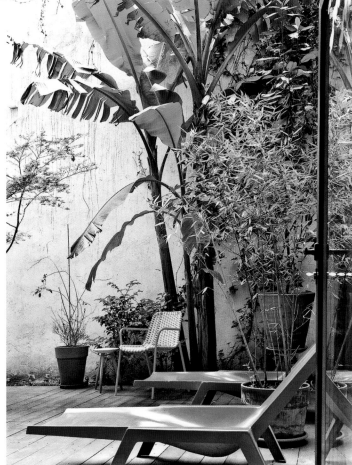

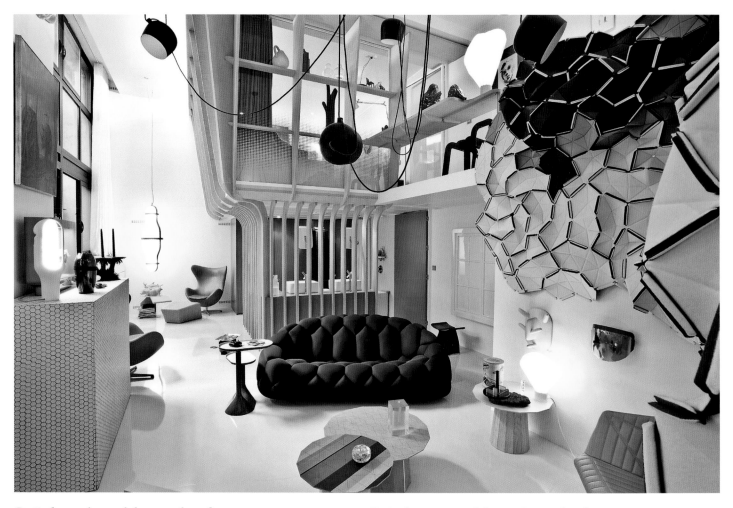

Stéphane's golden rules for
OPEN-PLAN LIVING

1. Use furniture as natural partitions in an open-plan space.

2. A variety of levels will naturally divide an area without resorting to walls. To move from one space to another, you only have to go up or go down a few steps rather than opening or closing a door.

3. To emphasize the different zones, play with shiny and matte finishes. This is especially successful on the floor.

4. Make the most of transition areas, such as a staircase, by installing shelves for books.

5. If it is a large architectural renovation, try to remain in control. Don't rely on the genius of a designer or an architect but be true to yourself.

Stéphanes goldene Regeln für einen
OFFENEN WOHNBEREICH

1. Verwenden Sie Möbel als natürliche Abgrenzung.

2. Verschiedene Ebenen teilen einen Raum auf, ohne dass man Wände einziehen muss. Um von einem Bereich zum anderen zu gelangen, muss man nur ein paar Stufen hoch oder runter gehen, anstatt eine Tür zu öffnen.

3. Spielen Sie mit glänzenden und matten Oberflächen, um unterschiedliche Zonen zu betonen. Das funktioniert beim Boden besonders gut.

4. Nutzen Sie Übergangsbereiche wie eine Treppe optimal aus, indem Sie dort Bücherregale platzieren.

5. Wenn es sich um umfangreiche Umbaumaßnahmen handelt, versuchen Sie, die Kontrolle zu behalten. Verlassen Sie sich nicht auf das Genie eines Designers oder Architekten, sondern bleiben Sie sich selbst treu.

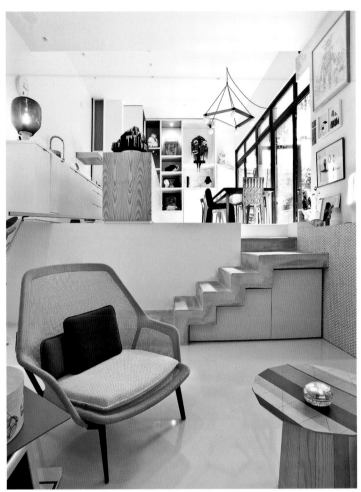

MY HOME TRUTHS

MEINE WOHN- WEISHEITEN

Our professional and personal lives are intimately
linked. Our work is our greatest passion. It is an
enormous pleasure to surround ourselves with the objects
we produce, and the house is a great way of expressing
our intentions as design publishers and the ideal we
are pursuing.

Our ambition as publishers is to propose an ideal
domestic environment for our era. Our house helps to
confirm or contradict our choices. In France, the phrase
"you are what you eat" is often used. It can also be
said, "You are how you live."

Beruf und Privatleben sind bei uns eng miteinander
verwoben. Unsere Arbeit ist unsere größte Leidenschaft.
Es bereitet uns enormes Vergnügen, uns mit den Objekten,
die wir herstellen, zu umgeben. Mit unserem Zuhause
können wir unsere Absichten und Ideale als Design-
produzenten zum Ausdruck bringen.

Wir haben den Anspruch, mit unseren Produkten das
ideale Wohnambiente für unsere Zeit zu schaffen. Unser
Appartement hilft, unsere Auswahl zu bestätigen oder zu
widerlegen. In Frankreich sagt man oft: "Du bist, was du
isst." Man könnte auch sagen: "Du bist, wie du wohnst."

STUDIO
MOVES

Sussy Cazalet's home takes seventies-style and adds
soothing colors and an eclectic twist to create a home that
looks glamorous yet is totally chilled out.

"I would call it an artistic mess," laughs London-based interior designer Sussy Cazalet when she describes the style of her west London home. "It matches my personality in exactly that. I'm not particularly precious. I'm always changing things, and I hate anything to be perfect. It is definitely an eclectic mix." Sussy's two-bedroom apartment is perched on the top floor of a late Victorian building in Ladbroke Grove. The property had masses of character even before Sussy moved in with its high ceilings, wide spaces, and big windows. It is lovely and big—which when you have a grand piano to accommodate, is pretty essential criteria. It is also split over three levels: the bedroom is in the attic, then there is another level down to the kitchen, and the living room is in the middle, so it feels very spacious.

The first thing Sussy did was to rip up the rose carpet in the sitting room and paint the floorboards white. "I didn't have very much money. Basically, I had none," she says. "I opened up the fireplace and literally lived with a piano, an amazing Willy Rizzo-esque dining room table, which was stained glass from my grandmother, and a mattress on the floor upstairs. That's pretty much how I lived for quite a long time."

Sussy's home is a creative space in the truest sense. Evolving over time in an intuitive way; nothing has been overly planned here. The décor matches Sussy's relaxed character—muted tones and natural materials are used to enhance the cool London light and to boost the mood. The sitting room and studio flow into one another, both physically and in terms of the color scheme. "It is unlikely for me to put a bright purple against a bright yellow," says Sussy. "And I can't bear geometric patterns. The idea of a feature wall upsets my brain. For me, anything that jars the mind is bad design. It is important to have a really lovely flow." The wide space is put to good use to display Sussy's collections of comfortable furniture, family heirlooms, and collections of cool new design. Artworks created by friends add even more of a personal touch.

"I like the combination of old and new," Sussy explains. "I have a mixture of both in my flat. I like to think that as a designer, I support young and new artisans. I think that new has been vilified as being modern and therefore not very nice, when actually you can get someone to make something that's new but has the craftsmanship of something old. I would rather work with a young artisan now and

get something made than buy something old. To me, that's giving back to today and what's going on."

All-in-all, Sussy's home reflects her love of nature and is a place where she feels inspired to play music, draw things, read books, and have conversation. "I wanted the main space to feel like a creative studio," explains Sussy. "I don't look at it as a design space. It is more of an expression of my own chaos: all the things I love, with nothing in the right place and books and drawings everywhere. It's a place where I can collect things. It's a very un-precious space where I am free to make a mess."

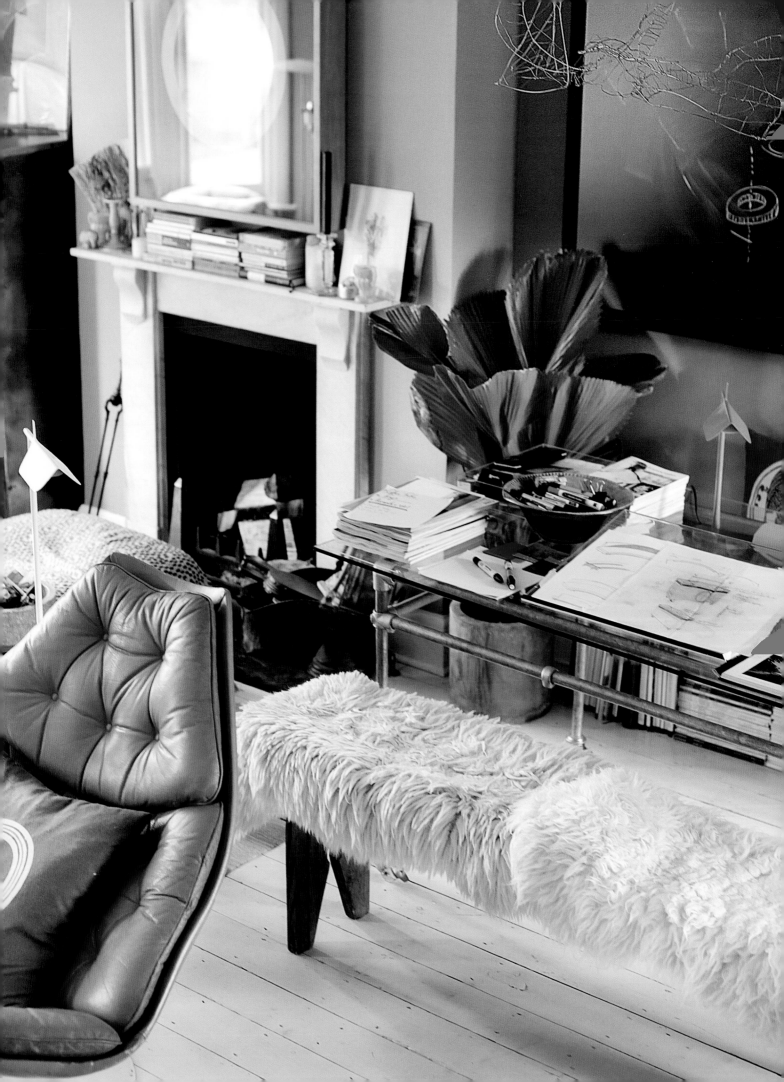

KREATIVES CHAOS

Sussy Cazalets Domizil kombiniert den Stil der 1970er-
Jahre mit beruhigenden Farben und eklektischen
Accessoires, um ein glamouröses, aber gleichzeitig total
entspanntes Interieur zu erschaffen.

„Ich würde es als künstlerisches Chaos bezeichnen", sagt Innenarchitektin Sussy Cazalet lachend, wenn sie den Stil ihrer Wohnung in Westlondon beschreiben soll. „Dadurch passt es perfekt zu meiner Persönlichkeit. Ich bin nicht besonders pingelig. Ich verändere ständig etwas und hasse Perfektion. Meine Einrichtung ist definitiv eine bunte Mischung." Sussys Drei-Zimmer-Wohnung befindet sich im obersten Stock eines spätviktorianischen Gebäudes in Ladbroke Grove. Mit hohen Decken, weitläufigen Räumen und großen Fenstern steuert bereits die Architektur jede Menge Charakter bei. Und Größe zählt auch, wenn man einen Flügel unterbringen muss. Der Wohnraum verteilt sich auf drei Ebenen: Das Schlafzimmer befindet sich im Dachboden, in der untersten Ebene kommt man zur Küche und das Wohnzimmer liegt in der Mitte. So entsteht ein Gefühl von Weite.

Als Erstes riss Sussy den rosafarbenen Teppich im Wohnzimmer raus und strich die Holzdielen weiß an. „Ich hatte nicht sehr viel Geld, im Grunde genommen gar keins", erzählt sie. „Ich legte den Kamin frei und lebte nur mit einem Klavier, einem fantastischen Esstisch im Stil von Willy Rizzo aus Buntglas von meiner Großmutter und einer Matratze, die oben auf dem Boden lag. So spartanisch hauste ich ziemlich lange."

Sussy Zuhause ist ein wahrhaft kreativer Raum. Er entwickelte sich mit der Zeit intuitiv; nichts wurde akribisch vorab geplant. Das Dekor passt zu Sussys entspannter Art – gedeckte Farbtöne und Naturmaterialien werden eingesetzt, um das kühle Londoner Licht zu verstärken und die Stimmung zu heben. „Wohnzimmer und Atelier fließen ineinander über, sowohl physisch als auch im Hinblick auf das Farbschema. „Es wäre untypisch für mich, etwas Knallgelbes neben leuchtendem Lila zu platzieren", sagt Sussy. „Und ich hasse geometrische Muster. Schon beim Gedanken an eine Wand mit Muster oder Motiv wird mir schwindelig. Für mich ist alles, was das Gehirn irritiert, schlechtes Design. Es ist mir wichtig, einen schönen Flow zu erzeugen." Die großzügige Wohnfläche beherbergt Sussys gemütliche Möbel, Familienerbstücke und diverse coole neue Designerobjekte. Von Freunden geschaffene Kunstwerke geben dem Ambiente noch mehr persönlichen Touch.

„Ich mag die Kombination aus alt und neu", erklärt Sussy. „In meiner Wohnung mische ich beides. Als Designerin möchte ich junge neue Künstler unterstützen. Ich glaube, das Neue wird oft automatisch als modern und damit nicht besonders schön abgestempelt, aber es gibt Kunsthandwerker, die Neues mit derselben handwerklichen Fertigkeit erzeugen, die früher gang und gäbe war. Ich würde mir lieber von einem jungen Kunsthandwerker etwas Neues anfertigen lassen als etwas Altes zu kaufen. Damit gebe ich der Gegenwart etwas zurück."

Insgesamt spiegelt Sussys Zuhause ihre Liebe zur Natur wider. Hier fühlt sie sich inspiriert zu musizieren, zu malen, zu lesen und sich mit anderen zu unterhalten. „Ich wollte, dass der Hauptwohnbereich sich wie ein kreatives Atelier anfühlt", erklärt sie. „Ich betrachte es weniger als Designfläche, sondern vielmehr als Ausdruck meiner chaotischen Persönlichkeit: alles, was ich liebe, nichts da, wo es hingehört, und überall Bücher und Zeichnungen. Es ist ein Ort, an dem ich Dinge sammeln kann. Ein sehr unprätentiöser Wohnraum, in dem ich unordentlich sein darf."

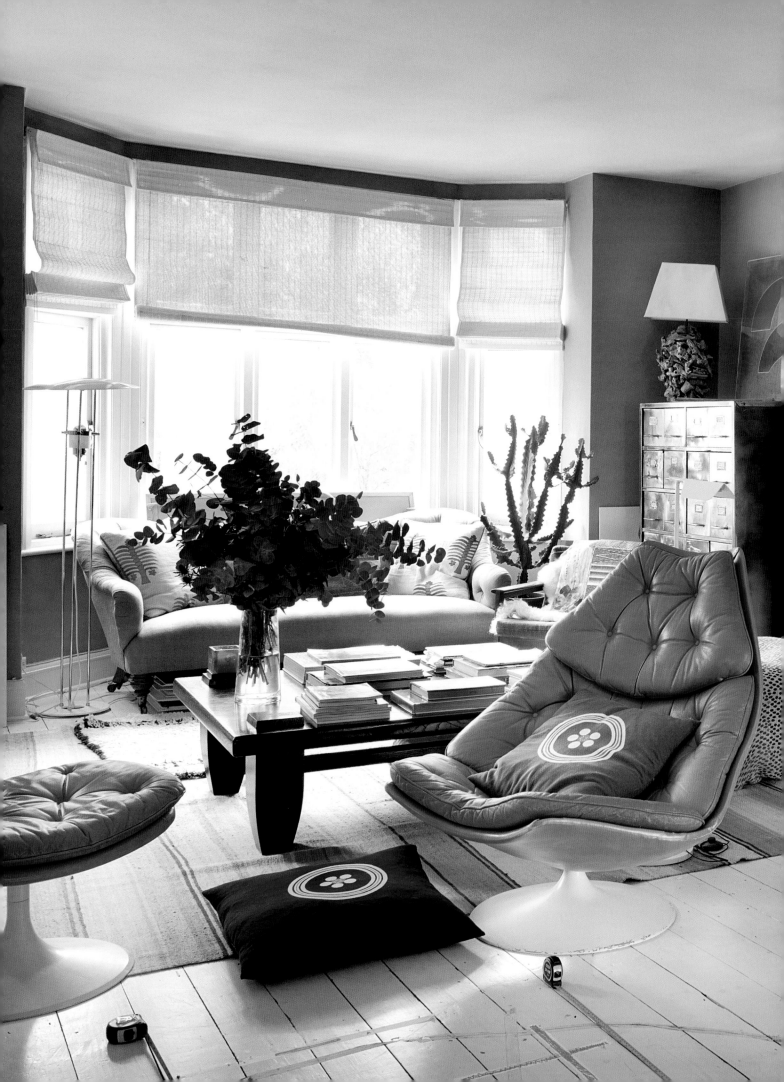

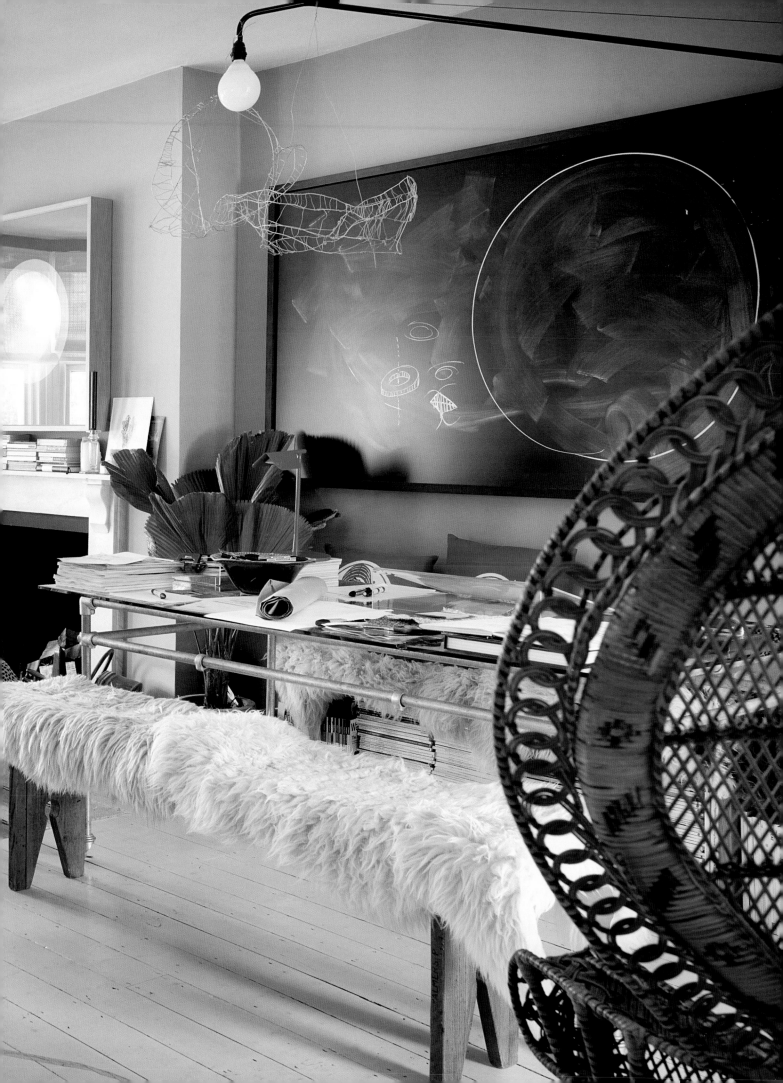

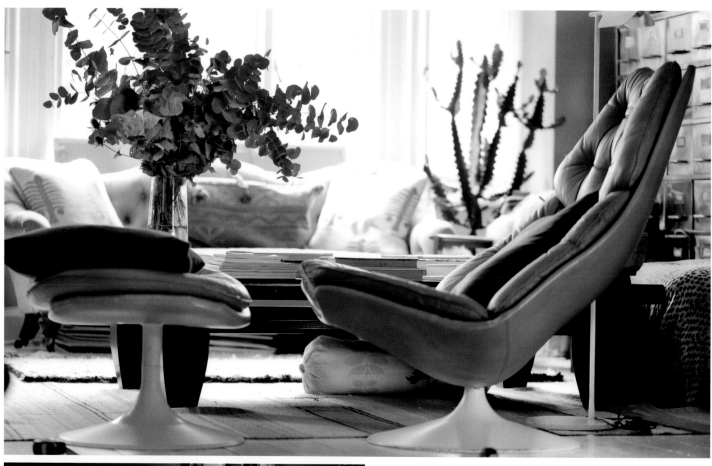

Living Area

"My favorite piece of furniture in the living room is the Geoffrey Harcourt swivel chair, which I found on eBay in Sweden, and my fig tree. I also love the picture above the fireplace, which is by an artist friend-of-mine called Piers Jackson.
There was no conscious thought process about designing my flat. I just buy things that I like. For me, it's my space where I don't have to worry about how it looks. As an interior designer, I spend my whole life being very precise. Here, I didn't want to think about design. I wanted to feel free."

Wohnbereich

„Meine Lieblingsstücke im Wohnzimmer sind der Drehstuhl von Geoffrey Harcourt, den ich in Schweden auf eBay gefunden habe, und mein Feigenbäumchen. Ich liebe auch das Bild über dem Kamin von meinem Künstlerfreund Piers Jackson.
Hinter der Einrichtung meiner Wohnung steht kein klar durchdachtes Konzept. Ich kaufe einfach Dinge, die ich mag. Das hier ist schließlich mein Wohnraum, wo ich mir keine Sorgen darüber machen muss, wie es aussieht. Bei meiner Arbeit als Inneneinrichterin muss ich sehr akribisch sein. Zuhause möchte ich nicht über Design nachdenken. Ich möchte mich frei fühlen."

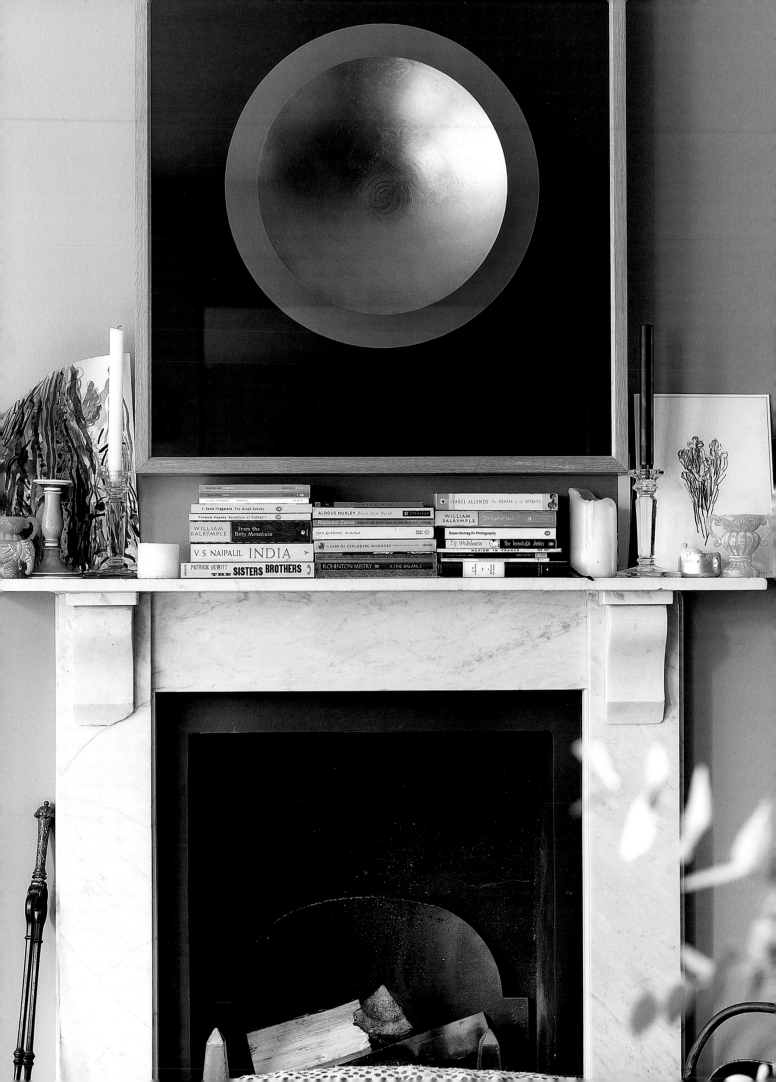

Kitchen

"Initially, the kitchen cupboards were an orangey-pine with a black granite countertop. Again, I had no budget, but as I figured it was a small, tight space, I might as well go dark. I'm not a natural fan of dark colors. I think if you have a beautiful thing, often a dark palette can take that away, but I felt that in this case, it would take the attention away from all the chaos. I changed the countertop to a lovely Carrara marble, I put in a mirror, and I suppose without really realizing, it all felt quite New York."

Küche

„Die Küchenzeile hatte ursprünglich eine ins Orange gehende Pinienfront und eine schwarze Arbeitsfläche aus Granit. Da der Raum klein und kompakt ist, entschied ich mich für dunkle Farben. Eigentlich bin ich kein Fan von dunklen Tönen, denn schöne Dinge werden davon oft verschluckt. Aber in diesem Fall hatte ich das Gefühl, dass ein dunkler Anstrich die Aufmerksamkeit von dem Chaos ablenken würde. Ich ersetzte die alte Arbeitsplatte durch eine aus wunderschönem Carrara-Marmor und hing einen Spiegel auf. Plötzlich fühlte es sich wie eine New Yorker Küche an, ohne dass ich das beabsichtigt hätte."

A lot of the pottery is from William Plumptre, an awesome English potter who trained in Japan.
--
Viele der Töpferarbeiten stammen von William Plumptre, einem wunderbaren englischen Töpfer, der in Japan ausgebildet wurde.

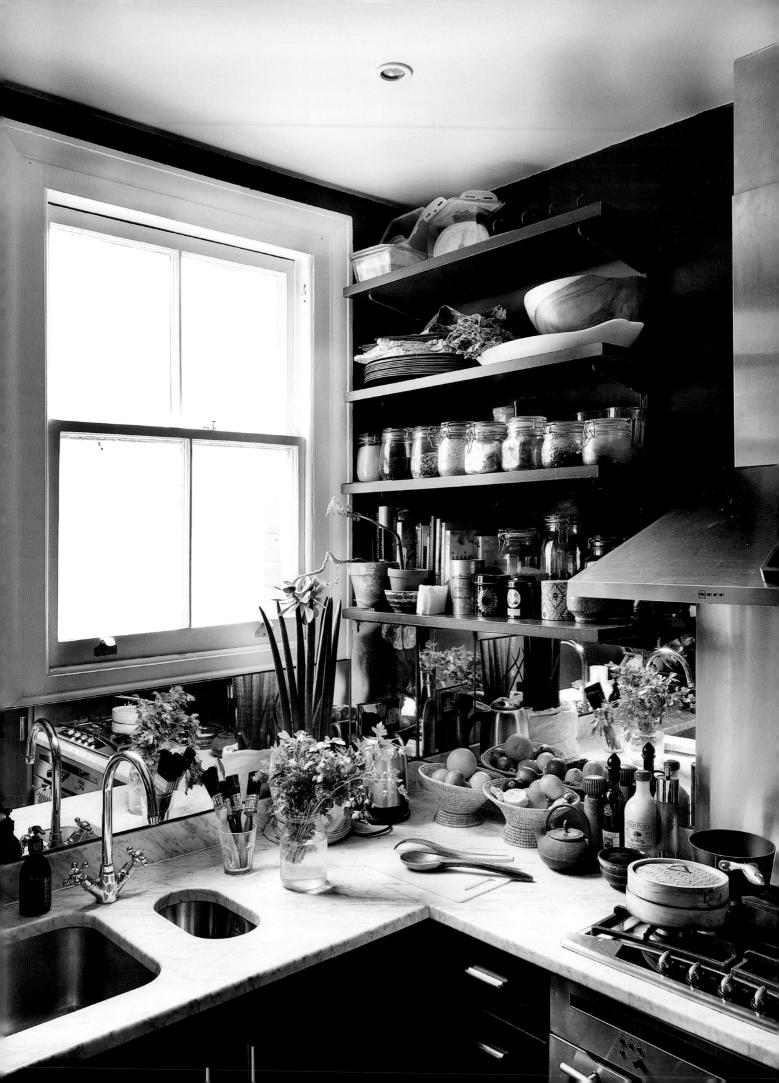

Bedroom & Bathroom

"Upstairs, I created a little en suite to my bedroom. It was quite a challenge in that the space is so small. So I kept things simple. I bought some beautiful oak for the floor—it's such a lovely feeling to walk with bare feet on wood rather than cold tiles. I had a bespoke shower made and used very plain matte white tiles on the walls. The other wall is lined with a mirror, and I put up Jasper Morrison wall lights. The end result is very calming. It's pretty Zen and works with my bedroom, which has a similar color palette."

Schlafzimmer & Badezimmer

„Oben baute ich ein kleines Bad ein, das direkt von meinem Schlafzimmer abgeht. Das war eine ziemliche Herausforderung, da der Raum so begrenzt ist. Also entschied ich mich für schlichtes Dekor. Ich kaufte wunderschönes Eichenholz für den Boden – es fühlt sich so viel besser an, barfuß auf Holz zu laufen als auf kalten Fliesen. Ich ließ eine Dusche nach Maß anfertigen und suchte für die Wand ganz einfache mattweiße Fliesen aus. Auf der gegenüberliegenden Wand hängen ein Spiegel und Wandlichter von Jasper Morrison. Das Resultat ist sehr ruhig und entspannend. Die Zen-Atmosphäre passt zu meinem Schlafzimmer, das eine ähnliche Farbpalette hat."

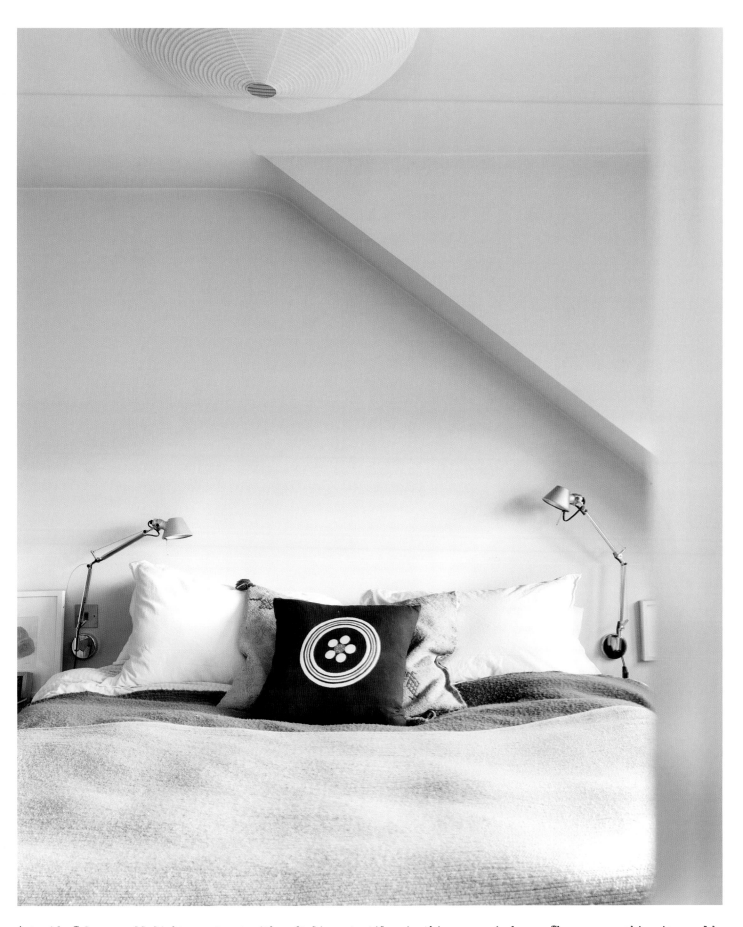

Artemide Tolomeo wall lights contrast with soft linen textiles in this serene bedroom. The green cushion is an old Japanese print Sussy got in Tokyo.

--

Tolomeo-Wandleuchten von Artemide kontrastieren in diesem entspannten Schlafzimmer mit weichen Baumwollstoffen. Sussy kaufte das grüne Kissen mit altem japanischem Design, als sie in Tokio war.

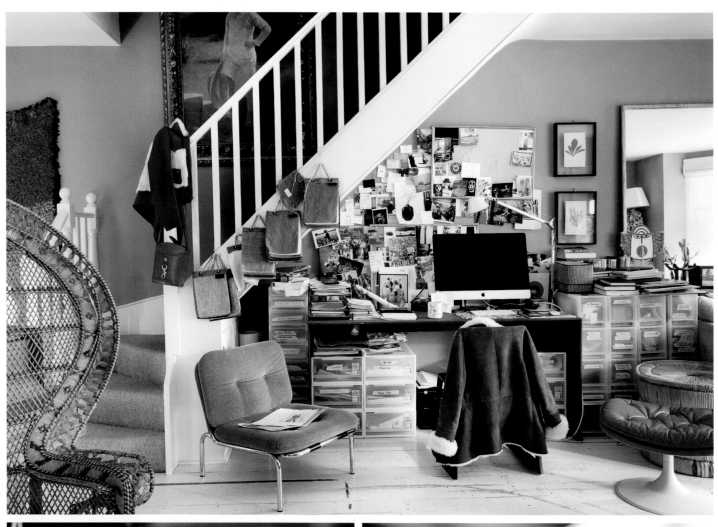

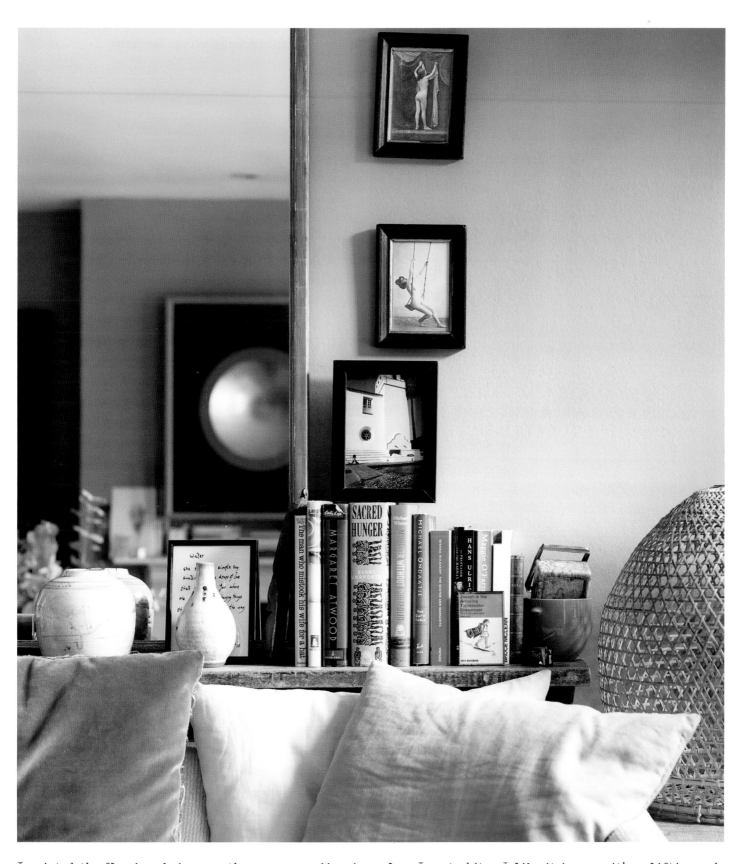

I painted the floorboards because they were a grubby pine color. I went white. I like it because it's uplifting and light. The blackboard is actually a photograph by a Spanish artist called Alejandro Guijarro. Some of his other blackboard photographs have years and years of scribbles and as I absolutely adore Cy Twombly, I was really drawn to his work.

--

Die Holzdielen habe ich neu lackiert, weil sie schon ziemlich schäbig waren. Ich entschied mich für Weiß, weil es hell und fröhlich wirkt. Was wie eine Schiefertafel aussieht, ist in Wirklichkeit eine Fotografie des spanischen Künstlers Alejandro Guijarro. Auf einigen seiner anderen Tafel-Fotos ist über Jahre gesammeltes Gekritzel zu sehen und da ich Cy Twombly verehre, spricht mich seine Arbeit stark an.

Home Office

"I work in lots of different ways. I have my computer under the stairs, I have a glass table, which I use to draw on and there's also the pin board that I use to stick things up and remind me of projects going on. When we are preparing for a presentation, I do tend to use the entire living space, which can get pretty chaotic but the pin boards are lovely to be able to see what's going on. I made this myself with cork and a wool fabric on top. It's a tricky one to switch off at the end of the day. I usually try and leave. For me, that's the cut off. I think that's why my bedroom is so simple with nothing on the walls."

Arbeitsbereich

„Ich arbeite auf viele verschiedene Weisen. Mein Computer steht unterhalb der Treppe, ich habe einen Glastisch, an dem ich zeichne, und dann gibt es noch eine Pinnwand, an die ich Sachen zu laufenden Projekten hefte. So hat man immer den aktuellen Stand im Blick. Diese Pinnwand habe ich aus Kork und Wollstoff selbst gebastelt. Wenn wir uns auf eine Präsentation vorbereiten, benutze ich manchmal den gesamten Wohnbereich, was ziemlich chaotisch sein kann. Natürlich ist es so schwierig, nach der Arbeit abzuschalten. Ich versuche dann, woanders hinzugehen. Deshalb ist mein Schlafzimmer wahrscheinlich so schlicht eingerichtet, mit leeren Wänden."

EFFORTLESS STYLE

1. It's important to take your time. The minute you begin to rush, bad decisions are made. Make time, and like anything in life, allow yourself to be educated.

2. The biggest mistake people can make is to under-estimate the effect an interior can have on your mood. A home should reflect the person living there, so get involved and build an emotional connection with the space.

3. I love color, but I've kept the walls and fabrics in my home more about tones and texture. This allows the people and objects to add color instead.

4. Good lighting is everything. You want to look good. You also want to look hot. I avoid horrible spotlights, because they are so unflattering. Instead, I have wall lights that are on a dimmer. With clever lighting, you can make the most chaotic room look chic.

5. My motto is: if you're going to do it, do it properly. Don't always go to the cheapest joiner. Find the best one and get it made really well.

DEKORATIONSTIPPS

1. Nehmen Sie sich ausreichend Zeit. Sobald man anfängt zu hetzen, trifft man schlechte Entscheidungen. Und lassen Sie sich auf einen Lernprozess ein.

2. Der größte Fehler, den man machen kann, ist zu unterschätzen, welch enorme Wirkung ein Einrichtungsstil auf die Stimmung hat. Ein Zuhause sollte die Personen, die dort leben, widerspiegeln. Bringen Sie sich also ein und schaffen Sie eine emotionale Bindung zum Interieur.

3. Ich liebe Farben, aber bei meinen Wänden und Textilien herrschen eher Texturen und gedeckte Töne vor. So können die Menschen und Objekte Farbakzente setzen.

4. Gute Beleuchtung ist extrem wichtig. Sie wollen schließlich gut aussehen. Ich vermeide Spotlights, weil sie alles in ein unvorteilhaftes Licht setzen. Stattdessen schwöre ich auf Wandleuchten mit Dimmern. Mit einem schlauen Beleuchtungskonzept kann man das chaotischste Zimmer schick aussehen lassen.

5. Mein Motto lautet: Wenn du es machen willst, dann richtig. Gehen Sie lieber immer zum besten Schreiner und lassen Sie sich ein richtig gutes Teil zimmern.

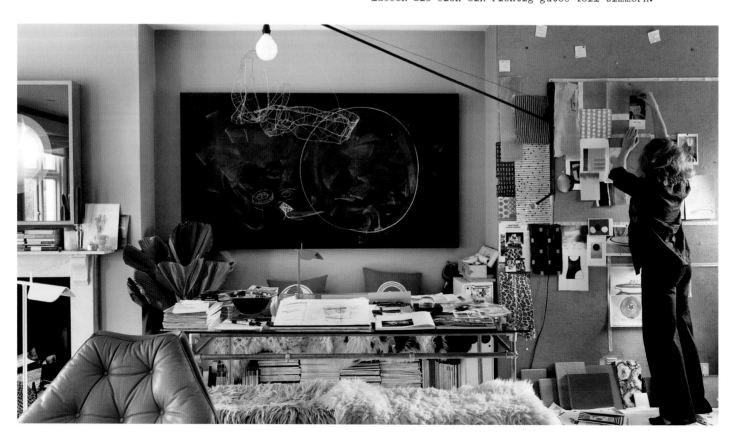

MY HOME TRUTHS

<u>I always describe my style</u> as a funny mixture of fun seventies American glamour meets very pared back Japan. There's a sense of fun, comfort and warmth, but also lots of natural materials. I use a lot of wood, tonal colors— I'm unlikely to be using metals and plastics. For me, the most important thing is to walk into a comfortable room that is slightly unusual. I like weird things in weird places. I don't think you need to have symmetry. I don't think that everything has to match.

<u>A dream project</u> would be to work with someone like the architect John Lautner in the hills of California, working with insane shapes, building a house around a mountain with rocks. I would like to have the freedom to create anything. I love California for the reason that you can kind of go and do whatever you want. I would also really love to do a spa or hotel in the mountains that was sustainably built. I think that is where I would like to go with my work.

MEINE WOHN-WEISHEITEN

<u>Ich beschreibe meinen Stil</u> immer als eine komische Mischung, die man 'amerikanischer 1970er-Jahre-Glamour trifft auf japanischen Minimalismus' nennen könnte. Die Wohnung verströmt Spaß, Gemütlichkeit und Wärme. Ich verwende viele natürliche Materialien — Holz, warme Farbtöne, kaum jemals Metall oder Kunststoffe. Ich möchte in ein gemütliches Zimmer eintreten, das ein wenig ungewöhnlich ist. Ich mag schräge Dinge an schrägen Orten und finde nicht, dass alles zusammenpassen muss.

<u>Mein Traumprojekt</u> wäre es, mit jemandem wie dem Architekten John Lautner in den Hügeln von Kalifornien zusammenzuarbeiten. Mit verrückten Formen zu arbeiten, ein Haus aus Felsen um einen Berg herum zu kreieren. Ich hätte gerne die Freiheit, alles nur Erdenkliche zu erschaffen. Ich liebe Kalifornien, weil man dort einfach machen kann, was man will. Außerdem würde ich wahnsinnig gern ein nachhaltig gebautes Spa oder Hotel in den Bergen einrichten. In diese Richtung möchte ich gehen.

COLOR
VISION

Eclectic, boldly colored, and a fusion of contemporary design with vintage chic,
Roisin Lafferty's home in Dublin is a distillation of her signature style.

Interior designer Roisin Lafferty's home is in the smart residential area of Ranelagh on the Southside Dublin. She lives in a three-story Georgian property, which serves as a studio, home, and entertaining space. In the basement is the light-filled studio—a spectacular glass extension extending out to the garden—where Roisin and her team come up with their fabulous designs. On the top floor is Roisin's private space, a place to retreat where muted green and mink shades combine with copper details and soft, velvet fabrics. But it's the ground floor that really takes your breath away. In the reception rooms, Roisin has given her imagination free rein, and the result is a dramatic and sumptuous interior layered with color and pattern.

Taking three years to complete, Roisin first set about the architectural renovations. "When we moved in, we had to excavate the basement as this was only 6.5 feet (two meters) high," says Roisin. "Also, as the garden was at first floor level, there was barely any natural light coming in. This was a huge consideration in the design. We planned the garden in three tiers to funnel in as much light as possible. Next, we added the double-height glass extension. This dictated a lot of the finishes and materials used. It was very much about giving the illusion of light and choosing materials that bounced it around."

Inspired by the period character of the house, Roisin wanted the interior to enhance that. "There isn't a right angle in this building," Roisin laughs. "Everything is skewed, so we wanted to play on that. However, we didn't want it to become a pastiche of the building's era either, so we've brought in a lot of other influences, too. There are a lot of antique pieces that we restored. There is the new extension and garden, which are quite a contemporary design. There's a lot of color and a lot of pattern. It was about having that mix of the old and new throughout the space. Because of the high ceilings and the building's character to begin with, the house lends itself to having fun."

Take for instance, the collage of tiles (on the wall, on the tabletops, on the floor), they are part of the studio's collection and are a great way of adding fun and color to a space. In the living room, the curvy Bubble sofa from Roche Bobois is unexpected and contrasts with the gilded surrounds. There are tempting colors, prints with attitude, and a new spin on antique chairs. The materials are eclectic in themselves. In the garden, salvaged bricks mix with glossy green tiles and a hand-painted peacock design on the wall. "This house has a lot of blues as a starting point," says Roisin. "Blue-and-green is one of my favorite color combinations. I love Art Deco and there's a lot of Parisian influence in the house, too. For me, Parisian design never dates."

As a designer, Roisin is constantly trying new things. It's a project that never ends. "I think the house reflects my personality in that I'm quite an ideas person," says Roisin. "I have a lot of ideas all at one given time, and it's all a bit of a mess. That's what this house is. There are so many different things, and it's a constant inspiration. It's definitely a 'more-is-more' kind of space."

"The spiral staircase is my favorite thing. We got it from a salvage yard in Ireland and then upcycled it by painting it blue. It's very much the statement piece. You see it as soon as you walk in the door."

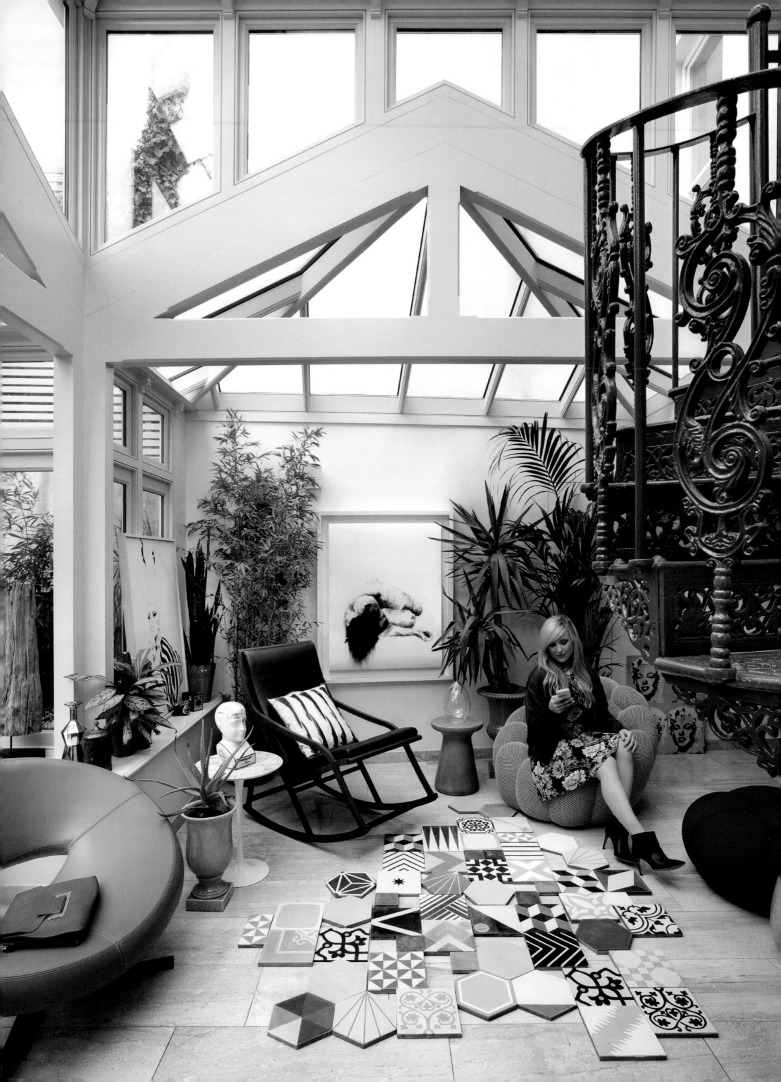

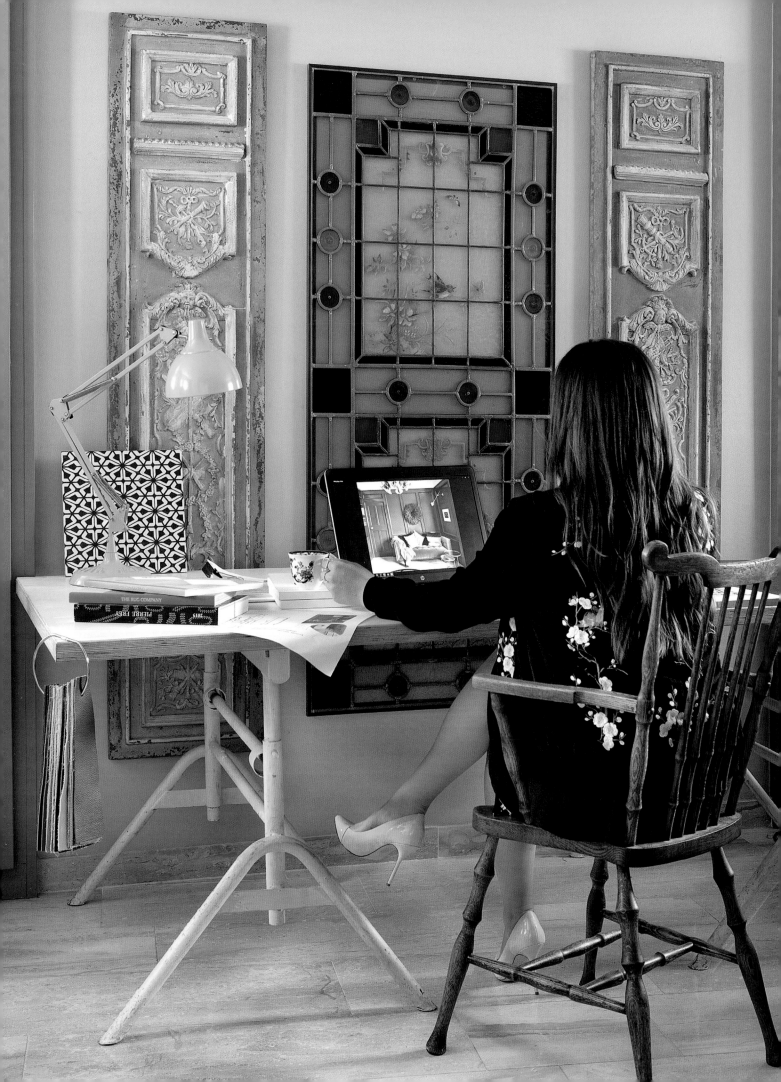

FABELHAFTE FLIESEN

Eklektisch, bunt und eine Fusion von zeitgenössischem
Design mit Vintage-Schick: Roisin Laffertys Dubliner Domizil
präsentiert alles, was ihren persönlichen Stil ausmacht.

———————— ... ————————
▽

Das Haus der Innenarchitektin Roisin Lafferty liegt im edlen Wohnviertel Ranelagh in Süddublin. Das dreistöckige Gebäude aus dem 18. Jahrhundert dient Roisin als Atelier, Zuhause und Partylocation. Im Untergeschoss befindet sich das lichtdurchflutete Atelier – ein spektakulärer Glasanbau, der in den Garten hineinragt –, wo Roisin und ihr Team sich ihre fantastischen Designs ausdenken. Ganz oben liegen die Privaträume, ein entspannter Ort des Rückzugs, wo gedeckte Grün- und Graulilatöne mit Messing und weichen Samtstoffen kombiniert werden. Am beeindruckendsten ist jedoch das Erdgeschoss. In den Empfangsräumen hat Roisin ihrer Fantasie freien Lauf gelassen und ein dramatisches und üppiges Interieur voller Farbe und Muster kreiert.

Die Renovierung dauerte drei Jahre. „Beim Einzug mussten wir den Keller erweitern, da er nur zwei Meter hoch war", sagt Roisin. „Und der Garten lag auf Höhe des ersten Stocks; es kam also kaum natürliches Licht rein. Dies war ein wesentlicher Faktor beim Umbau. Wir legten den Garten auf drei Ebenen

an, um so viel Licht wie möglich durchzulassen. Dann errichteten wir den Glasanbau in doppelter Raumhöhe. Wir wollten Helligkeit vermitteln und wählten deshalb Materialien aus, die das Licht stark reflektieren."

Roisin wollte den Charakter des 18. Jahrhunderts im Interieur aufgreifen. „Im ganzen Gebäude gibt es keinen rechten Winkel", sagt sie lachend. „Alles ist schief und krumm; damit wollten wir spielen. Allerdings wollten wir die Vergangenheit nicht einfach nachahmen und haben deshalb auch viele andere Inspirationen einfließen lassen. Wir haben viele antike Stücke restauriert, aber der neue Anbau und der Garten sind vom Design her ziemlich modern. Es gibt viele Farben und Muster. Wir wollten durchgängig einen Mix aus Altem und Neuem. Mit den hohen Decken und dem Originalcharakter des Hauses kann man viel Spaß haben."

Da sind zum Beispiel die Fliesencollagen (an den Wänden, auf Tischen, auf dem Boden), sie gehören zu unserer Kollektion und machen den Raum lustig und farbenfroh. Im Wohnzimmer

wird das kurvige Sofa Bubble von Roche Bobois von goldenen Elementen umrahmt. Hier stößt man auf verlockende Farben, gewagte Muster und antike Stühle, die keineswegs altmodisch wirken. Auch die Auswahl an Materialien ist eklektisch. Im Garten harmonieren alte Ziegelsteine mit glänzend-grünen Fliesen und einem handbemalten Pfau an der Wand. „Blauschattierungen bilden das Grundfarbschema des Hauses", sagt Roisin. „Blau und Grün ist eine meiner Lieblings-Farbkombinationen. Ich liebe Art déco und im Haus stecken auch viele Pariser Einflüsse. Für mich kommt Pariser Design nie aus der Mode."

Als Designerin probiert Roisin ständig Neues aus. Deshalb ist ihr Zuhause ein nie endendes Projekt. „Ich glaube, das Haus spiegelt meine Persönlichkeit insofern wieder, als ich ein Mensch mit vielen Ideen bin", sagt Roisin. „Die Ideen sprudeln alle gleichzeitig aus mir heraus, was etwas chaotisch ist. Genau wie dieses Haus. Es enthält so viele verschiedene Elemente und inspiriert mich ständig. Hier gilt definitiv das Motto ‚Mehr ist mehr'."

VORHERIGE SEITE: "Die Wendeltreppe ist mein absolutes Lieblingsteil. Wir fanden sie auf einem Schrottplatz in Irland und haben sie blau lackiert. Das ist ein echter Hingucker. Der Blick fällt darauf, sobald man zur Tür reinkommt."

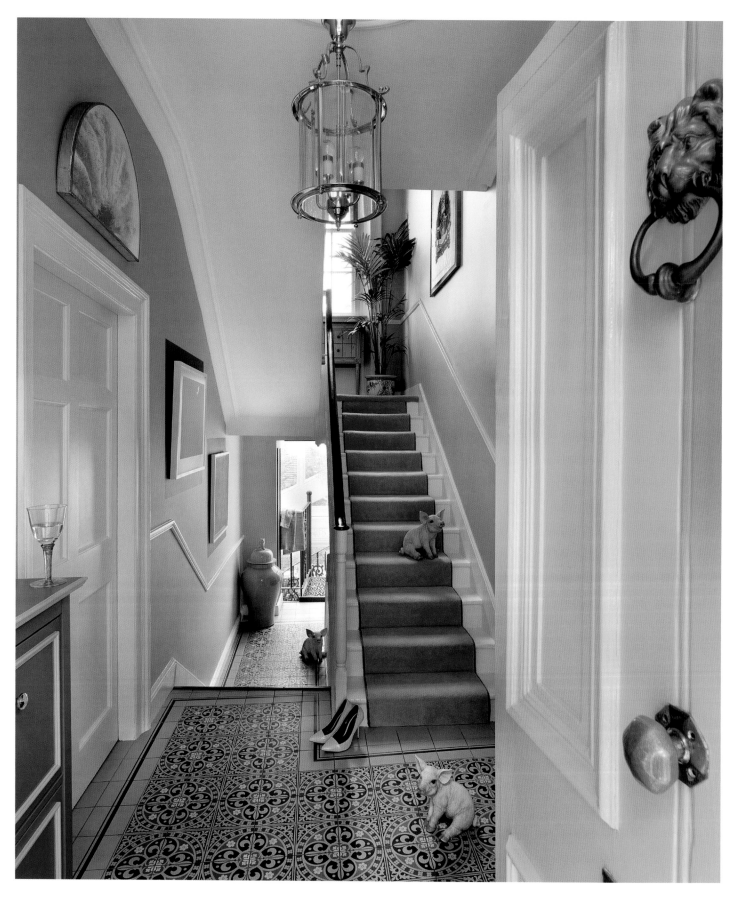

"I wanted to make a statement with the yellow door. A lot of Georgian homes used to have bright red doors, whereas nowadays, it's all very muted. It links to the blue inside and Victorian-tiled floor."

--

"Mit der gelben Tür wollte ich ein Statement setzen. Viele Häuser aus dem 18. Jahrhundert hatten früher knallrote Türen, aber heute bevorzugt man eher gedeckte Töne. Das Gelb korrespondiert mit dem Blau innen und dem Boden mit den viktorianischen Fliesen."

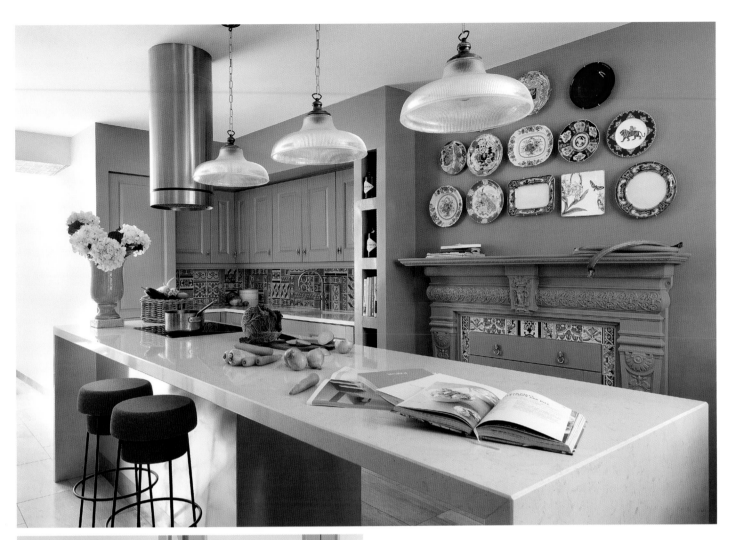

Kitchen

"The base of the island unit is clad in brass and the countertop is silestone. The railway pendants are from Hicken lighting. We didn't need the fireplace so we packed it out and put in drawers instead. We framed it with the fire surround as I really liked the detail. The splashback tiles are hand-painted from Seville, which we collaged together into a pattern. We weren't trying to create an old fashioned room. We wanted it traditional but also fun."

Küche

„Die Basis der Kochinsel ist mit Messing verkleidet und die Arbeitsfläche ist aus Silestone. Die Hängelampen im Eisenbahnstil stammen von der Firma Hicken. Den Kamin brauchen wir nicht und haben deshalb Schubladen in die Öffnung eingebaut. Die Kaminumrandung ließen wir aber stehen, da mir die Ornamentik so gut gefällt. Die handbemalten Fliesen, die wir zu einem Muster zusammengesetzt haben, kommen aus Sevilla. Wir haben nicht versucht, einen altmodischen Raum zu erzeugen. Wir wollten, dass er traditionell ist, aber gleichzeitig Spaß ausstrahlt."

Living Room

"This is a more formal room, which reflects how the room used to look. That's why there is the gilded mirror, the consoles, and the original fireplace. I wanted the walls to be tiled, but instead we made it out of individual pieces of paper, which we cut out and put on the wall. Rather than keeping it too formal, we mixed the scheme with industrial light fittings, and then there's the rhino head and the pigs. These are about having fun. I don't take it too seriously."

"The color palette in this room was inspired by the painting by artist Daniel Henson on the wall. Rather than frame it, I wanted to draw it out. I picked up on the yellow and made the large yellow square. Straight away this made a big statement and led to everything else. I also think that planting inside is a very good way of adding texture and height. I look at the furniture in the room as architectural elements. The different shapes and structures add interest in the space."

———— ··· ————
▽

The cast metal pigs are from Rowell Design in Donnybrook.

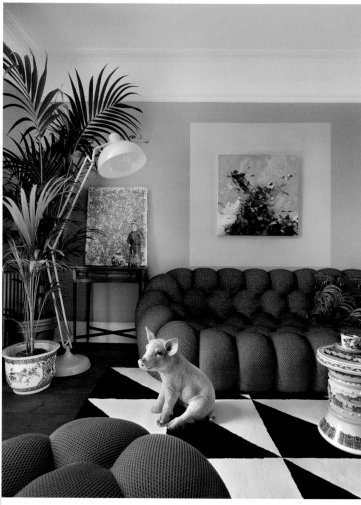

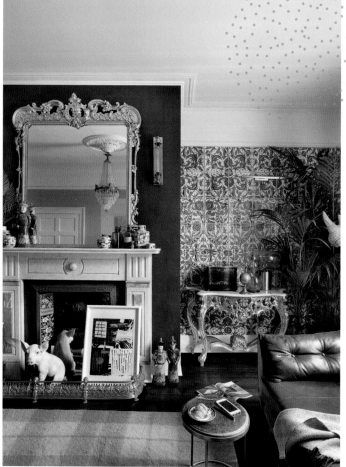

Wohnzimmer

„Dieser Raum ist etwas formeller und erinnert daran, wie es früher hier aussah. Deshalb auch der Spiegel mit vergoldetem Rahmen, die Konsolen und der authentische Kamin. Ich wollte die Wände ursprünglich richtig kacheln, aber stattdessen schnitten wir individuelle Papierquadrate aus und klebten diese an die Wand. Damit es nicht zu steif wird, installierten wir Hängelampen im Industrial Style. Und dann gibt es da noch einen Nashornkopf und die Schweine. Die sind für den Spaßfaktor zuständig. Ich nehme Einrichtungen nicht zu ernst."

„Die Farbpalette in diesem Raum wurde inspiriert vom Gemälde des Künstlers Daniel Henson, das an der Wand hängt. Anstatt es zu rahmen, wollte ich es sich weiter ausbreiten lassen. Ich griff den Gelbton auf und malte ein großes gelbes Quadrat drumherum. Das hatte sofort einen großen Effekt und führte automatisch zu allem anderen. Große Pflanzen geben Räumen Textur und Höhe. Möbel betrachte ich als architektonische Elemente. Die unterschiedlichen Formen und Strukturen machen den Raum interessant."

———— ··· ————
▽

Die Schweine aus Gusseisen sind von Rowell Design in Donnybrook.

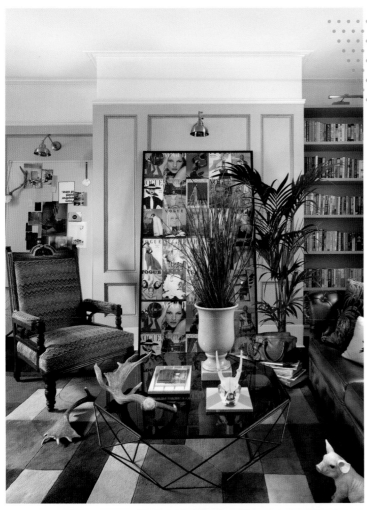

Home Office

"I love paneling and I love texture. The walls are mint green and hand-painted with gold. We reupholstered the antique chair with a Missoni fabric to add a bit of youthfulness to the period design. The books and *Vogue* panel set the tone. It is a centenary special edition silk scarf commissioned by the V&A for *Vogue's* anniversary. I got it for my thirtieth birthday present and had it framed so that I could better appreciate it."

Arbeitszimmer

„Ich liebe Paneele und ich liebe Textur. Die Wände sind Mintgrün mit handbemalten Goldrahmen. Den antiken Sessel ließen wir mit einem Missoni-Stoff neu beziehen, um dem alten Design etwas jugendliche Frische zu verleihen. Die Tafel aus *Vogue*-Covern prägt den Raum. Eigentlich handelt es sich dabei um ein Seidentuch, dass zum 100-jährigen Jubiläum von *Vogue* vom Victoria and Albert Museum als Sonderedition in Auftrag gegeben wurde. Ich bekam ihn zu meinem dreißigsten Geburtstag geschenkt und ließ ihn rahmen, damit ich ihn besser würdigen kann."

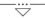

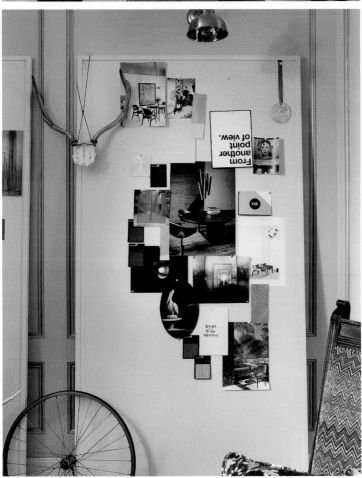

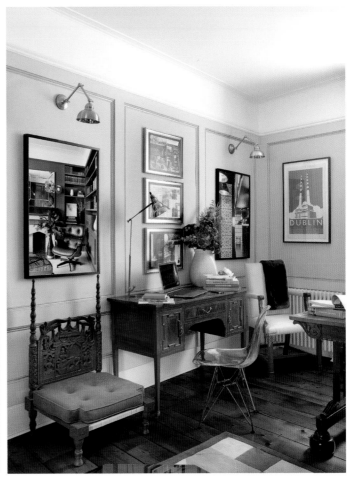

Garden

"The garden is a decorative space layered up with a lot of tiles. We created three different zones for three different experiences and also to make the space feel much bigger than it is. The bottom tier is almost like an extra room, so it's perfect for parties. We made the table with lots of different tiles, and the peacock was made in Seville. Because it's Ireland and the weather's really bad, we wanted it to be well lit. There's a lot of lighting, so at night or if it is raining, the lights can be turned on."

—···—
▽

Garten

„Der Garten ist ein dekorativer Ort mit vielen Fliesen. Wir haben drei unterschiedliche Bereiche für unterschiedliche Erlebnisse kreiert, die die Fläche insgesamt viel größer erscheinen lassen. Die untere Ebene ist fast wie ein zusätzliches Zimmer und deshalb perfekt für Partys. Den Tisch haben wir aus vielen verschiedenen Fliesen zusammengesetzt und der Pfau wurde in Sevilla hergestellt. Weil das Wetter hier in Irland so schlecht ist, haben wir viele Leuchten installiert, die bei Nacht oder Regen angeschaltet werden können."

—···—
▽

A lot of pieces in the garden—the fireplaces and pots—are from salvage yards, which Roisin painted to make more vibrant and so that they don't feel so old.
--
Viele Dinge im Garten — die Kamine und Töpfe — sind Schrottplatzfunde. Roisin hat sie bunt lackiert und ihnen damit neues Leben eingehaucht.

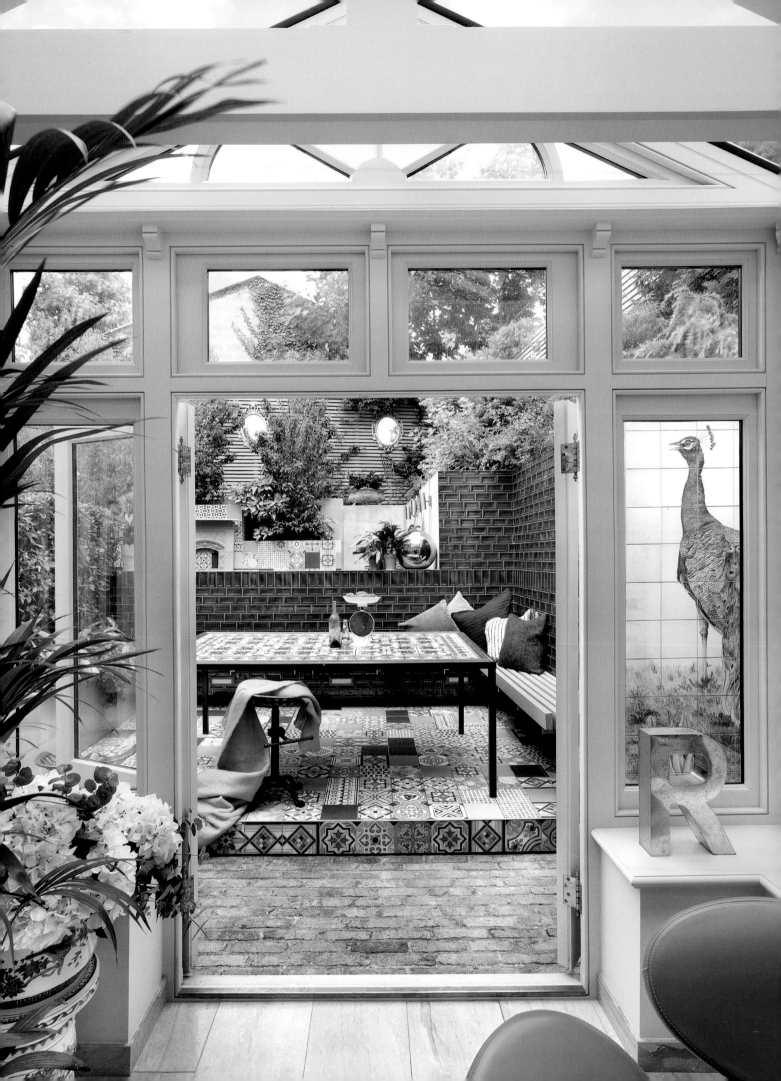

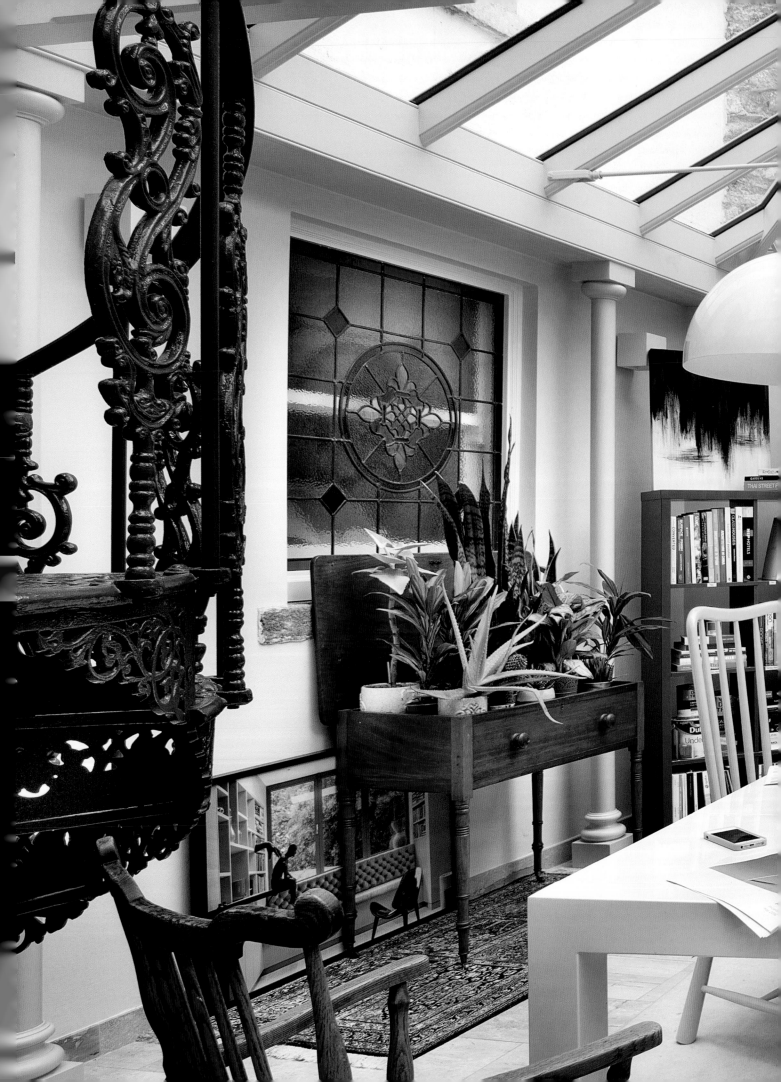

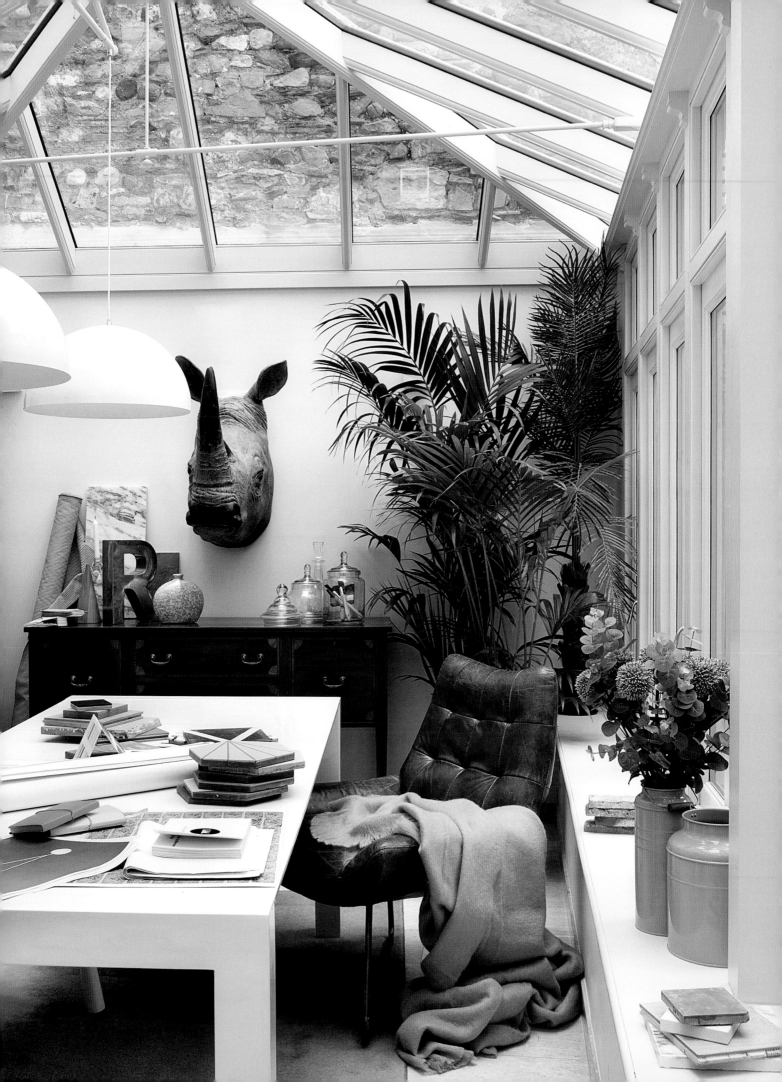

Roisin's golden rules of
DECORATING WITH PATTERN

1. Think about the overall look and feel that you want to have in the end. Good design is less about creating an inviting atmosphere.

2. Choose one starting point in the room, for instance a piece of art and build up the scheme from there. Don't be afraid of mixing different colors and patterns. It adds richness and excitement to the space.

3. When buying vintage pieces, think about the color palette in the rest of the room. I source a lot of antique furniture and have them reupholstered in a complementary scheme. Try to view everything in the room in isolation as well as mixed with everything else.

4. Avoid following trends too closely. Like fashion, interior trends come and go. The most important thing is to select items that emotionally appeal to you, that you can't live without, rather than buying things because they are on trend.

5. I like to take a holistic approach to design. I believe that a space should take homeowners' on an exciting journey.

Roisins goldene
DEKOREGELN

1. Denken Sie an den Gesamtlook, den Sie am Ende erzeugen wollen. Bei gutem Design geht es nicht nur darum, eine einladende Atmosphäre zu kreieren.

2. Wählen Sie einen Startpunkt aus, zum Beispiel ein Kunstobjekt, und bauen Sie Ihr Einrichtungsschema darauf auf. Haben Sie keine Angst davor, Farben und Muster zu mischen. Das macht den Raum vielschichtig und aufregend.

3. Denken Sie an die Farbpalette des Zimmers, wenn Sie Vintage-Stücke kaufen. Ich lasse antike Möbel oft neu aufpolstern. Betrachten Sie alle Elemente eines Raumes sowohl für sich allein als auch in Kombination mit den übrigen Dingen im Raum.

4. Folgen Sie Trends nicht zu sklavisch, denn die sind bei Interieurs genauso kurzlebig wie in der Mode. Wählen Sie Teile aus, die Sie emotional ansprechen und ohne die Sie nicht leben können, anstatt Sachen nur zu kaufen, weil diese gerade angesagt sind.

5. Ich wähle beim Design gern einen ganzheitlichen Ansatz. Ich glaube, dass ein Haus seine Bewohner auf eine aufregende Reise mitnehmen sollte.

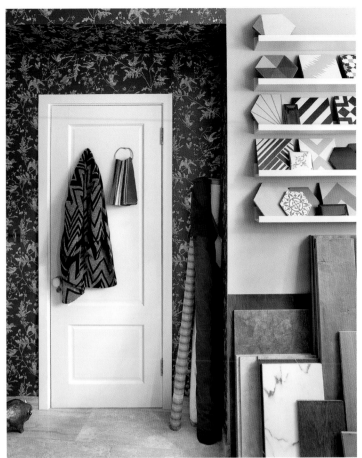
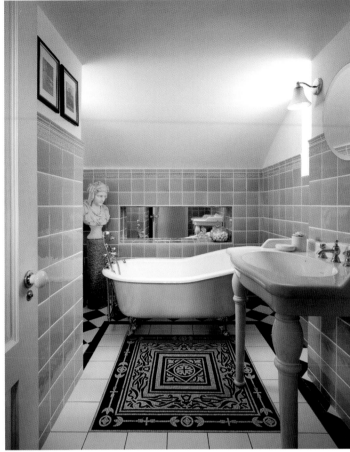

MY HOME TRUTHS

MEINE WOHN-WEISHEITEN

I like to create unique environments. We focus on the space first and foremost, and then make the layout as exciting as possible. We like to turn the norm on its head, reconfiguring the layout and proportions of a room to make a space more interesting. Clients that come to us tend to want something different, fun, and creative, whether it's a minimal project or over-the-top.

My dream project would be a boutique hotel. An old building from the 1800s would be spectacular. As a design practice, we do furniture and lighting as well as interior design. So, with a hotel everything could be considered—from the music, the branding, to how it smells—right from the moment someone walks inside.

Ich erschaffe gern einmalige Räumlichkeiten. Wir konzentrieren uns zunächst auf den gegebenen Raum und machen das Layout dann so aufregend wie möglich. Dabei stellen wir die Norm oft auf den Kopf, rekonfigurieren Layout und Proportionen eines Zimmers, um es interessanter zu gestalten. Unsere Kunden wollen in der Regel etwas, das anders ist, ein bisschen ausgeflippt und kreativ. Das kann minimalistisch sein oder auch total prunkvoll.

Mein Traumprojekt wäre ein Boutiquehotel. Ein altes Gebäude aus dem Anfang des 19. Jahrhunderts wäre spektakulär. Wir richten nicht nur Häuser ein, sondern entwerfen auch Möbel und Leuchten. Bei einem Hotel würden wir alles berücksichtigen — von der Musik und dem Branding bis zum Geruch. Das Konzept würde spürbar sein, sobald jemand das Hotel betritt.

DANS LE
SALON

On the edge of fantasy and romance, the old-world charm of this Bohemian home is complemented by its owner's collection of rare antiques, unique furniture, and passion for plants.

The magical London apartment of interior designer Sera Hersham-Loftus captures the bygone beauty of the city's past. Restored to its former glory from the previous owner's masculine, loft-style fit-out, Sera put her own spin on the property, reinstating the period wood-paneled walls, timber flooring, and ornate, stucco plasterwork. Her creative impulse for sure leans towards a Bohemian and vintage spirit—but it's in no way dot-to-dot Victoriana. It's a place where influences from several centuries have been brought together. Here, fin de siècle French mirrors share wall space with Rothko paintings, and on the ceiling, a 1970s disco ball. Exposed brick walls and leather and metal dining chairs add an industrial touch.

In a way that perfectly expresses the personality and spirit of its owner, Sera's Little Venice flat is as gloriously arresting and convention defying as her own glamorous sense of style. "I think that your house and the place that you live in should be the same as your personality, and if it's not, then there's something wrong

with it," she says. "It's definitely me. It's the way I dress. I do dress very Bohemian and very floaty. I really enjoy dressing the apartment for dinner parties—and I like dressing up, too."

The apartment is on the first floor of an imposing 19th-century mansion block, where the grand feel of the building is at its height. Opening the vast reception rooms into one big, flowing space, Sera knocked through the walls, revealing the fireplaces and stripping back plaster from the walls. The end result is dramatic yet inviting. "I have two salons and a bedroom that looks as though it could be a salon," describes Sera. "Every room looks as though it is ready to lie down and relax."

Sera's love of dark paint has been given free rein throughout the space. All the ceilings are black as well as some of the door frames, while some are stripped back to their original wood. "I've always painted ceilings dark, even in quite a low ceilinged room," she explains. "It brings everything together really nicely." Another design trick of Sera's is to use a lot

of lace on the windows and also to divide the walls, which billows beautifully in the wind. "Everything's quite transparent," she says. "Sometimes when you have a really big open space, it can feel quite cold. But if you divide it with muslin, it's quite sexy, a bit more cozy, too. My windows are really large and the light is very bright, so I have blackout blinds like the old Parisian blinds, that I pull down to control the light."

Crammed with beautiful things, Sera's magpie-like attraction for glint and glitter is contradicted by her attraction to unrefined, timeworn things. There's great attention to detail, but also a free-spirited feel. "I'm drawn to rustic pieces that are a bit battered around," she explains. "I don't want to feel as though when I put something down, it's going to get ruined. Nothing is ever perfect. I like everything to have a bit of charm and wit,"— just like herself. All-in-all Sera's home is trés, trés sexy, but with lashings of class.

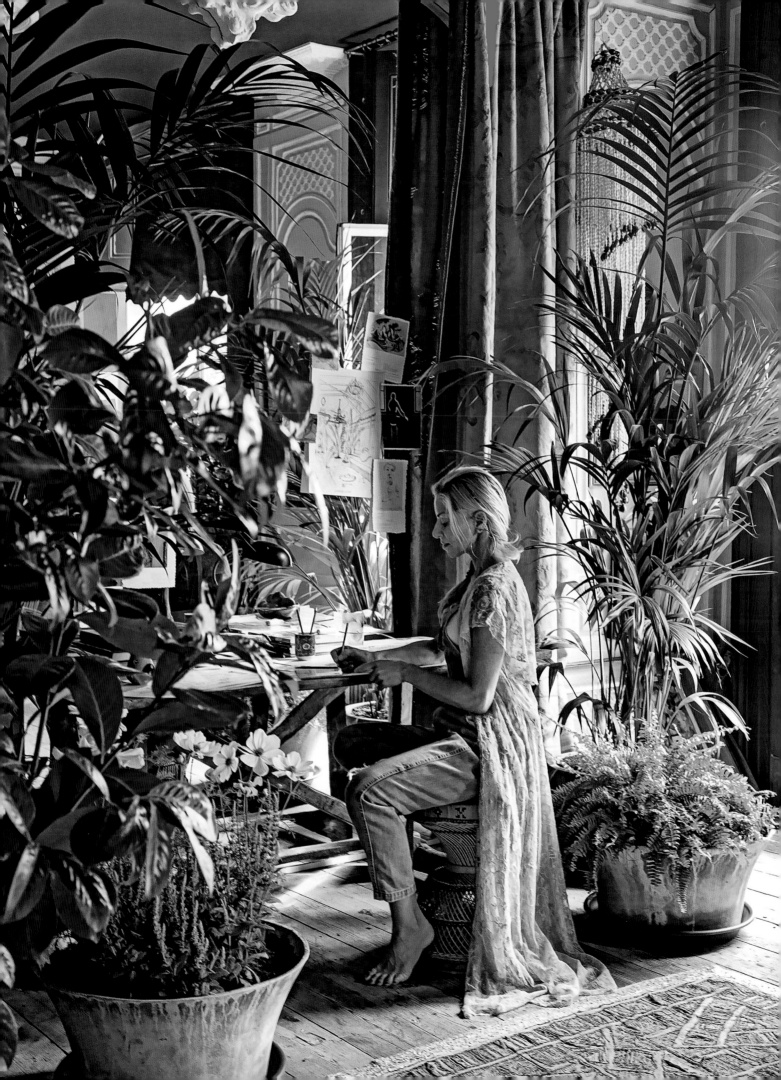

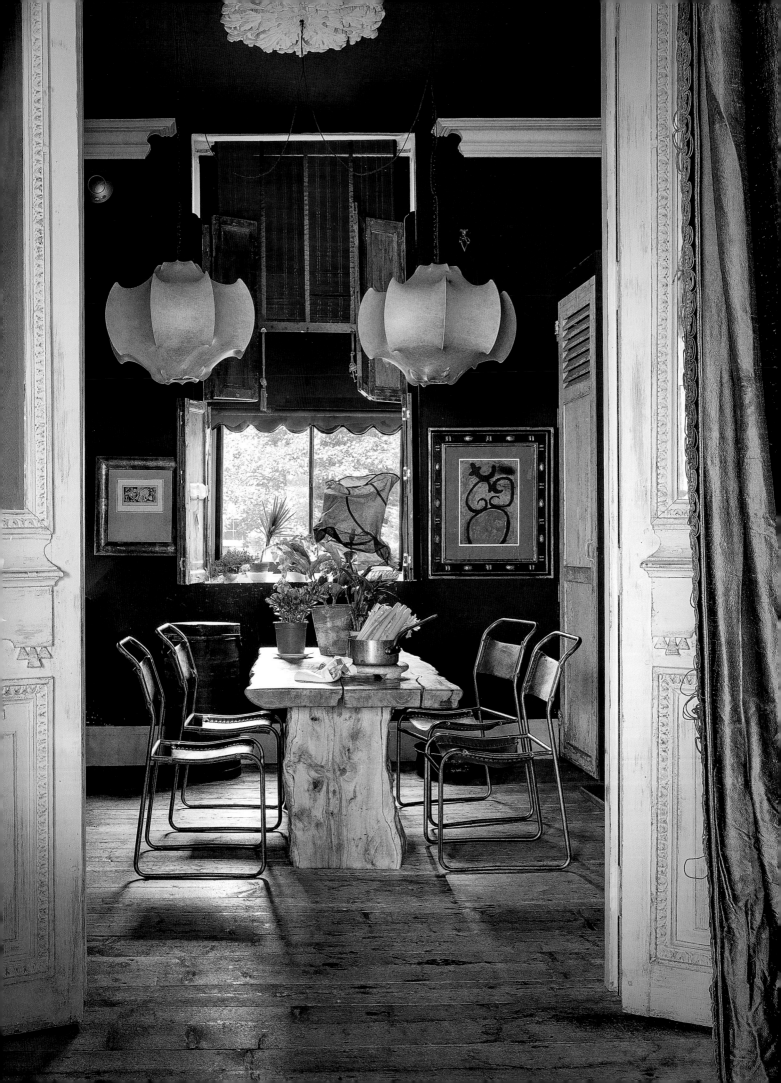

DER MAGISCHE GARTEN

Fantasie und Romantik durchziehen dieses Haus, das den Charme
der Alten Welt verströmt. Das Interieur spiegelt die Leidenschaft seiner Besitzerin
für seltene Antiquitäten, außergewöhnliche Möbel und Pflanzen wieder.

Das magische Londoner Domizil von Inneneinrichterin Sera Hersham-Loftus konserviert die Schönheit von Londons Vergangenheit. Sera hat den maskulinen Loft-Style des vorherigen Besitzers rückgängig gemacht und die Wohnung zu alter Pracht zurückgeführt. Sie hat die Wandpaneele, die Holzdielen und den dekorativen Stuck aus dem 19. Jahrhundert restauriert und dem Wohnraum trotzdem ihren Stempel aufgedrückt. Ihr kreativer Impuls ist eindeutig auf Vintage ausgerichtet, hält sich aber nicht streng an eine Blaupause aus dem viktorianischen Zeitalter: Hier fließen Stilelemente aus mehreren Jahrhunderten zusammen. Französische Spiegel aus dem Fin de Siècle teilen sich Wandfläche mit Rothko-Gemälden und einer von der Decke hängenden Diskokugel aus den 1970er-Jahren. Freigelegte Mauersteine und Essstühle aus Leder und Metall fügen einen industriellen Touch hinzu.

Das Interieur von Seras Wohnung in Little Venice ist so atemberaubend und unkonventionell wie ihr persönlicher Stil und gibt ihre Persönlichkeit perfekt wieder. „Ich bin der Meinung, dass das Zuhause eines Menschen seinem Charakter entsprechen sollte und wenn nicht,

stimmt etwas nicht damit", sagt Sera. „Meine Wohnung spiegelt definitiv meinen Stil wider. Wie ich mich anziehe. Ich kleide mich oft nostalgisch-romantisch. Es macht mir Spaß, die Wohnung – und mich – für Dinnerpartys herzurichten."

Das Apartment befindet sich im ersten Stock eines imposanten Wohnblocks aus dem 19. Jahrhundert. Sera ließ die Wände zwischen mehreren Empfangsräumen abreißen, um einen großen, durchgehenden Wohnbereich zu schaffen. Sie legte alte Kamine und Stuckdecken frei. Das Resultat ist dramatisch, aber einladend. „Ich habe zwei Salons und ein Schlafzimmer, das wie ein Salon wirkt", erklärt Sera. „Jedes Zimmer sieht aus, als könne man sich darin hinlegen und entspannen."

Sera hat ihrer Vorliebe für dunkle Wandfarbe freien Lauf gelassen. Sämtliche Decken und auch einige Türrahmen sind schwarz gestrichen. Bei anderen Türrahmen wurde das Originalholz freigelegt. „Ich habe meine Decken schon immer dunkel gestrichen, sogar in Räumen mit niedriger Deckenhöhe", erklärt sie. „Das bringt alles schön zusammen." Ein weiterer ihrer Designtricks

ist der Einsatz von Spitzengardinen vor den Fenstern und als Raumteiler, weil sie sich bei Luftzug so hübsch aufbauschen. „Alles ist transparent", sagt sie. „Eine große, offene Wohnfläche kann sich manchmal ziemlich kalt anfühlen. Aber wenn man sie mit einem leichten Musselinstoff unterteilt, wirkt es ziemlich sexy und auch etwas gemütlicher. Meine Fenster sind sehr groß und das einfallende Tageslicht ist sehr hell. Deshalb habe ich blickdichte alte Pariser Rollos, die ich bei Bedarf herunterziehe.

Seras geradezu elsterhafte Faszination für Glitzer und Glimmer steht im Gegensatz zu ihrer Begeisterung für robuste und leicht verschlissene alte Dinge. „Ich fühle mich zu rustikalen Teilen hingezogen, die schon einiges hinter sich haben", erklärt sie. „Ich möchte nicht das Gefühl haben, dass ein Gegenstand leicht kaputt geht, wenn ich ihn abstelle. Nichts ist jemals perfekt. Ich möchte, dass alle Objekte ein wenig Charme und Esprit versprühen" – genau wie sie selbst. Alles in allem ist Seras Zuhause sehr sinnlich mit jeder Menge Klasse und Stil.

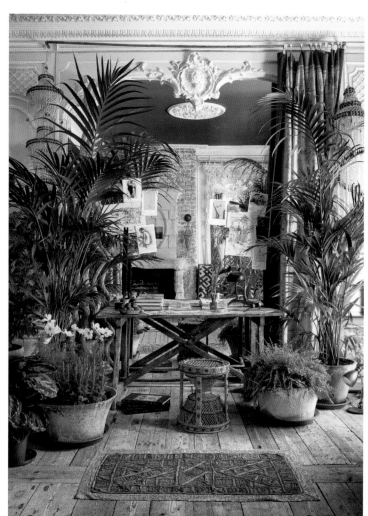

Kitchen

"I designed the kitchen around a really beautiful 1940s console table and had the cabinets made to match. I found a French La Cornue oven, which goes with it really well. The walls are matte black and the tiles are handmade by a ceramicist. He made them by hand so each one is a little bit wobbly. They are actually brand new, but look like they have been there for a hundred years. Lighting is very important in a dark room. If you light a black room well, it's gorgeous. If you don't light a black room well, it's really depressing."

Küche

„Die Küche habe ich rund um einen wunderschönen Konsolentisch aus den 1940er-Jahren entworfen. Die Schränke wurden darauf abgestimmt. Ich fand einen französischen Herd von La Cornue, der auch bestens dazu passt. Die Wände sind matt schwarz gestrichen und die Fliesen wurden von einem Keramiker handgefertigt. Deshalb sind sie auch etwas uneben. Sie sind brandneu, sehen aber aus, als wären sie schon seit hundert Jahren da. Die Beleuchtung ist in einem dunklen Raum besonders wichtig. Wenn man ein schwarzes Zimmer gut beleuchtet, ist es grandios. Wenn man es nicht gut beleuchtet, wirkt es total deprimierend."

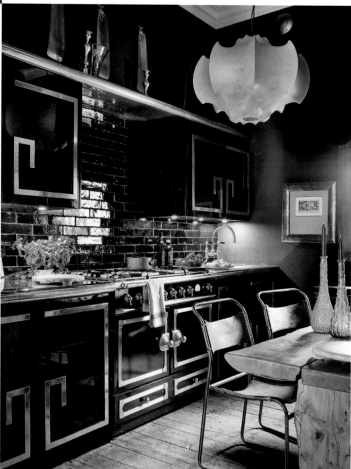

Sera lives in Little Venice on the Regent's Canal. It's a stucco building, originally built by Sir Randolph, who owned all the buildings in Maida Vale at the time. "This is where all the brothels were back in the day," says Sera. "This is where the term 'randy' comes from."

--

Sera lebt in Little Venice am Regent's Canal. Das stuckverzierte Gebäude wurde von Sir Randolph erbaut, dem damals alle Häuser in Maida Vale gehörten. "Damals waren hier die Bordelle", sagt Sera. "Daher stammt der Begriff 'randy' (Englisch für 'lüstern')."

Living Area

"As I do up people's homes, there are always new pieces coming in to my home, but there are certain things I would never sell. I found the amazing disco ball from Studio 54 and my Peacock chairs are from the film *Emmanuelle*. I also really love plants in a room. I think they add so much life. They bring the outdoors in."

Wohnbereich

„Da ich die Häuser anderer Leute einrichte, trenne ich mich oft von Dingen und finde dafür neue für mein Zuhause, aber einige Gegenstände würde ich nie verkaufen. Diese wunderbare Diskokugel hing im Studio 54 und meine Pfauenstühle stammen aus dem Film *Emmanuelle*. Ich liebe Pflanzen im Wohnbereich. Sie machen alles so lebendig und bringen die Natur von draußen herein."

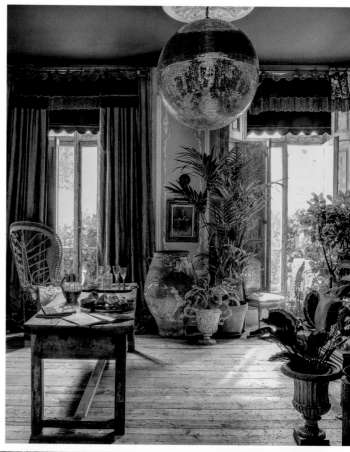

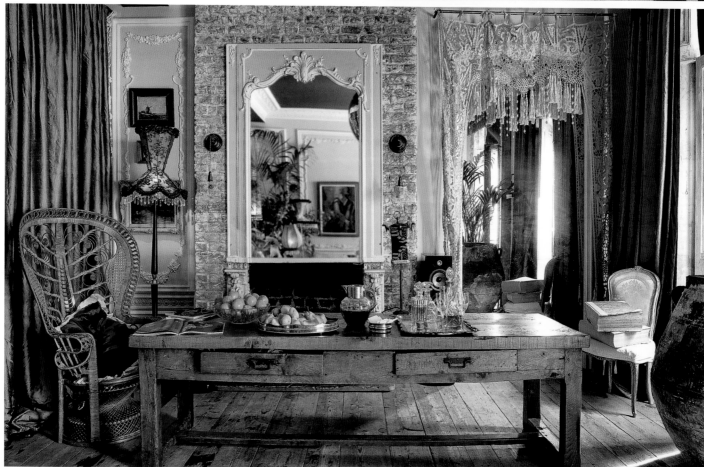

The refectory table is one piece of wood, probably an old butcher's block.
--
Der Refektoriumstisch ist aus einem Stück Holz gemacht, wahrscheinlich aus einem alten Schlachtblock.

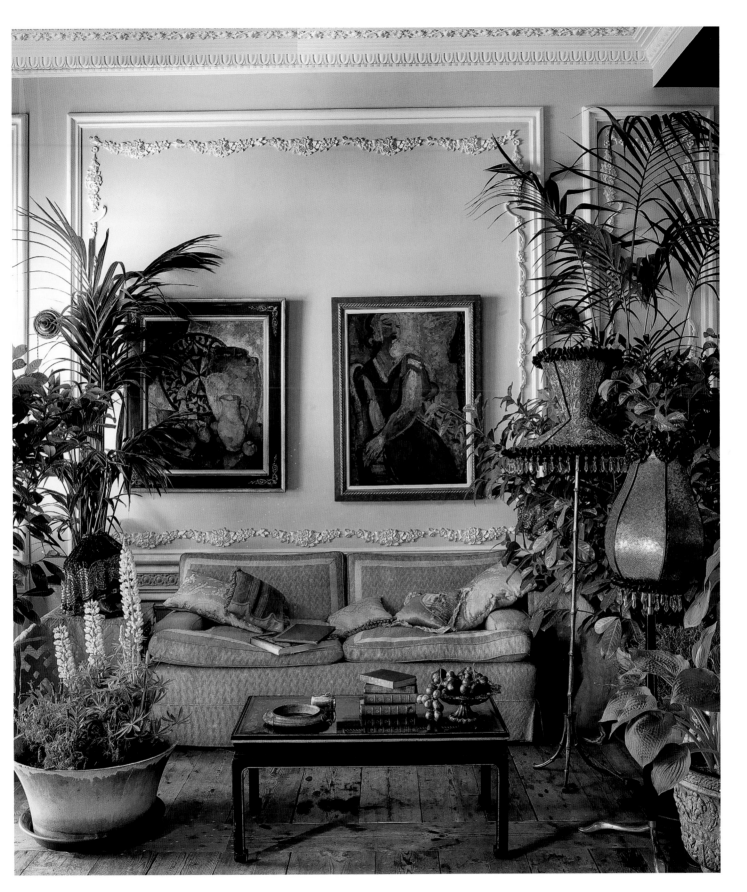

"I love paintings. My father was an art collector, and when he passed away last year, he left his art collection. So I have some beautiful paintings on the walls. When I was younger I used to have paintings of sexy rock-and-roll chicks or Lemmy from Motörhead, but as I've grown up I've become more sophisticated in my taste."

--

"Ich liebe Gemälde. Mein Vater war Kunstsammler und hinterließ mir seine Kollektion, als er letztes Jahr verstarb. Deshalb hängen bei mir einige wunderschöne Werke an der Wand. Als ich jünger war, gefielen mir Bilder von heißen Rock'n'Roll-Typen oder Lemmy von Motörhead, aber inzwischen ist mein Geschmack deutlich kultivierter."

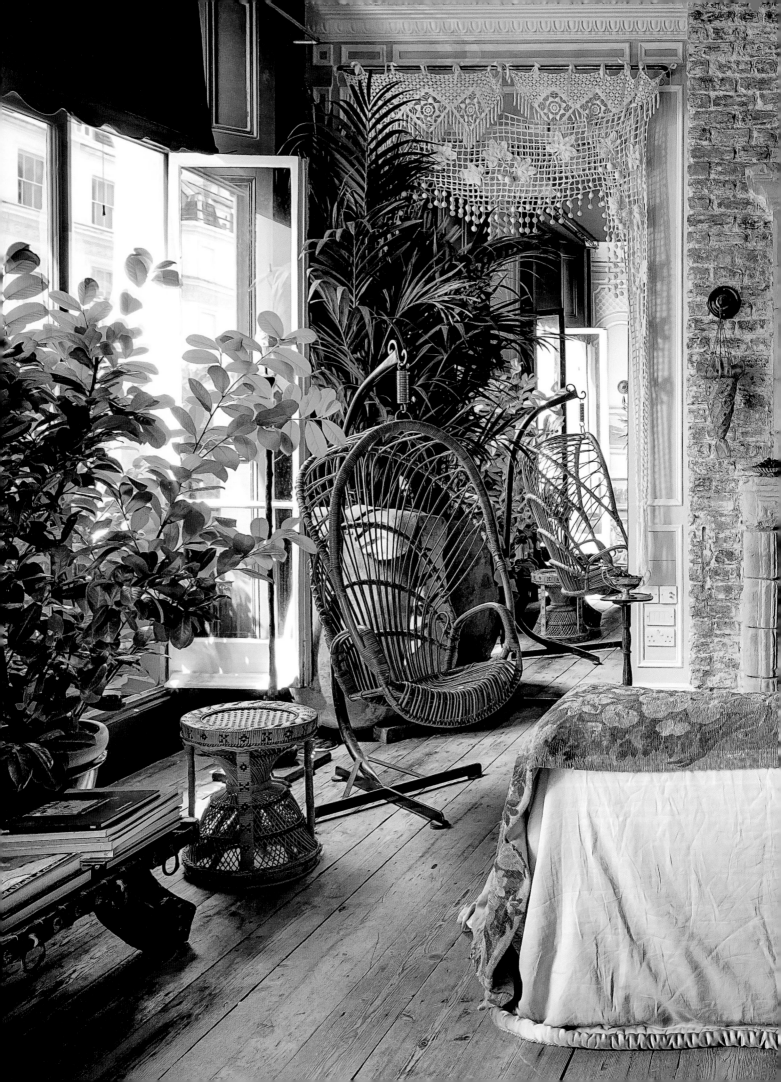

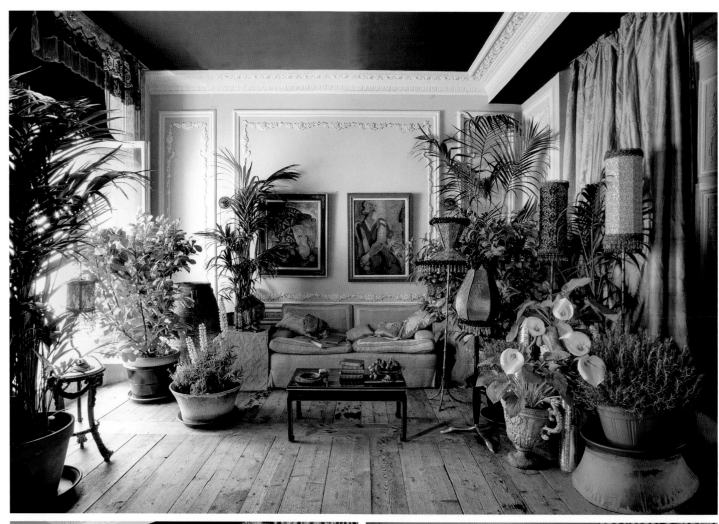

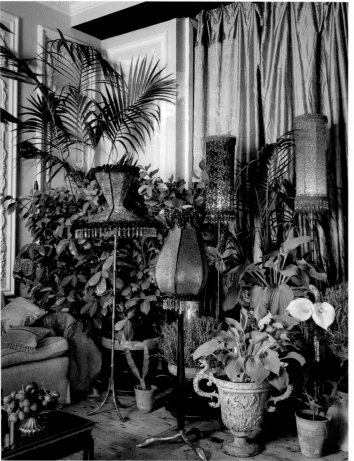

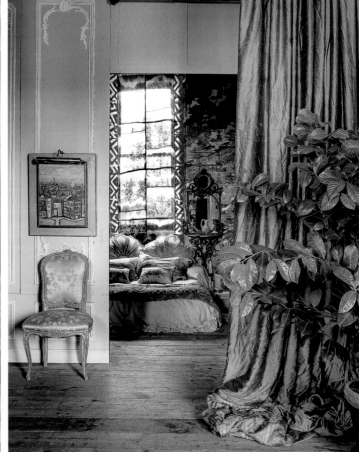

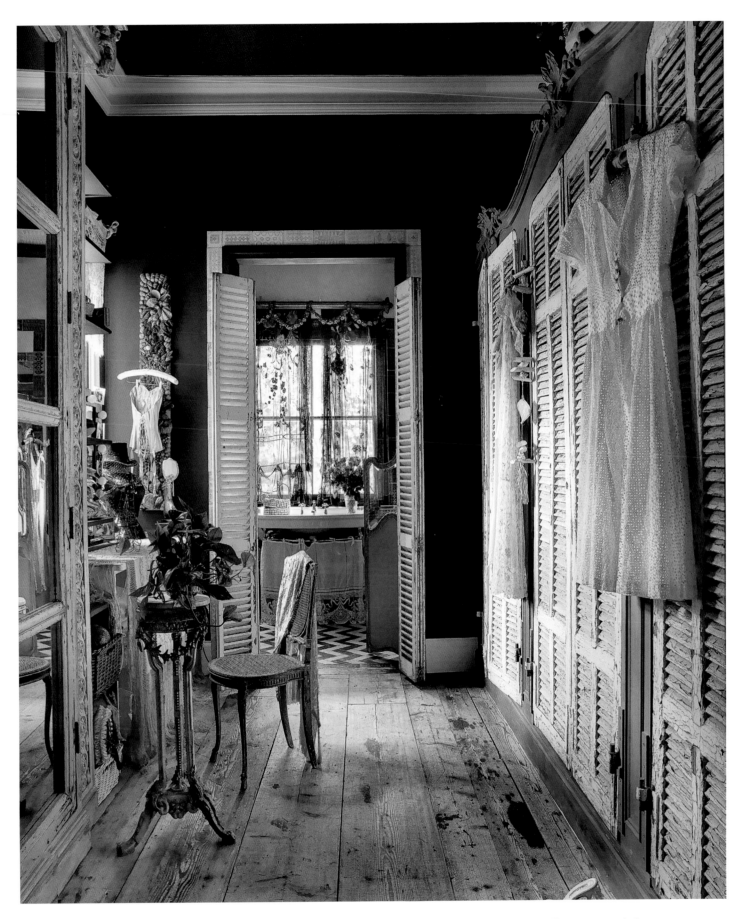

Sera's dressing room sits between her bedroom and shower room. The space really flows. The cupboard doors are created using old French window shutters, which would usually be found on the outside of a building.

--

Seras Ankleidezimmer befindet sich zwischen Schlaf- und Badezimmer. Die Schranktüren bestehen aus alten französischen Fensterläden, die normalerweise außen am Gebäude angebracht wären.

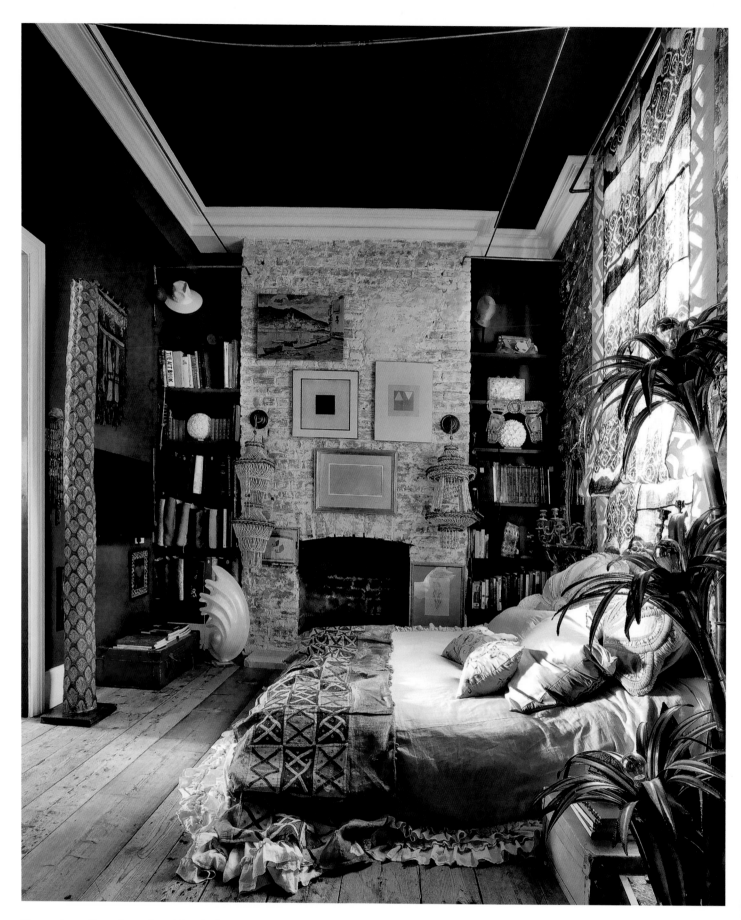

There is a fireplace in all of the rooms, where Sera burns frankincense.
"I get sent a packet every month from a friend. It's very dreamy and romantic."
--
In jedem Zimmer gibt es einen Kamin, in dem Sera Weihrauch abbrennt.
"Ein Freund schickt mir jeden Monat eine Packung. Das ist sehr verträumt und romantisch."

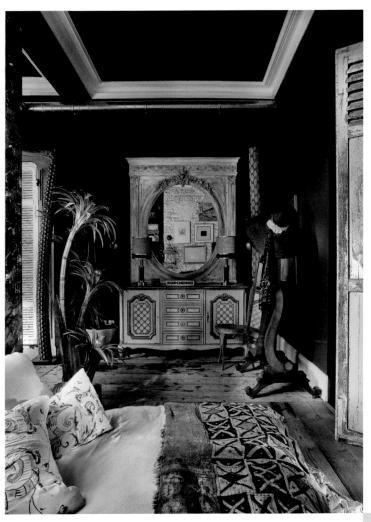

Bedroom

"I found the vintage Chinese wallpaper in a
market. The Chinoiserie print is almost 3-D. The
cornice is white. The chimney I've stripped back
to the brickwork, and there are bookcases on
either side of the chimney. On the other side of
the space, there's a really beautiful 1930s Italian
cabinet with a large antique mirror on top and
the 1970s brass palm tree lamp by my bedside is
by the American lighting designers Curtis Jeré."

Schlafzimmer

„Die chinesische Vintage-Tapete habe ich auf
einem Markt gefunden." Der Chinoiserie-Druck
ist fast dreidimensional. Das Gesims ist weiß.
Den Kamin habe ich bis auf das Mauerwerk
freigelegt und links und rechts davon Regale
eingebaut. Gegenüber steht eine sehr schöne
italienische Kommode aus den 1930ern mit
einem großen antiken Spiegel. Die Messing-
Palmenlampe aus den 1970er-Jahren neben dem
Bett wurde von dem amerikanischen Designer-
Kollektiv Curtis Jeré entworfen."

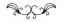

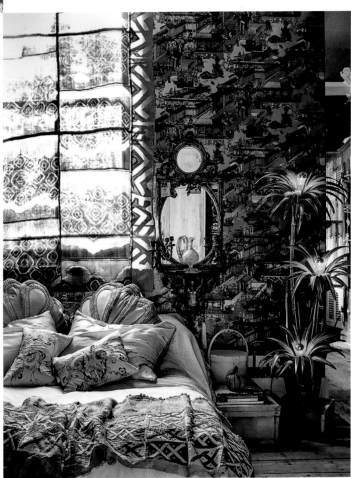

Bathroom

"The black-and-white chevron tiles are handmade by my ceramicist. We wanted it to look as though they had always been there. There's a 1930s sink and a Victorian black lace curtain on the window. Where the shower is, there's an Art Deco dressing screen. It's not very practical, but it looks pretty. I've used the shell lamp and accessories to soften the monochrome scheme. Overhead lighting is banished—even if it's a chandelier. It gives too harsh a light without any shadows or mystery."

Badezimmer

„Die schwarzweißen Chevron-Fliesen wurden von meinem Keramiker handgemacht. Wir wollten, dass sie so aussehen, als wären sie schon immer da gewesen. Es gibt ein Spülbecken aus den 1930er-Jahren und vor dem Fenster eine schwarze viktorianische Spitzengardine. Vor der Dusche steht ein Art-déco-Paravent – nicht sehr praktisch, aber hübsch. Mit der Muschellampe und den Accessoires habe ich das monochrome Farbschema aufgelockert. Oberlichter sind bei mir streng verboten, sogar in Form von Kristalllüstern. Sie geben ein zu hartes Licht ohne Schatten oder etwas Geheimnisvollem."

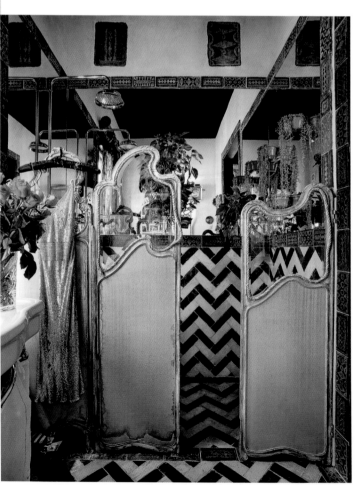

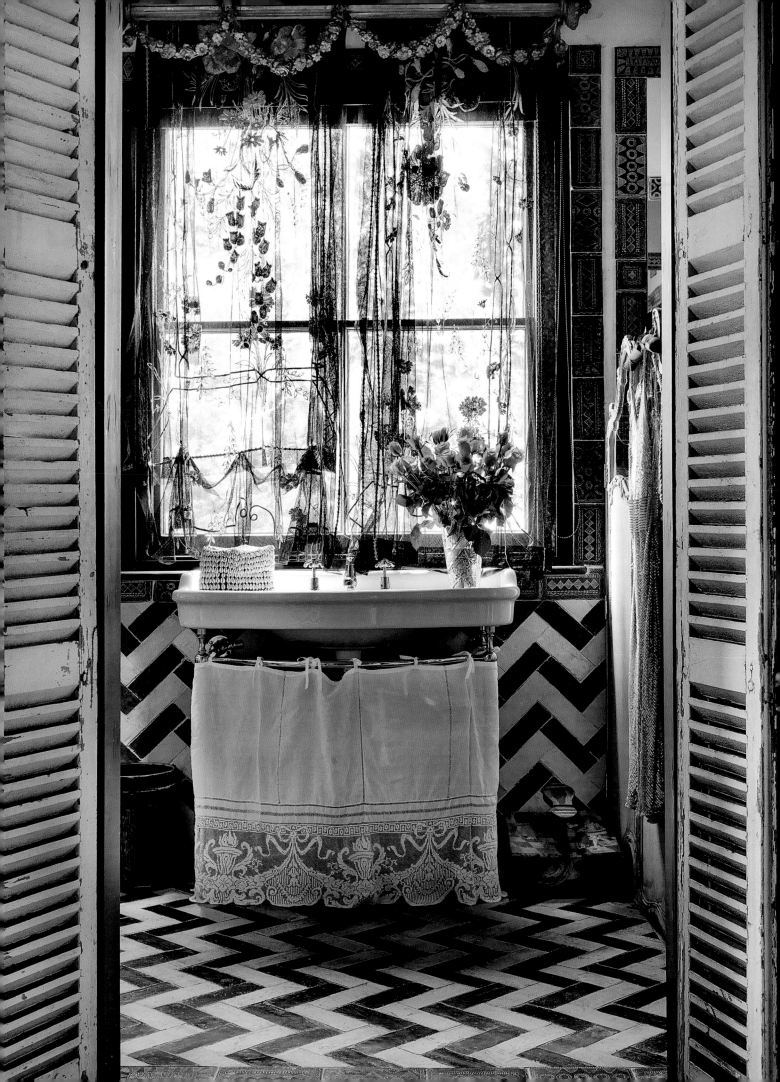

Sera's golden rules for
LIVING WITH PLANTS

1. I like to create clusters of plants in a corner with large plant in the back, such as a large fatsia, a pair of cheese plants in front, and then a smaller plant in the middle. I always think that to create an impact, you need a lot of something.

2. Plants, such as ferns, look good on either side of the sofa. I put them in really interesting antique pots with a table light alongside.

3. Lighting is important. I like to backlit my plants so that the reflections of the leaves go on the ceiling, giving a really romantic effect.

4. Every morning I water the plants. It's quite cathartic. It's a ritual I do each day—some people do yoga; I go round and water my plants with my coffee. Some plants need more water than others. For plants that need a little less attention, choose Dicksonia plants, which are so hardy you only need to water them once a week.

5. Don't have expectations that are too high when you bring an outdoor plant such as a hosta or hollyhocks indoors. As soon as you see it waning a bit, take it back outside.

Seras goldene Regeln für
DAS LEBEN MIT PFLANZEN

1. Ich gruppiere Pflanzen gern in einer Ecke: eine große Pflanze wie zum Beispiel eine Zimmeraralie hinten, zwei Köstliche Fensterblätter vorne und eine kleinere Pflanze in der Mitte. Ich finde, man braucht viel von etwas, um eine Wirkung zu erzielen.

2. Pflanzen wie Farne können ein Sofa schön an beiden Seiten flankieren. Ich stecke sie in interessante antike Übertöpfe und platziere eine Tischlampe daneben.

3. Licht ist wichtig. Ich beleuchte meine Pflanzen gern von unten, sodass sie Schatten auf die Decke werfen. Das sieht sehr romantisch aus.

4. Ich gieße meine Pflanzen jeden Morgen. Das ist ziemlich kathartisch und ein tägliches Ritual für mich. Manche Menschen machen Yoga, ich wässere meine Pflanzen, während ich Kaffee trinke. Manche Pflanzen brauchen mehr Wasser als andere. Taschenfarne sind so genügsam, dass man sie nur einmal pro Woche gießen muss.

5. Haben Sie keine zu hohen Erwartungen, wenn Sie Außengewächse wie Funkien oder Stockrosen nach drinnen bringen. Stellen Sie sie wieder raus, sobald sie zu welken anfangen.

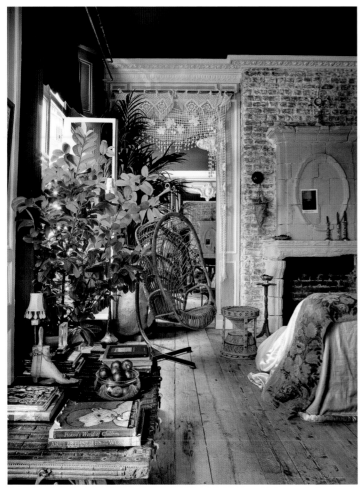

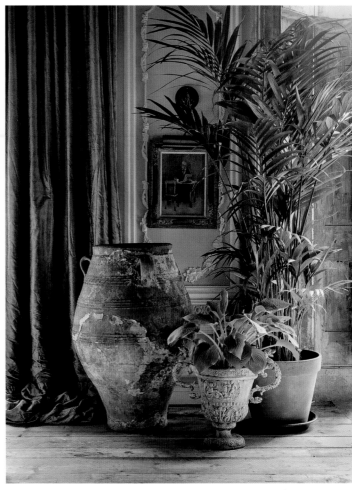

MY HOME TRUTHS

MEINE WOHN-WEISHEITEN

My style is how I like to live, very relaxed, unpretentious, and with a kind of romantic, Bohemian feel. I don't like any formality. That's how I like to live, so that's how my interiors get translated.

Mein Wohnstil entspricht der Art, wie ich leben möchte: sehr entspannt, unprätentiös und in einer romantischen, unkonventionell-künstlerischen Atmosphäre. Ich mag keine Förmlichkeiten.

Lighting is one of the most important things for me. I never use overhead lighting for example. I only ever use table lighting, up-lit plants, low level wall lighting and then candles, open fires, and all of those kinds of things.

Die Beleuchtung ist für mich einer der wichtigsten Aspekte. Ich verwende zum Beispiel nie Oberlichter, sondern setze nur Tischlampen und niedrige Wandleuchten ein und beleuchte Pflanzen von unten. Und dann gibt es natürlich noch Kerzen, offene Kaminfeuer und so weiter.

A dream project would be a really lovely hotel. I would do it exactly like I would anybody's home—a really lovely Bohemian home. It would be lush, comfortable, sexy, and romantic.

Mein Traumprojekt wäre ein wunderschönes Hotel. Ich würde es wie ein romantisch-künstlerisches Zuhause einrichten. Es wäre üppig, gemütlich, sexy und romantisch.

COUTURE
REVIVAL

With polished resin walls and upcycled furniture, this enchanting Italian villa on the edge of Lake Como demonstrates a homeowners' passion for giving old things a new lease of life.

Beautiful materials, an artist's palette, and a keen eye for reviving vintage finds are key to producing the raw, yet classic look of this majestic villa on the Swiss-Italian borders. Villa Pisani Dossi is home to Serbian furniture designer Draga Obradovic and her German husband, artist Aurel K. Basedow, who playfully put together tough elements such as resin-rendered walls and megalithic tables with delicate, refined pieces like the antique chandeliers and soft leather chairs.

A restored 19th-century villa, the talented couple has transformed the space into an individual style, dreaming up an interior that effortlessly mixes the rough with the smooth, the old with the new. In Draga's own words, it is the antithesis of luxury. "We wanted to find beauty where you least expect to see it," she explains. "We use a lot of secondhand furniture in our designs—a chair, a table—and part of our design process is undressing the pieces to discover how wonderful they were originally made. We like to reveal the beauty of what's hidden underneath."

For the couple, the house was love at first sight. High ceilings and period details such as the huge, arched windows and the glazed internal doors that you can see through from one room to the next sold the property to Draga and Aurel on the spot. As you walk up the staircase from the entrance on the ground floor—the main living space is upstairs—a gallery of empty picture frames introduces you to their distinctive personalities and passion for reinventing tired vintage finds.

Upcycling, or in some cases de-cycling, pieces from various periods of style, there is an endless game of deconstructing, matching, and generally figuring things out. Each piece of furniture has its own story to tell: the 1950s Umberto Mascagni swivel chairs in the dining room have been reupholstered by Draga in smart polka dots; the antique bed in their daughter's room has been revamped with a colorful patchwork headboard. Be it a striped fresco on the walls, a revamped mid-century chair, or a magical green and blue palette throughout, the decoration reflects the

couple's interests and their inquisitive approach to life. "We wanted to invoke a kind of dreamy romanticism, and then offset it with a twist of real-world modernity," says Draga. "For us, the house combines the warmth of a family home with the creativity of a designer's showroom."

The building reveals spacious living areas that showcase Draga and Aurel's art and creative ideas. In the dining room, a group of antique chandeliers are clustered together to make a dramatic focal point over the table. In terms of materials, resin plays a strong role—it is liquid-like and glossy on tabletops, or on the walls it has an opaque matte finish, much like colored concrete. "I love the contrast between the worn out interior and the glossy items," explains Draga. "This, with the addition of our hand-painted fabric, I feel there is a lot of personality. In the past, the house was gray and dark, so we introduced lots of color to make it feel more joyful and relaxed. It's very peaceful here; it also represents our characters and point of view."

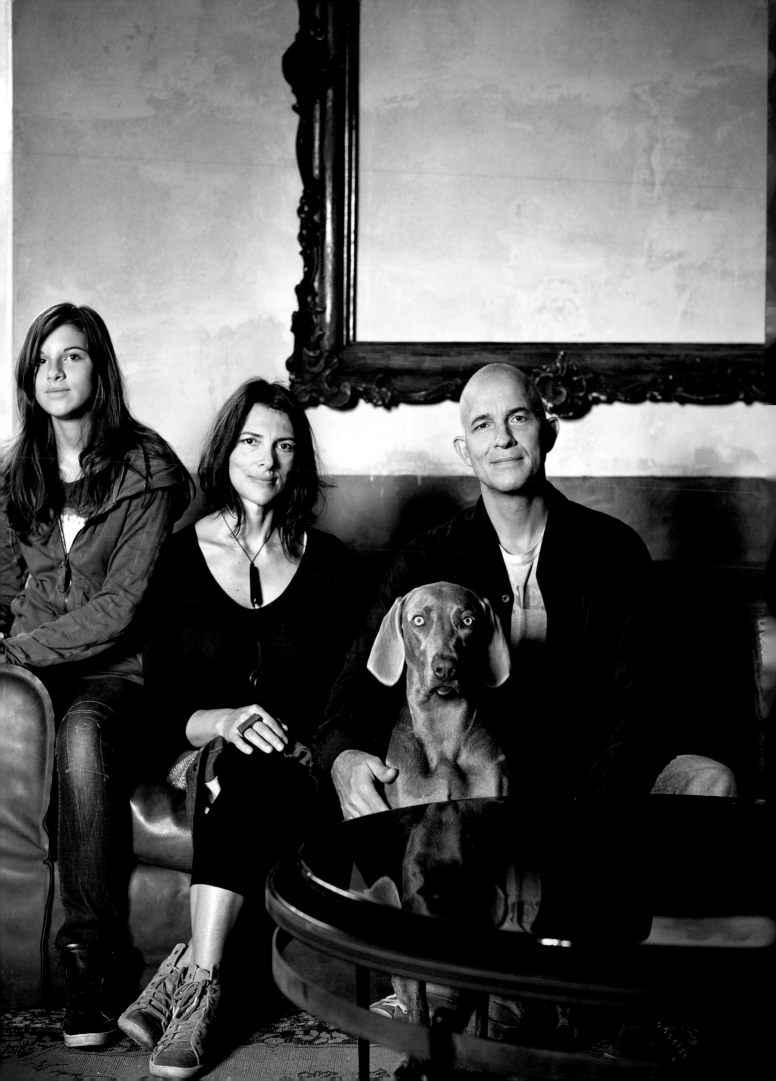

UPCYCLING IST TRUMPF

Mit ihren polierten Harzwänden und den aufgepeppten
Vintage-Möbeln reflektiert diese bezaubernde italienische
Villa am Comer See die Lust ihrer Besitzer, alten Dingen
neues Leben einzuhauchen.

Wunderschöne Materialien, eine künstlerische Ader und ein gutes Auge für Vintage-Fundstücke sind der Schlüssel zum rauen und gleichzeitig klassischen Look dieser prächtigen alten Villa an der Grenze zwischen Italien und der Schweiz. In der Villa Pisani Dossi leben die serbische Möbeldesignerin Draga Obradovic und ihr deutscher Mann, der Künstler Aurel K. Basedow. Spielerisch hat das Paar eher grobe Elemente wie harzverputzte Wände und megalithische Tische mit zierlichen, fein gearbeiteten Stücken, wie den antiken Kronleuchtern und weichen Lederstühlen, kombiniert.

Draga und Aurel haben dem Interieur der restaurierten Villa aus dem 19. Jahrhundert ihren Stempel aufgedrückt – mit einem eigenen, einzigartigen Stil, der Raues und Poliertes, Altes und Neues mischt. Draga sieht darin die Antithese von Luxus. „Wir wollten Schönheit dort finden, wo man sie am wenigsten erwartet", erklärt sie. „Wir richten immer mit vielen Secondhandmöbeln ein – Stühle, Tische – und zu unserem Designprozess gehört es, die Stücke auseinanderzunehmen, um zu sehen, wie wunderbar sie hergestellt wurden. Wir legen die verborgene Schönheit frei."

Das Haus war für die beiden Liebe auf den ersten Blick. Vor allem die hohen Decken, die riesigen Bogenfenster und die verglasten Innentüren, die von einem Raum zum anderen blicken lassen, hatten es ihnen sofort angetan. Die Treppe zum Hauptwohnbereich im ersten Stock führt an einer Galerie von leeren Bilderrahmen vorbei – ein erstes Anzeichen für die Leidenschaft der Besitzer, Flohmarktfunde neu zu erfinden.

Das Upcycling von Gegenständen ist ein endloses Spiel, bei dem man dekonstruiert, neu zusammenstellt und generell viel ausprobiert und kombiniert. Jedes Möbelstück erzählt seine eigene Geschichte: Die Drehstühle von Umberto Mascagni aus den 1950er-Jahren wurden von Draga mit einem smarten Pünktchenstoff neu bezogen; das antike Bett im Zimmer ihrer Tochter wurde mit einem bunten Patchwork-Kopfteil aufgepeppt. Ob es nun das gestreifte Wandfries ist, ein aufgearbeiteter Sessel aus der Mitte des 20. Jahrhunderts oder die magischen Grün-Blau-Schattierungen, die sich durchs ganze Haus ziehen: Das Dekor verrät die Interessen des Paares und ihre neugierige Lebenseinstellung. „Wir wollten eine Art verträumter Romantik

heraufbeschwören und diese dann mit einem Schuss realistischer Modernität kontrastieren", sagt Draga. „Für uns verbindet das Haus die Wärme einer Familien-Behausung mit der Kreativität eines Designer-Showrooms."

Das Gebäude birgt geräumige Wohnbereiche, in denen Dragas und Aurels Kunst und kreative Ideen Platz finden. Im Esszimmer wurden mehrere antike Kristalllüster zusammen gruppiert, die über dem Tisch einen dramatischen Blickfang bilden. Beim Material spielt Harz eine große Rolle – auf Tischoberflächen ist er glänzend und wirkt fast flüssig, an der Wand ist der Effekt eher matt, wie bei farbigem Beton. „Ich liebe den Kontrast zwischen abgenutzten und glänzenden Elementen", erklärt Draga. „Das verströmt, zusammen mit unseren handbemalten Stoffen, viel Persönlichkeit. Früher war das Haus grau und dunkel. Also brachten wir viel Farbe ins Spiel, um die Atmosphäre fröhlicher und entspannter zu gestalten. Es ist sehr friedlich hier. Die Einrichtung spiegelt unsere Charaktere und unsere Lebenseinstellung wider."

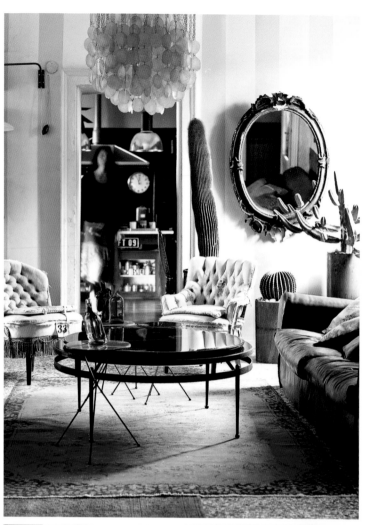

Living Room

"In the living room, there is a large empty frame on the wall. We like paintings without frames, and we love frames without paintings. We wanted to frame the surface of the wall as we felt it was worth looking at. It deserved it. Also, the stripes on the wall are not painted. They are a resin coating, which we applied to the walls. They have an incredible impact because they are not precise and change color with the light."

Wohnzimmer

„Im Wohnzimmer hängt ein großer leerer Rahmen an der Wand. Wir lieben Bilder ohne Rahmen und Rahmen ohne Bilder. Wir wollten die Wandoberfläche einrahmen, weil wir finden, dass sie es wert ist, betrachtet zu werden. Die Streifen an der Wand sind nicht gemalt, sondern von uns aufgetragene Harzschichtbahnen. Diese Harzstreifen entfalten eine enorme Wirkung, weil sie nicht ganz exakt gerade sind und je nach Licht changieren."

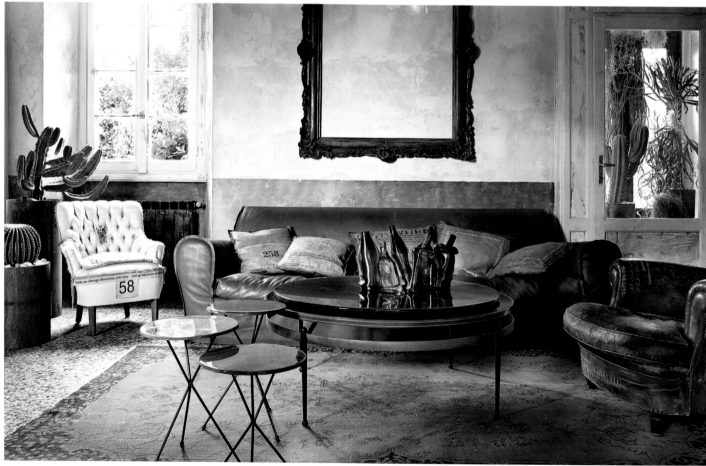

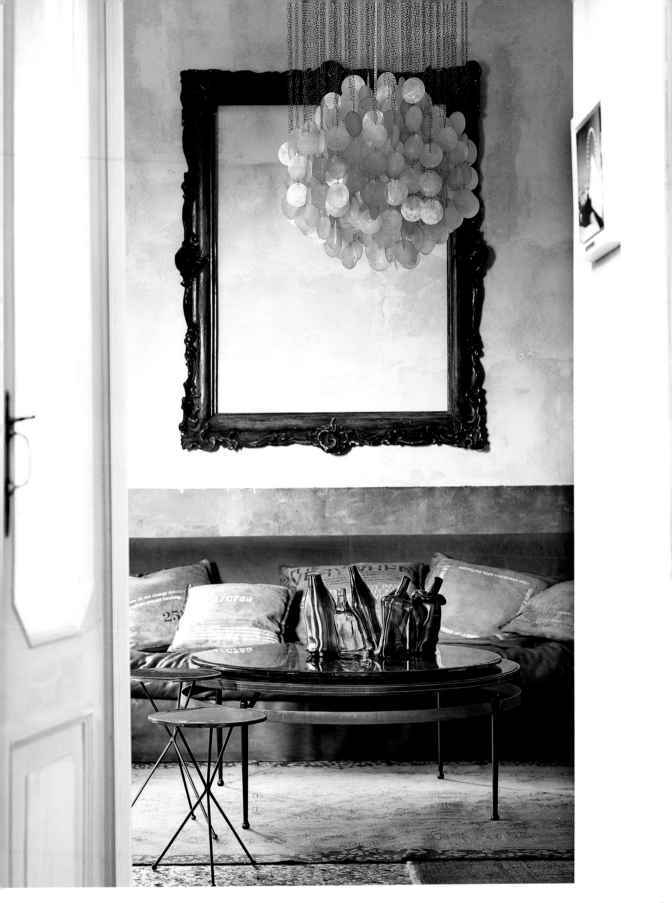

The layered turquoise rugs, leather sofa, and vintage chandelier are all from the Italian furniture brand Baxter, who the couple create unique pieces for. "The overlapping of the rugs is part of our playing with color and form," says Draga. "They are like the green side tables, which crisscross over one and other. We like layers."

--

Die mehrlagigen türkisfarbenen Teppiche, das Ledersofa und der alte Kronleuchter stammen alle von der italienischen Möbelmarke Baxter, für die das Paar einzigartige Stücke entwirft. "Dass sich die Teppiche überlappen, gehört zu unserem Form- und Farbenspiel", sagt Draga. "So wie die grünen Beistelltischchen, die auch etwas ineinander geschoben sind. Wir mögen Schichten."

Dining Room

"We were initially attracted to the house because of the large arched windows and the 1930s cement tiled floor. There are lots of period features, which we love—also, items such as the chandeliers all came with the house. We wanted to bring them all together to create a focal point in the room. The resin-coated table is one of our designs, and the 1950s dining chairs by Umberto Mascagni add an unexpected and playful touch."

Esszimmer

„Was uns an dem Haus sofort begeisterte, waren die großen Bogenfenster und die Beton-Bodenfliesen aus den 1930er-Jahren. Es gibt hier viele historische Elemente, die wir lieben. Einige davon, wie zum Beispiel die Kristalllüster, waren bereits im Haus. Wir haben sie zusammen gruppiert, um einen Raummittelpunkt zu erschaffen. Den harzbeschichteten Tisch haben wir entworfen, die Stühle von Umberto Mascagni aus den 1950ern geben dem Ganzen eine unerwartet verspielte Note."

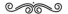

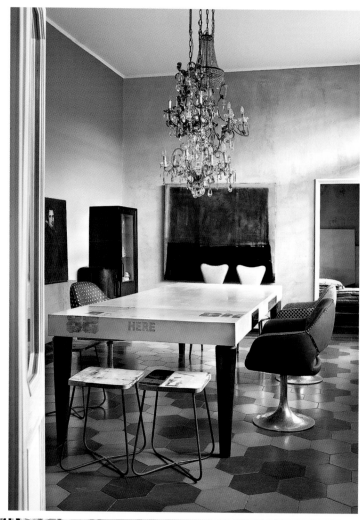

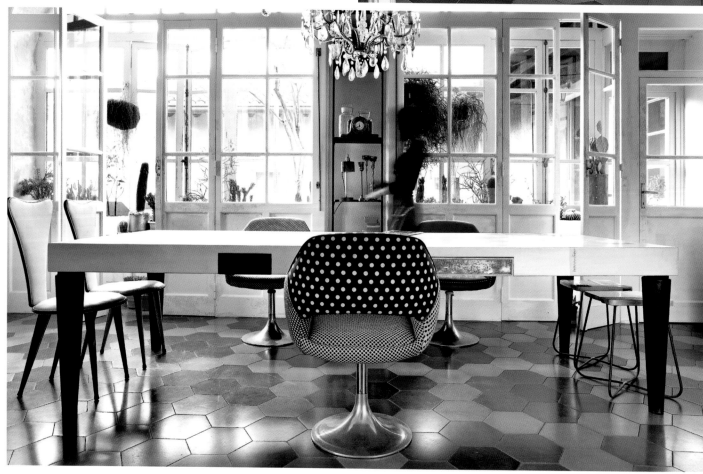

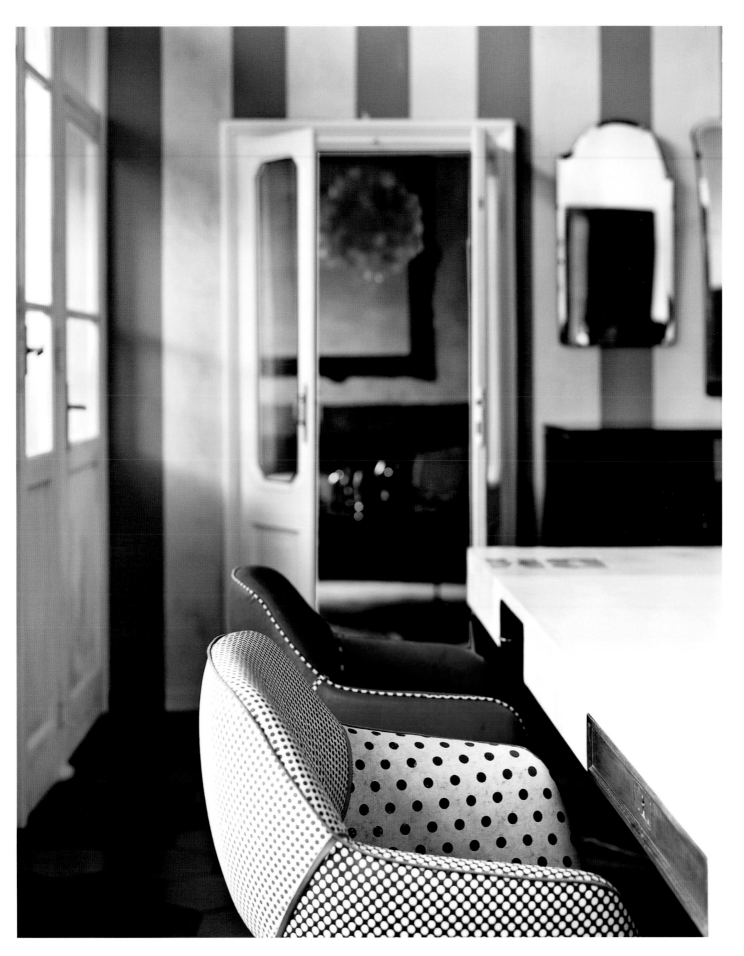

The contrasting polka-dot chairs show Draga's sense of freedom and fun.
--
Die unterschiedlich gepunkteten Stühle demonstrieren Dragas Sinn für Freiheit und Spaß.

Kitchen

"There was an incredible marble sink in the
kitchen, so we tried to follow this feeling
of luxury mixed with a utilitarian touch.
Everything was already in place—the units and
the floor—but we painted the walls and cabinets
dark. The drum shades, old metal drawers, and
the vintage wood dresser add to the industrial
feel. We upcycled the old metal table with a
glossy resin top."

Küche

„In der Küche gab es bereits dieses unglaubliche
Marmorbecken und wir haben versucht, diese
Kombination aus Luxus und Funktionalität
beizubehalten. Alles war schon an Ort und
Stelle – die Schrankeinheiten und der Boden –,
aber wir haben die Wände und Schrankfronten
dunkel angestrichen. Die Lampenschirme,
die alten Metallschubladen und die Vintage-
Holzkommode verströmen den Charme von
Industrial Design. Den alten Metalltisch haben
wir mit einer glänzenden Harzoberfläche
upgecycelt."

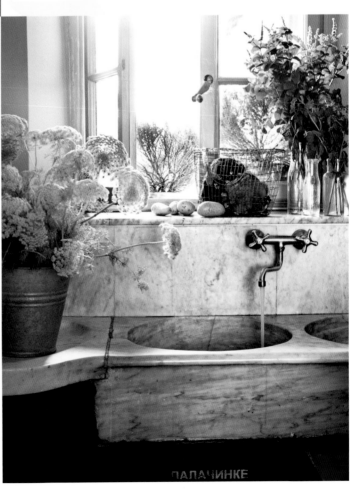

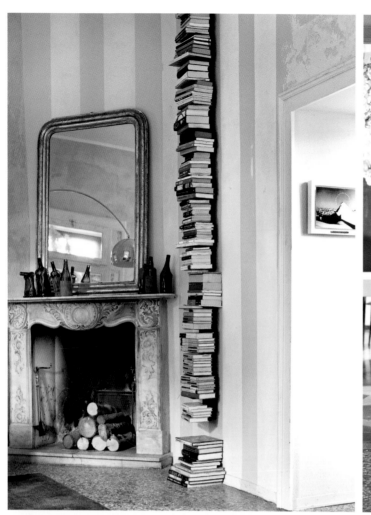

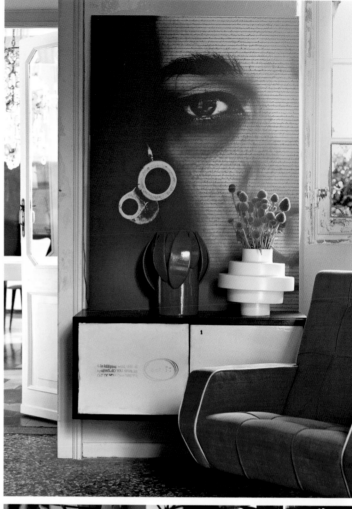

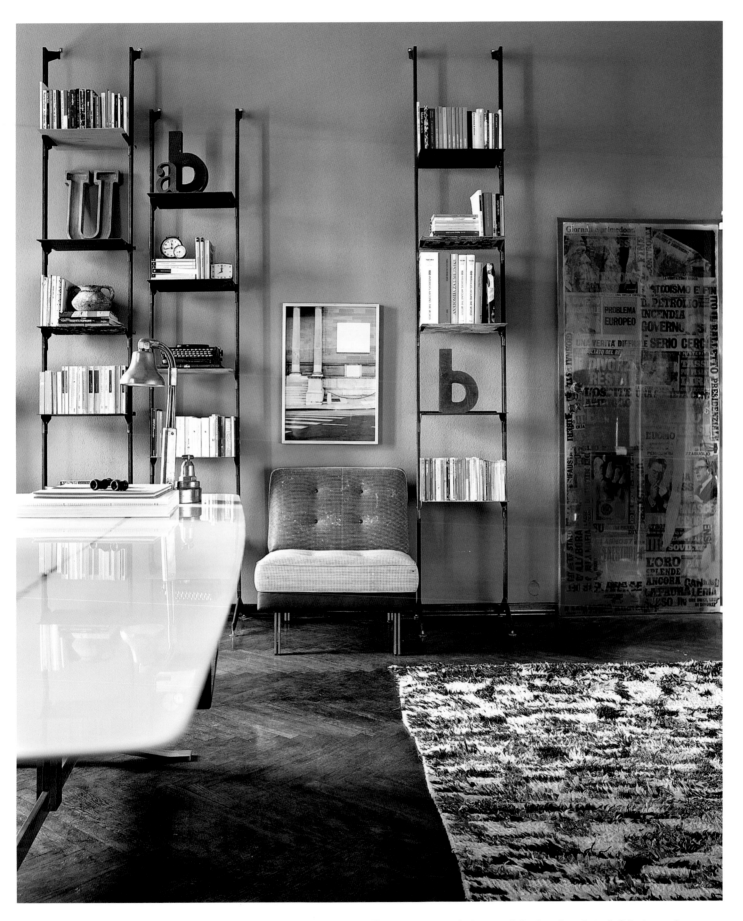

This smart space is made up of beautiful pieces such as a Knoll chair upholstered in hand-painted fabric and a gorgeous shag-pile rug.

--

Dieser smarte Arbeitsbereich wurde mit wunderschönen Teilen eingerichtet, zum Beispiel einem mit handbemaltem Stoff bezogenen Knoll-Stuhl und einem traumhaften Flokati-Teppich.

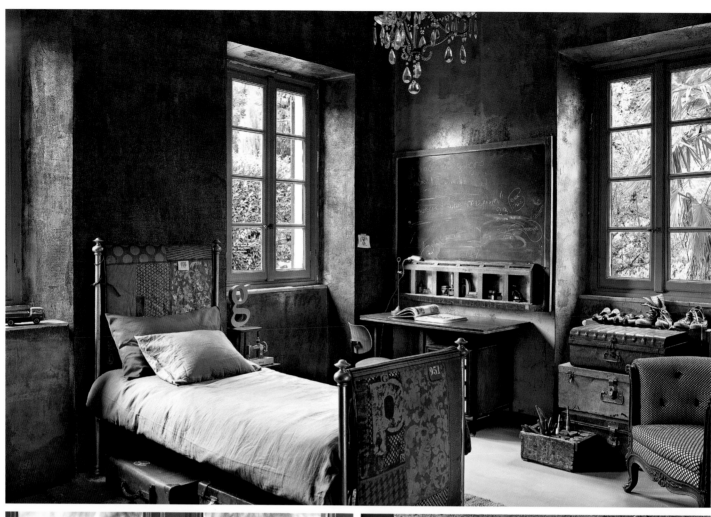

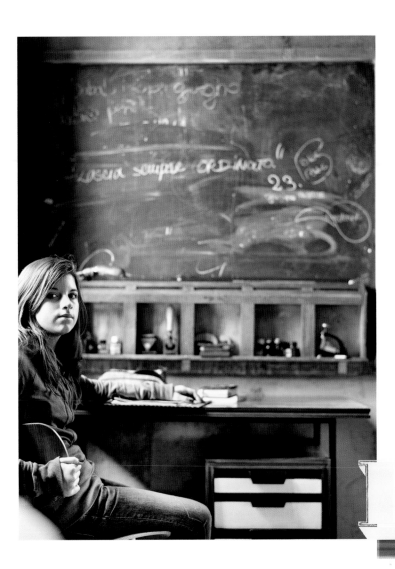

Daughter's Bedroom

"We updated our daughter's bed with a patchwork of hand-painted fabrics of our own design. We like to give old pieces of furniture a new identity, and the softness of the fabric made the bed feel cozier than before. The color scheme in the room is a dark blue, which feels deep and profound. As there are so many windows, it is actually quite a bright room so we were able to go dark."

Zimmer der Tochter

„Das Bett unserer Tochter haben wir mit einem Patchwork aus selbstentworfenen handbemalten Stoffen modernisiert. Die Weichheit der Stoffe macht das Bett gemütlicher als vorher. Wir verpassen alten Möbeln gern eine neue Identität. Das Farbschema des Raums basiert auf Dunkelblau, was sich tiefgründig anfühlt. Wegen der vielen Fenster bekommt das Zimmer viel Tageslicht. Deshalb konnten wir eine dunkle Farbe wagen."

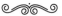

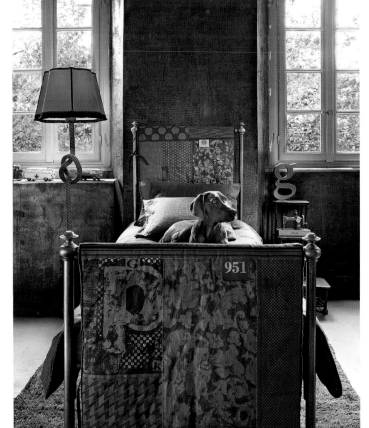

The vintage metal suitcases were found at a flea market, and the desk and side tables are by Paola Navone for Baxter.
--
Die Vintage-Metallkoffer stammen vom Flohmarkt, den Schreibtisch und die Beistelltischchen hat Paola Navone für Baxter entworfen.

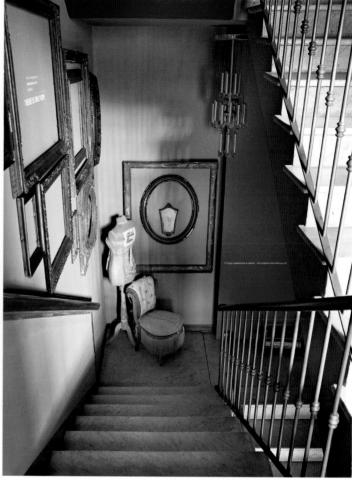

Draga's top tips for
MIXING THINGS UP

1. When it comes to combining patterns, take courage. Put all of your favorite materials in a box to see if they work together. If it works in the box, it will also work in the home.

2. To create a display with lots of impact, take one object and build a story around it with other things.

3. When I'm putting a look together, I always consider the balance. When something is hot, you need something cold. For instance, if there is a lot of wood (warm), gloss resin (cool) goes well. A vintage armchair (warm) matches a contemporary print (cool).

4. Learn to upcycle! By changing the context of a piece of furniture or fabric, you can make something new.

5. My motto is that beauty is in the eye of the beholder. If something is beautiful to you, then that is all that matters.

Dragas Top-Tipps, um Interieurs
AUFZUMISCHEN

1. Seien Sie mutig, wenn es um das Kombinieren von Mustern geht. Legen Sie Ihre Lieblingsmaterialien in eine Schachtel, um zu sehen, ob sie zusammenpassen. Wenn es in einer Schachtel funktioniert, tut es das auch daheim.

2. Nehmen Sie ein Objekt und konstruieren Sie mit anderen Dingen eine Geschichte drumherum — das erregt Aufsehen.

3. Wenn ich einen Look zusammenstelle, achte ich immer auf Ausgewogenheit. Wenn etwas heiß ist, braucht man etwas Kaltes. Zu viel Holz (warm) passt zum Beispiel eine Harzbeschichtung (kühl). Ein alter Sessel (warm) passt zu einem modernen Druck (kühl).

4. Lernen Sie die Kunst des Upcyclings! Sie können etwas Neues erschaffen, indem Sie den Kontext eines Stücks ändern.

5. Mein Motto lautet, dass Schönheit im Auge des Betrachters liegt. Wenn Sie etwas schön finden, ist das alles, was zählt.

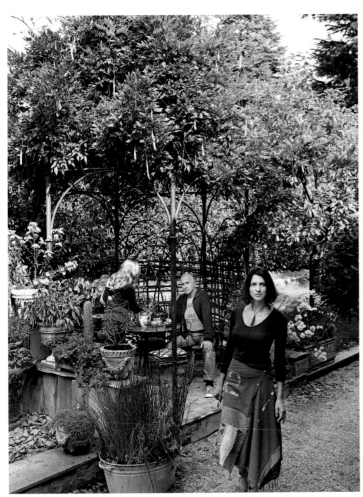

MY HOME TRUTHS

I would describe our style as eclectic. We upcycle
and rescue midcentury designs to create bespoke
furniture, each piece personalized with our layered,
screen printing technique.

My dream project would be to work on another boutique
hotel in Sicily, Sardenia, or Puglia. I love the
artisanal materials and atmosphere of southern Italy.

MEINE WOHN-WEISHEITEN

Ich würde unseren Stil als eklektisch bezeichnen.
Wir upcyceln und retten Designermöbel aus der Mitte
des 20. Jahrhunderts, um Möbel nach Maß anzufertigen.
Jedes Stück wird mit unserer eigenen Siebdrucktechnik
personalisiert.

Mein Traumprojekt wäre ein weiteres Boutiquehotel
auf Sizilien, Sardinien oder in Apulien. Ich liebe
die handwerklichen Materialien und die Atmosphäre
von Süditalien.

HOUSE OF
FUN

A playground for creative ideas, colorful details, and thrifty finds, this modern family home in Sweden is the essence of cool, Scandi chic.

Step-by-step Scandinavian Style is easy to do. Just kit yourself out with a Hans J. Wegner chair, Louis Poulsen light, and some Jacobsen mixer taps and tick those design icons off that list. What's harder to do is create a space that treats the rules with flagrant disregard, yet manages to combine old with new, classic with maverick in a way that perfectly expresses the personality of its owner.

Jenny Brandt has definitely got the knack: her countryside home in Skårby, a small village in the south of Sweden, is as coolly unexpected and full of playful delights as her shock of purple hair and passion for DM boots. It's a place where art, contemporary lighting, and upcycled furniture have been brought together, but every piece has been treated with the same irreverence with Verner Panton chairs sharing the same space as a Vita Copenhagen Eos light and also a neon dinosaur light—on floral wallpaper behind.

A gifted photographer and comprehensive style blogger, Jenny shares her home with illustrator hubby Jens, daughter Viola, and son Frank. Its not the architecture of the house but Jenny and Jens' own creative impulse that gives the interior its presence—you can see it in the vignettes assembled on every surface, such as the vintage dolls and action figures in the powder pink retro kitchen. It's there in the dining room, which Jenny had wallpapered with a floor-to-ceiling mural of her face. Turning the idea of minimal Scandinavian style on its head, this alternative Scandi home is free-spirited, bold, and full of colorful fun.

But this is only the latest of the home's incarnations. The couple is constantly rearranging and reinventing things in the space. They have painted their hallway eleven times, every time in another shade of yellow. Their current work-in-progress is the first floor landing where Jenny is creating a jungle gym for Saba, the family cat. "Our home is a never-ending make over," Jenny says. "It's constantly changing. As an interior photographer, I often photograph things in my own house, so there is a lot going on in every room. I hope people find it playful and inclusive."

The 1940s house is split over two floors with five rooms and one studio, where Jenny and Jens work. Jenny was attracted to the building's potential. "It was such a mess when we bought it," Jenny explains. "Lucky for us, no one else wanted it. There was nothing fancy or worth saving, so we could really start afresh." The studio—in Jenny's words, "a big, wooden box"—is a recent addition to the house, connected by a sliding door so they can keep an eye on the kids. "Or rather, they can keep an eye on us," laughs Jenny. "Before we had our studio, we sat at the kitchen table. It's such a drag having your work things—boxes, paperwork, 10,000 USB cords—mixed with your personal stuff. We now have the luxury of feeling as though we are 'going to work'."

The unconventional use of space is just another part of Jenny's contradictory style. She loves color—her favorite color combination is black and pink—but is also drawn to monochrome. There's a great attention to detail, but also a free-spirited feel. She insists she is not a collector ("...although I'm always hunting at flea markets"), but the house is crammed with beautiful things. "I think that the inside of my brain looks just like our home," smiles Jenny, which makes it is as beautiful on the inside, as it is on the out.

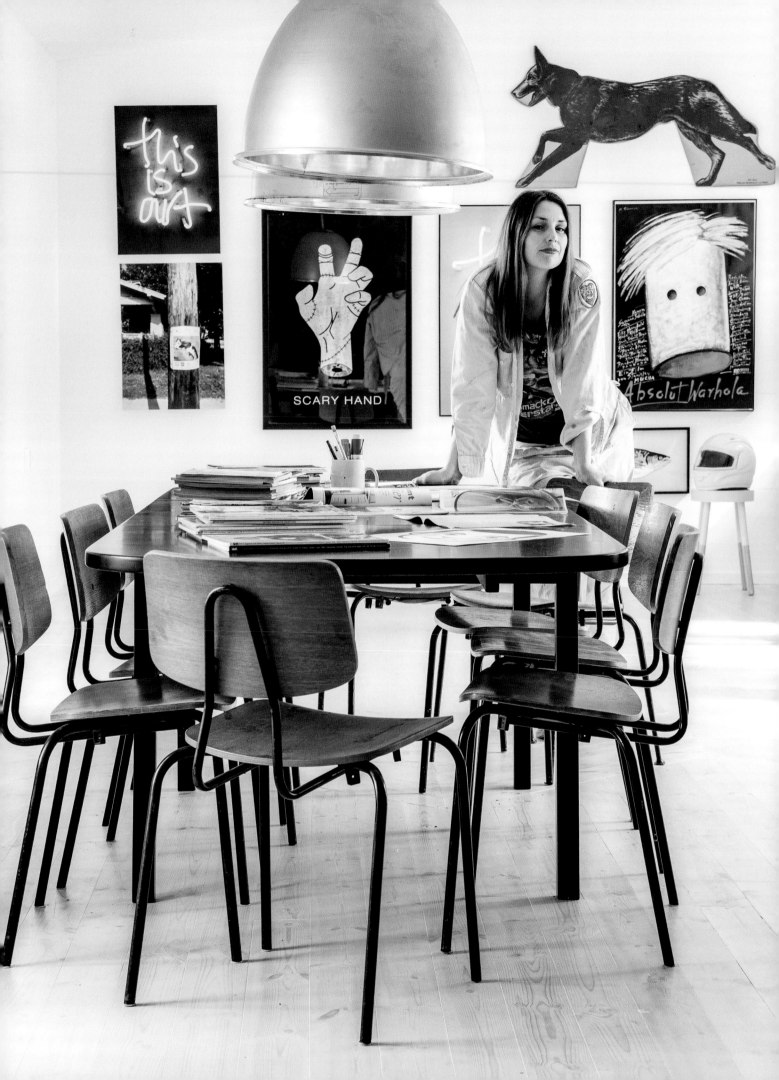

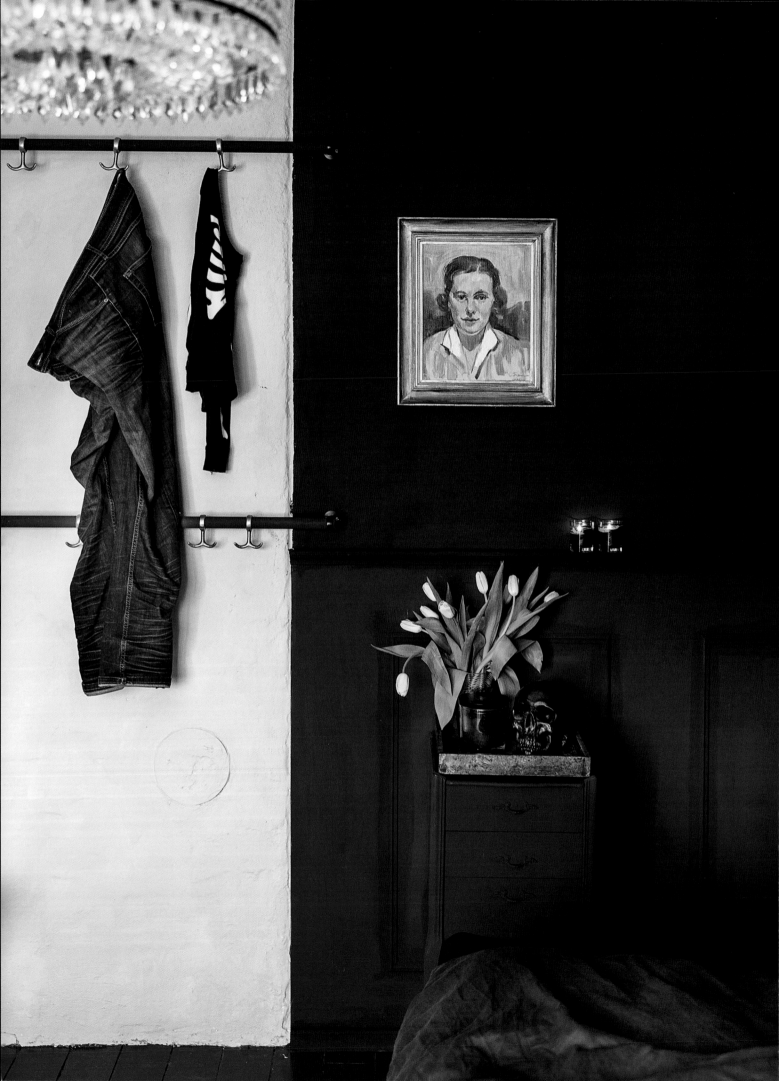

SPASS UND SPIEL

Ein Spielplatz für kreative Ideen, bunte Details und Flohmarktschnäppchen: Dieses moderne schwedische Zuhause sprüht vor Fantasie und verkörpert gleichzeitig den coolen Scandi-Chic.

Der skandinavische Stil lässt sich leicht kreieren: Sie brauchen nur ein paar Designklassiker wie einen Stuhl von Hans J. Wegner, eine Lampe von Louis Poulsen und ein paar Jacobsen-Mischbatterien und fertig ist der Look. Schwieriger ist es da schon, ein Interieur zu erzeugen, das die Regeln missachtet und es schafft, Altes mit Neuem, Klassiker mit ausgefallenen Unikaten so zu kombinieren, dass die Persönlichkeit der Bewohner sich in der Einrichtung widerspiegelt.

Jenny Brandt hat den Bogen raus. Ihr ländliches Domizil in Skårby, einem Dorf in Südschweden, ist so überraschend und verspielt wie ihr lila gefärbtes Haar und ihre Leidenschaft für Doc-Martens-Boots. Unter diesem Dach wurden Kunst, moderne Beleuchtung und aufgepeppte Vintage-Möbel vereint, wobei jedes Teil mit derselben Nonchalance behandelt wird: So leben die Stühle von Verner Panton und die Hängelampe Eos von Vita Copenhagen einträchtig Seite an Seite mit einer Blümchentapete und einem Dinosaurier-Neonlicht.

Die Fotografin und Style-Bloggerin Jenny teilt ihr Zuhause mit ihrem Mann, dem Illustrator Jens, sowie Tochter Viola und Sohn Frank. Nicht die Architektur des Hauses, sondern Jennys und Jens' kreativer Input verleiht dem Interieur seinen besonderen Charakter. Dieser manifestiert sich zum Beispiel in vielen kleinen Dekoobjekten wie den Vintage-Puppen und Actionfiguren in der rosafarbenen Retroküche. Oder der Tapete im Esszimmer, auf der ein überlebensgroßes Foto von Jennys Kopf prangt. Dieser alternative Scandi-Stil stellt den sonst so minimalen Look sozusagen auf den Kopf – er ist frei, verwegen und bunt.

Das jetzige Dekor ist jedoch nur die bisher letzte von vielen Inkarnationen, denn das Paar stellt ständig um und erfindet Dinge neu. Den Eingangsbereich haben sie bereits elf Mal gestrichen, jedes Mal in einem anderen Gelbton. Das aktuelle Projekt ist der Flur im ersten Stock, wo Jenny gerade einen Urwald-Parcours für Familienkatze Saba entwirft. „Unser Zuhause ist im permanenten Wandel", sagt Jenny. „Es verändert sich ständig. Ich fotografiere hier oft für meine Arbeit im Bereich Innenarchitektur, weshalb sich in jedem Zimmer ziemlich viel tut. Ich hoffe, es wirkt verspielt und zugänglich."

Das Haus aus den 1940er-Jahren bietet auf zwei Etagen fünf Zimmer und ein Atelier, wo Jenny und Jens arbeiten. Jenny begeisterte das Potenzial des Gebäudes. „Es war in einem schrecklichen Zustand, als wir es kauften", erzählt sie. „Glücklicherweise hatte niemand sonst Interesse daran. Es gab nichts Besonderes, was sich zu erhalten lohnte, wir konnten also von Grund auf neu starten." Das Atelier – in Jennys Worten „eine große Holzkiste" – wurde kürzlich angebaut und ist mit dem Rest des Hauses durch eine Schiebetür verbunden, sodass sie die Kinder im Auge behalten können. „Oder vielmehr können die uns im Auge behalten", scherzt Jenny. „Bevor wir das Atelier hatten, saßen wir immer am Küchentisch. Es ist total nervig, wenn die Arbeitsutensilien – Kartons, Papiere, 10.000 USB-Kabel – sich mit dem persönlichen Zeug vermischen. Jetzt haben wir den Luxus, uns so zu fühlen, als würden wir ‚zur Arbeit gehen'."

Die unkonventionelle Raumnutzung ist eine weitere Ausprägung von Jennys widersprüchlichem Stil. Sie liebt Farbe – ihre Lieblingsfarbkombination ist Schwarz und Pink –, fühlt sich aber auch zum Monochromen hingezogen. Hier herrscht viel Liebe zum Detail, aber auch eine anarchische Atmosphäre. Jenny besteht darauf, dass sie keine Sammlerin ist („... obwohl ich immer auf Flohmärkten herumstöbere"), aber das Haus ist mit hübschen Dingen vollgestopft. „Ich glaube, in meinem Hirn sieht es aus wie bei uns zu Hause", sagt Jenny mit einem Lächeln.

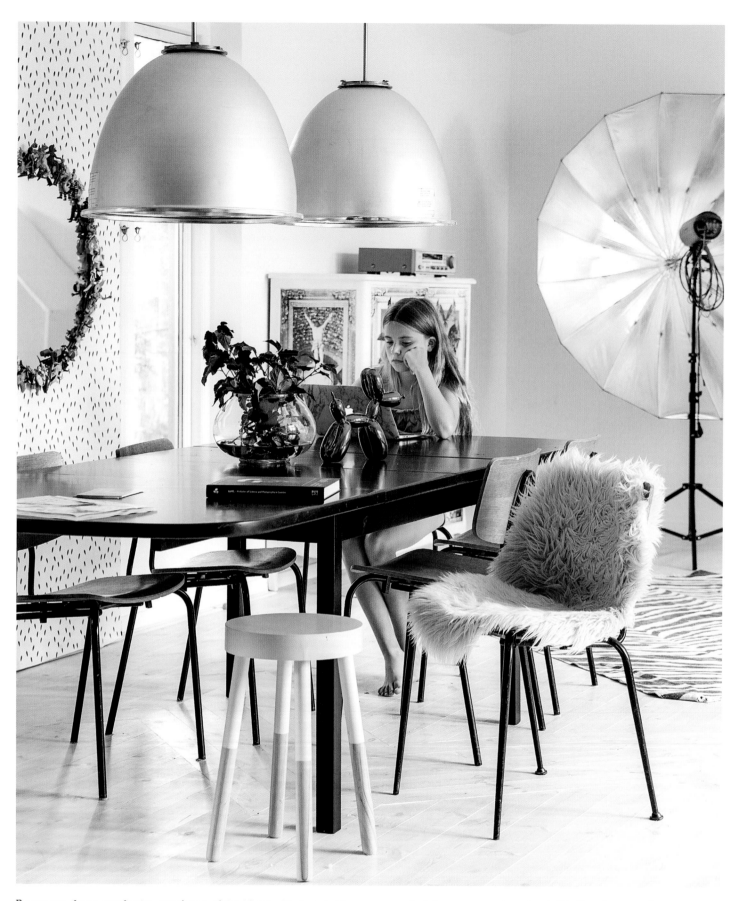

Enormous drum pendants overhang this black dining table, surrounded by an assortment of fluffy, bentwood, and painted chairs. A Jeff Koons Balloon Dog completes the look.

--

Riesige Hängelampen im Industrial Style beleuchten den schwarzen Esstisch, der von einer bunt zusammengewürfelten Sammlung aus flauschigen, Bugholz- und neu lackierten Stühlen vom Flohmarkt umgeben ist. Ein Ballonhund von Jeff Koons komplettiert den Look.

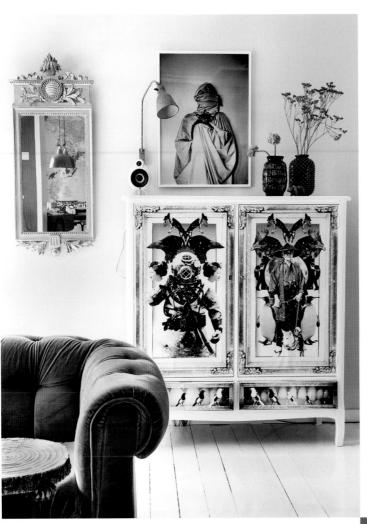

Living Room

"I'm drawn to the unexpected. The cabinet in our living room used to belong to my grandfather Sven. We keep our stereo, computer, and other cord-connected stuff in it. It used to be a really nice blue color, but it was quite beaten up. So we decided to redo it. Jens made the collages, which we printed on photographic paper and glued to the cabinet with wallpaper glue."

Wohnzimmer

„Mich zieht das Unerwartete an. Die Kommode im Wohnzimmer gehörte früher meinem Großvater Sven. Darin bewahren wir unsere Stereoanlage, Computer und andere Elektrogeräte auf. Die Kommode hatte früher eine hübsche blaue Farbe, war aber ziemlich heruntergekommen, weswegen wir beschlossen, sie neu aufzuarbeiten. Jens machte die Collagen, die wir auf Fotopapier druckten und dann mit Tapetenkleister an die Kommode klebten."

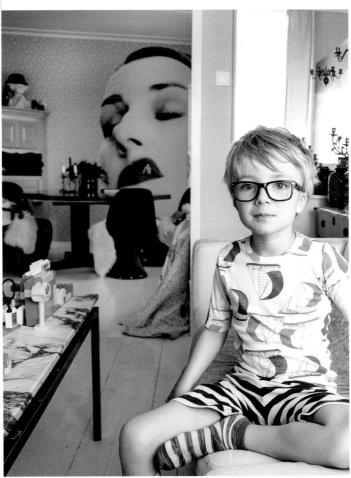

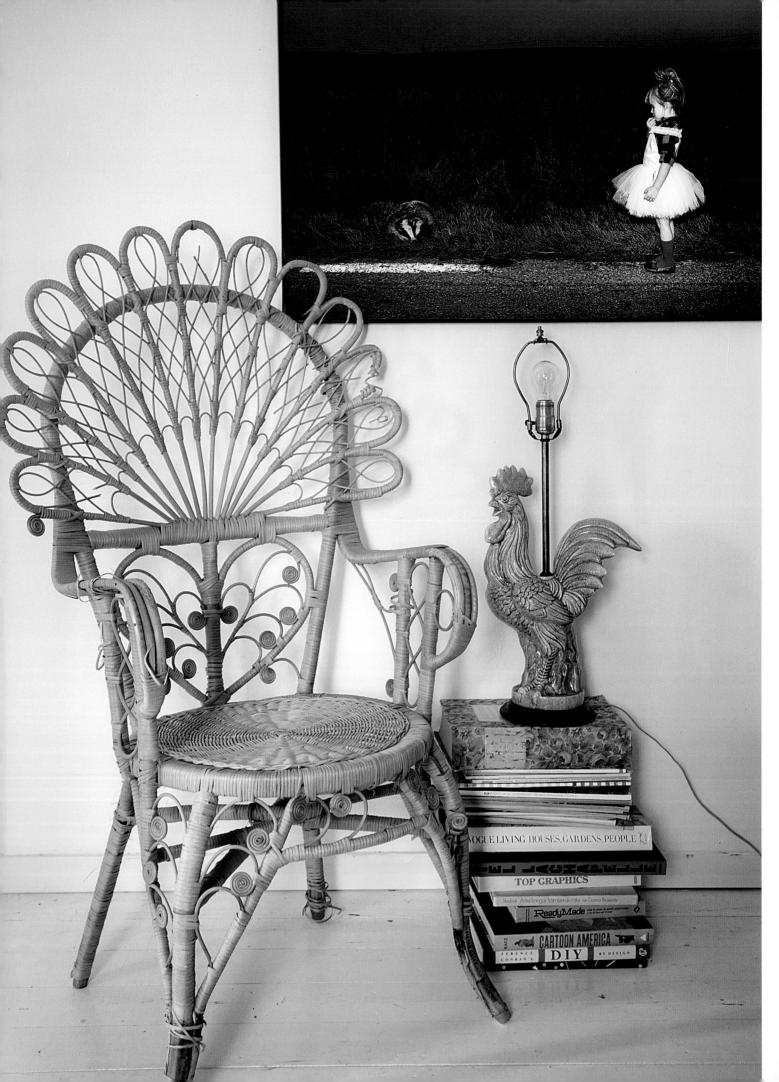

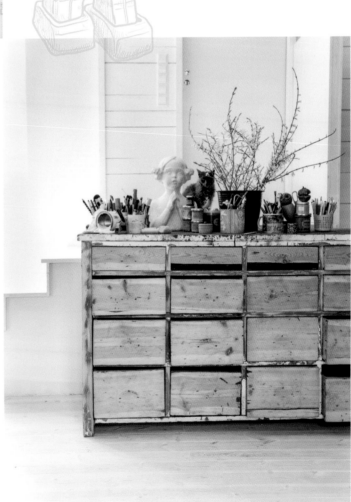

Everything in Jenny's home is ad hoc, from the canework Peacock chair to the rooster table lamp. A stack of books makes an impromptu coffee table.
--
Alles in Jennys Zuhause ist spontan und impulsiv platziert, von dem Pfauenthron aus Korb bis hin zur Hahnlampe. Ein Bücherstapel bildet einen provisorischen Coffee Table.

Dining Room

"I've had so many different tables for this room but now I think I've found the right one. I like the classical style and how it stands out from everything else in the room. Scandinavia is very dark, so the white floor helps. The mural is my face! It is from Mr Perswall who does customized wallpaper, as well as ready-to-buy wallpaper designs. The feather pendant is a Vita Copenhagen Eos light. I buy pretty much everything secondhand except for lamps and carpets. Those are my treats."

Esszimmer

„Ich hatte für dieses Zimmer schon so viele Tische, aber jetzt habe ich, glaube ich, endlich den richtigen gefunden. Ich mag seinen klassischen Stil und wie er den Raum dominiert. In Skandinavien ist es sehr dunkel, da hilft der weiße Boden. Das Wandbild ist mein Gesicht! Es stammt von der Firma Mr Perswall, die sowohl vor- als auch maßgefertigte Tapeten verkauft. Die Hängeleuchte aus Federn ist eine Eos von Vita Copenhagen. Ich kaufe so ziemlich alles secondhand außer Lampen und Teppichen. Die gönne ich mir neu."

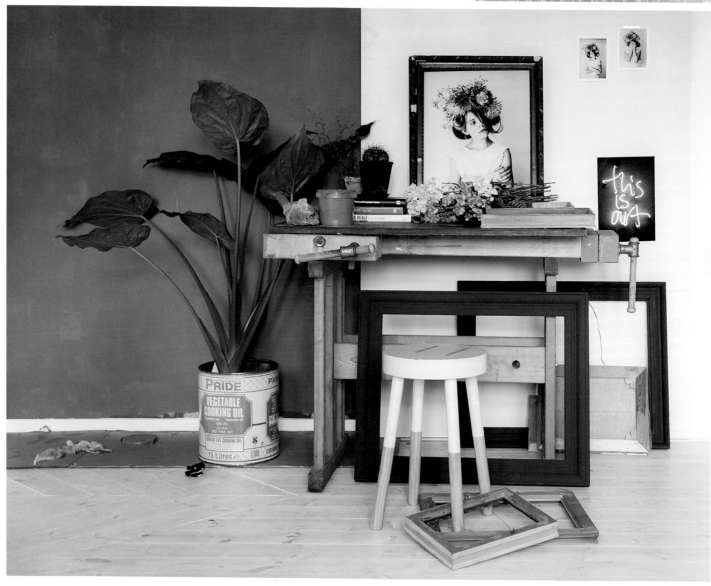

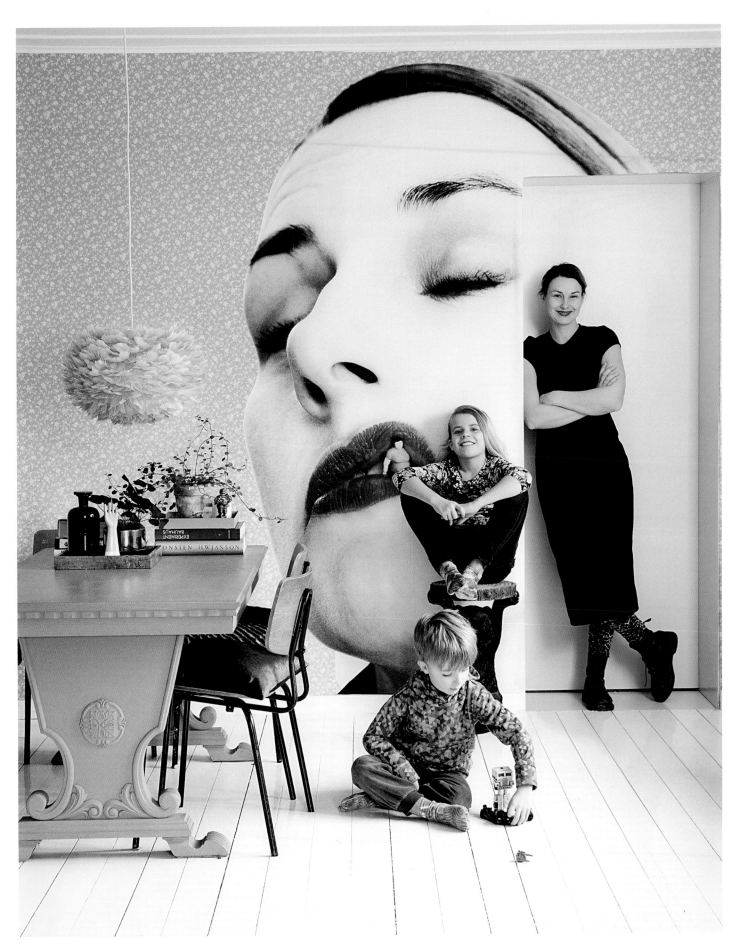

Jenny, Viola, and Frank at home in their white, pink, and floral wallpapered dining room.
--
Jenny, Viola und Frank in ihrem weiß, rosa und floral tapezierten Esszimmer.

Daughter's Bedroom

"The door is decorated with chalk paint and the doodles are my husband Jens'. One of the best things about this room is the climbing net on the ceiling. To my mind, a child's room doesn't have to match the rest of the house. I like to let them choose for themselves. Since a bed takes up so much room in a child's room, we wanted to add some storage underneath. My daughter is very creative. She makes short films and likes to draw."

Zimmer der Tochter

„Die Tür wurde von meinem Mann Jens mit Kreide bemalt. Eines der tollsten Dinge in diesem Zimmer ist das Kletternetz an der Decke. Ich finde, dass ein Kinderzimmer nicht zum Rest des Hauses passen muss. Ich lasse die Kinder gern selber auswählen.

Da ein Bett so viel Platz im Kinderzimmer einnimmt, wollten wir darunter Stauraum schaffen. Meine Tochter ist sehr kreativ. Sie macht Kurzfilme und zeichnet gern."

Kitchen

"This is a mix of old cabinets and a few new Ikea cabinets painted pink by my father who owns a car body paint shop. He has painted so many pieces of furniture for me over the years. I like to change the color of something, rather than buying new. We added a wooden floor, which we painted in one of my favorite color combinations, gray and pink."

Küche

„Unsere Küche ist eine Mischung aus alten Schränken und ein paar neuen Schränken von Ikea, die von meinem Vater, der eine Autolackierwerkstatt besitzt, rosa lackiert wurden. Er hat im Laufe der Jahre schon unzählige Möbelstücke für mich umlackiert. Ich verändere lieber die Farbe von einem Teil, als etwas Neues zu kaufen. Wir haben einen Holzdielenboden verlegt und ihn in einer meiner Lieblingsfarbkombis gestrichen: Grau und Rosa."

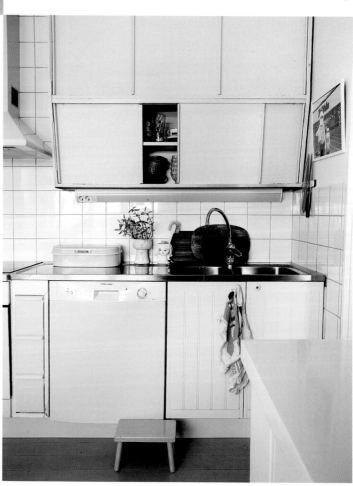

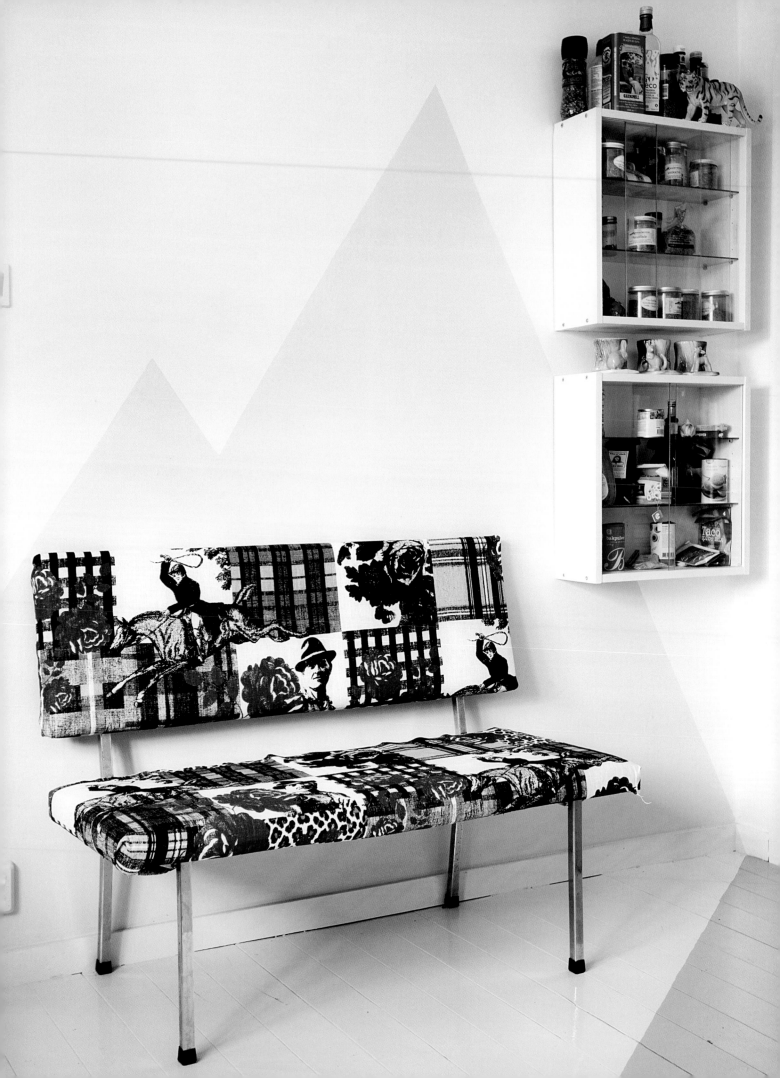

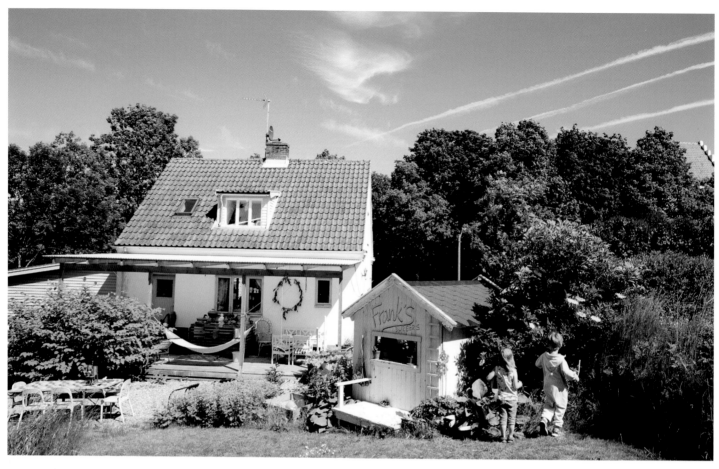

Jenny's golden rules of
DECORATING

1. My approach to decorating is not to think about it too much. Instead, let it just happen. "Far from perfect" is perfect to me.

2. Go vintage. It adds so much more personality to a room plus, it's wallet-friendly. Pretty much everything in my home is secondhand.

3. Since I decorate my house in thrifty ways, the one thing I do like to treat myself to is new lightning. I've bought so many lamps secondhand but never got around to fixing them, so they just sit in my basement waiting for new cords and sockets.

4. Get to know a local auto body painter. They can turn any old find into a glossy gem.

5. My approach to life is: don't take your home—or yourself—too seriously. It's just décor, so have a little fun.

Jennys goldene Regeln fürs
DEKORIEREN

1. Mein Motto beim Einrichten: Nicht zu viel darüber nachdenken, sondern es einfach geschehen lassen. "Nicht annährend perfekt" ist perfekt für mich.

2. Wählen Sie Vintage-Stücke. Sie verleihen jedem Raum so viel Charakter und schonen das Portemonnaie. Bei mir zu Hause ist so ziemlich alles secondhand.

3. Da ich bei den Möbeln spare, gönne ich mir neue Lampen. Ich habe zwar auch schon unzählige Secondhand-Lampen gekauft, aber die setzen nur im Keller Staub an, weil ich noch nicht dazu gekommen bin, ihnen neue Kabel und Fassungen zu verpassen.

4. Lernen Sie einen Autolackierer in der Umgebung kennen. Er kann jedes alte Fundstück in ein glänzendes Juwel verwandeln.

5. Mein Lebensmotto: Nehmen Sie Ihre Einrichtung — oder sich selbst — nicht zu ernst. Es ist doch nur Dekoration und sollte einfach Spaß machen.

MY HOME TRUTHS

MEINE WOHN-WEISHEITEN

I would describe my style as playful and unexpected. Kids usually like it a lot.

Even though I love my home, I would love to buy an all-wooden house in the middle of the forest. That is the dream.

Ich würde meinen Stil als verspielt und unerwartet beschreiben. Kindern gefällt er meistens sehr gut.

Obwohl ich mein jetziges Zuhause liebe, würde ich gerne ein Haus ganz aus Holz mitten im Wald kaufen. Das ist mein Traum.

PRETTY COOL

A bright, white interior is typically associated with a simple, modern living space but this English home shows how white can also be decorative, warm, and cozy.

Janet Parrella-van den Berg, a Dutch designer, stylist, and photographer, and her Swiss husband used to live in Switzerland before they decided to up sticks and move to this Edwardian four-bedroom home in the English countryside. The 1915 property was in need of a total makeover from a previous 1960s reincarnation, but it was the original period features in particular that were the main draw. "I hated everything about the house except for the tree in the garden," says Janet. "But I knew with my vision I could bring it back to its former glory given its high ceilings, original floors, and good bones."

The building is set on two floors, serves as a workspace for her online vintage boutique White & Faded (whiteandfaded.co.uk), and as a home for her husband and their five children. Inside, the all-white interior emphasizes the architectural details as well as being a showcase for the heirloom treasures Janet collects and sells around the world. The furnishings are a mix of vintage English, French, and Dutch pieces influenced from Janet's childhood and her parent's passion for antiques. From an early age, she remembers visiting antique markets, saving her pennies for Victorian dolls, old white-painted furniture, and lots of frilly lace. It is an obsession that still remains. "In my early teens I bought an antique washstand and painted it white," says Janet. "My father was quite shocked but I knew it was right. Little did I know this would be the start of my lifelong love for all things white."

A self-confessed romantic, the shabby chic interior reflects Janet's pared-back aesthetic and love for dishevelled things. "I call it relaxed elegance," she explains. "I love rescuing unloved pieces, which have the potential to be made beautiful again." Throughout her home, vintage cabinets, desks, and tables are combined with timeworn antique chairs—some with torn fabrics and springs hanging out of them. "The more weathered, tattered, and chipped, the more I like them," she says. The white walls and floor throughout the house exhibit these pieces perfectly. "There's a purity, peace, and tranquility in a white room," she explains. "To be creative, I need the calmness that white provides."

Where possible, every item that isn't antique is painted in a white antique wash or covered in white upholstery to match her favorite palette. "Many people think that an all-white interior is difficult to live with," she continues. "But that's not the case. White is easy to keep clean especially if you use washable wall paint and slip covers on your furniture. And you can avoid things looking too clinical by adding texture and warmth with cushions, rugs, and quilts as I've done."

The walls are white, floors are white, and the furniture is white—in many varied shades of white—yet the mood is far from cold. It feels peaceful and cozy. "I don't mind a bit of wear and tear," smiles Janet. "I grew up in a home where all the furniture was museum-like quality. This feels more relaxed."

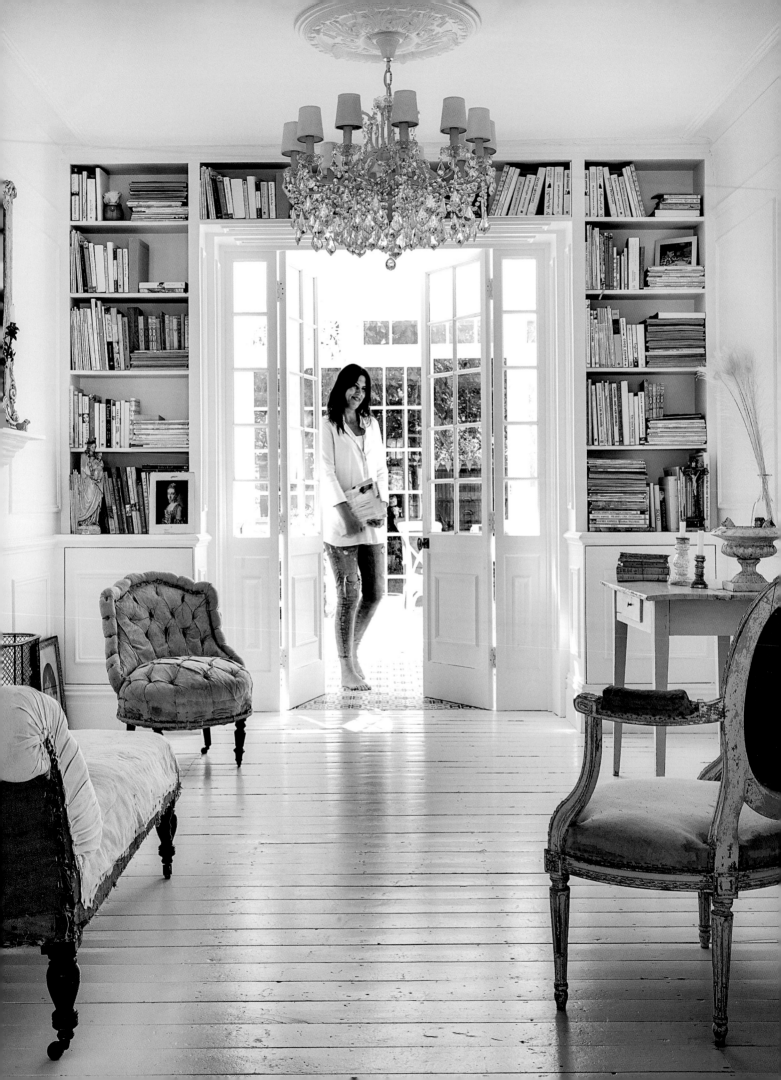

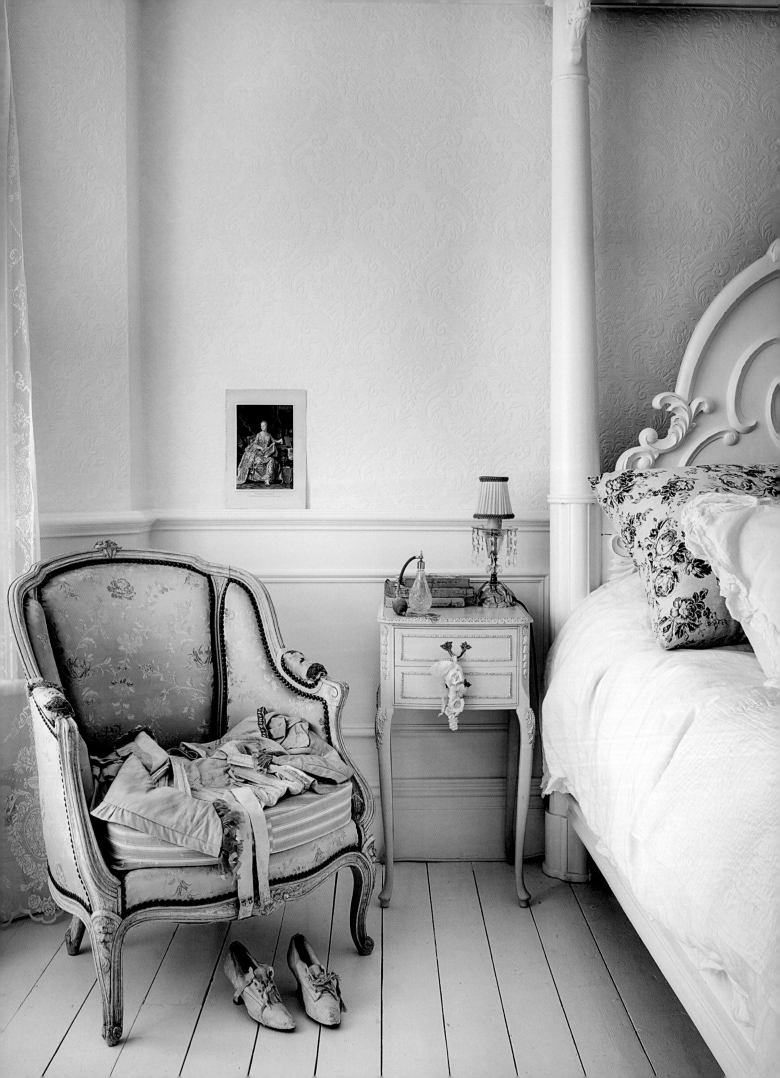

GANZ IN WEISS

Ein helles, weißes Dekor verbindet man üblicherweise mit Schlichtheit und Modernität, doch dieses englische Interieur beweist, dass Weiß auch verspielt, warm und gemütlich sein kann.

◆

Die holländische Designerin, Stylistin und Fotografin Janet Parrella-van den Berg und ihr Schweizer Mann lebten in der Schweiz, bevor sie beschlossen, nach Großbritannien zu ziehen, in dieses Haus auf dem Lande mit vier Schlafzimmern. Das 1915 errichtete Gebäude musste von seiner Komplettrenovierung aus den 1960-Jahren befreit werden, um die schönen Originalmerkmale wieder zum Vorschein zu bringen. „Ich hasste alles an dem Haus außer dem Baum im Garten", sagt Janet. „Aber ich wusste, dass ich es mit meiner Vision zu alter Pracht zurückführen konnte, dank der hohen Decken, Originalböden und der guten Struktur."

Das zweistöckige Gebäude dient nicht nur als Zuhause für Janet, ihren Mann und ihre fünf Kinder, sondern auch als Arbeitsumfeld für ihre Online-Vintage-Boutique White & Faded (whiteandfaded.co.uk). Die komplett in Weiß gehaltene Einrichtung betont die architektonischen Details und ist Ausstellungsfläche für die antiken Schätze, die Janet sammelt und auf der ganzen Welt verkauft. Die Möblierung des Hauses besteht aus einer Mischung englischer, französischer und holländischer Stücke. Ihre Leidenschaft für Antiquitäten hat Janet von ihren Eltern geerbt. Schon früh besuchte sie

Antikmärkte und sparte auf viktorianische Puppen, antike, weiß gestrichene Möbel und alte Spitze. Diese Obsession hält bis heute an. „Als Teenager kaufte ich einen antiken Waschtisch und strich ihn weiß an", erzählt Janet. „Mein Vater war ziemlich geschockt, aber ich spürte, dass es so richtig war. Damals ahnte ich aber noch nicht, dass daraus eine lebenslange Liebe zu weißen Dingen entstehen würde."

Der Shabby Chic der bekennenden Romantikerin reflektiert Janets zurückgenommene Ästhetik und ihre Liebe zu abgenutzten Gegenständen. „Ich nenne es ‚entspannte Eleganz'", sagt sie. „Ich rette gerne ungeliebte Teile, die das Potenzial haben, wieder schön zu werden." In ihrem Zuhause kombiniert sie alte Vitrinen und Tische mit antiken Stühlen – bei einigen kommen schon die Sprungfedern durch die abgewetzte Polsterung hervor. „Je verschlissener, zerkratzter und ramponierter sie sind, desto besser gefallen die Möbel mir", sagt sie. Die weißen Wände und Böden im ganzen Haus stellen diese Stücke perfekt zur Schau. „Ein weißer Raum strahlt Reinheit, Frieden und Ruhe aus", erklärt Janet. „Ich brauche die Ruhe, die Weiß vermittelt, um kreativ zu sein."

Jedes Element, das hier nicht alt ist, wurde – soweit möglich – mit einem antikweißen Anstrich versehen oder mit weißem Stoff gepolstert. „Viele Leute glauben, dass ein völlig weißes Interieur unpraktisch ist", fährt Janet fort. „Aber das ist ein Irrtum. Weiß lässt sich leicht sauber halten, vor allem, wenn man abwaschbare Wandfarben verwendet und Schonbezüge auf die Möbel legt. Um zu vermeiden, dass es zu steril aussieht, füge ich mit Kissen, Teppichen und Quilts Textur und Wärme hinzu."

Die Wände sind weiß, die Böden sind weiß und die Möbel sind weiß – in vielen verschiedenen Weißnuancierungen –, doch die Atmosphäre ist alles andere als kalt. Es fühlt sich friedlich und gemütlich an. „Mich stört nicht, wenn alles ein bisschen verschlissen ist", sagt Janet mit einem Lächeln. „Ich wuchs in einem Zuhause auf, in dem die Möbel alle perfekt wie im Museum waren. Das hier fühlt sich entspannter an."

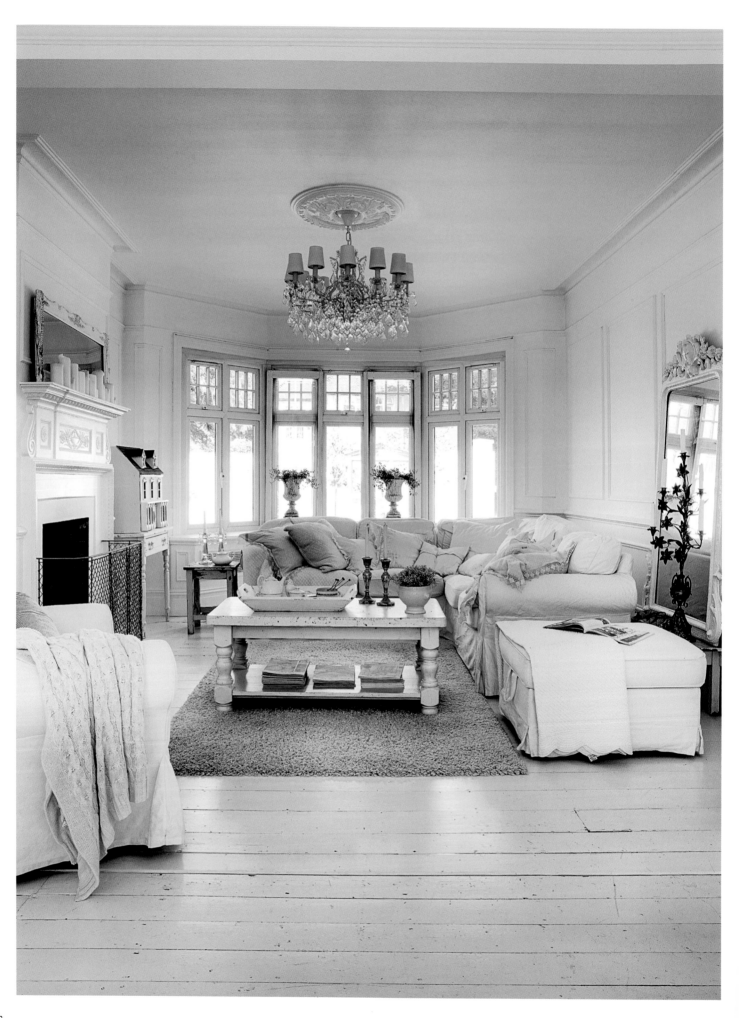

Living Room

Wraparound bookshelves surround the French doors that lead from the living room to the kitchen—filled mainly with white books, which Janet often buys solely for the cover. The 1960s fireplaces were opened up and replaced with Victorian fire surrounds, and the sofas are from Ikea and covered with white slipcovers for easy cleaning. The shabby chic chairs are some of Janet's favorite pieces, loved for the warmth they bring to the space.

Wohnzimmer

Bücherregale umrahmen die Flügeltüren, die vom Wohnzimmer in die Küche führen – darin stehen hauptsächlich weiße Bücher, die Janet oft nur wegen ihres Covers kauft. Die Kamine aus den 1960er-Jahren wurden erweitert und durch viktorianische Kaminverkleidungen ersetzt und die Sofas von Ikea mit weißen Schonbezügen bedeckt, die sich leicht reinigen lassen. Die Shabby-Chic-Sessel gehören zu Janets Lieblingsstücken, weil sie Wärme ausstrahlen.

Janet installed the reclaimed Victorian fireplace for this living room. The large dollhouse is handmade by Janet.
A brass French candelabra stands out in front of a white-painted antique mirror in the family room.
--
Im Wohnzimmer hat Janet den viktorianischen Kamin wiederbelebt. Das große Puppenhaus hat sie selbst gebaut.
Der prachtvolle französische Kerzenständer aus Bronze kommt vor dem weiß lackierten antiken Spiegel besonders gut zur Geltung.

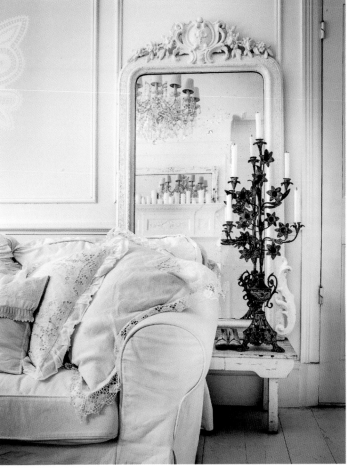

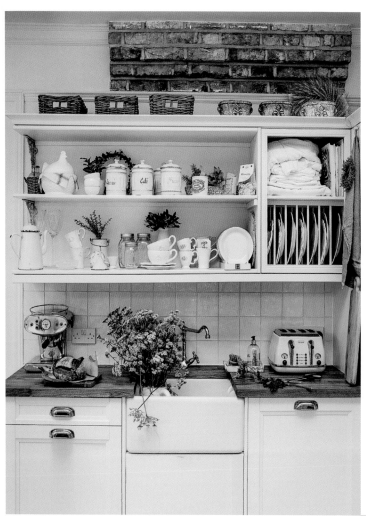

Kitchen

The large country-style kitchen with its central island and handmade floor tiles was added when they did the refurbishments to the house. "What I love most about the kitchen is the floor," says Janet. "I was slightly scared it would be overpowering as we have so much white, but it works really well." In the back, a brimming kitchen dresser holds Janet's much-loved collection of French soup tureens and candlesticks.

Küche

Die große Küche im Landhausstil mit Kochinsel und handgemachten Bodenfliesen wurde komplett neu renoviert. „An der Küche gefällt mir der Boden am besten", sagt Janet. „Am Anfang hatte ich Angst, dass er bei dem ganzen Weiß zu dominant sein würde, aber es funktioniert wirklich gut." Ein übervoller alter Küchenschrank enthält Janets heißgeliebte Sammlung französischer Suppenterrinen und Kerzenständer.

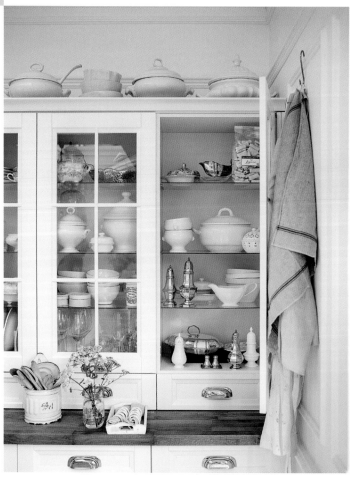

Janet's collections of soup terrines are displayed in the white-painted dresser.
--
Janets Suppenterrinen-Sammlung findet in der weiß lackierten Anrichte Platz.

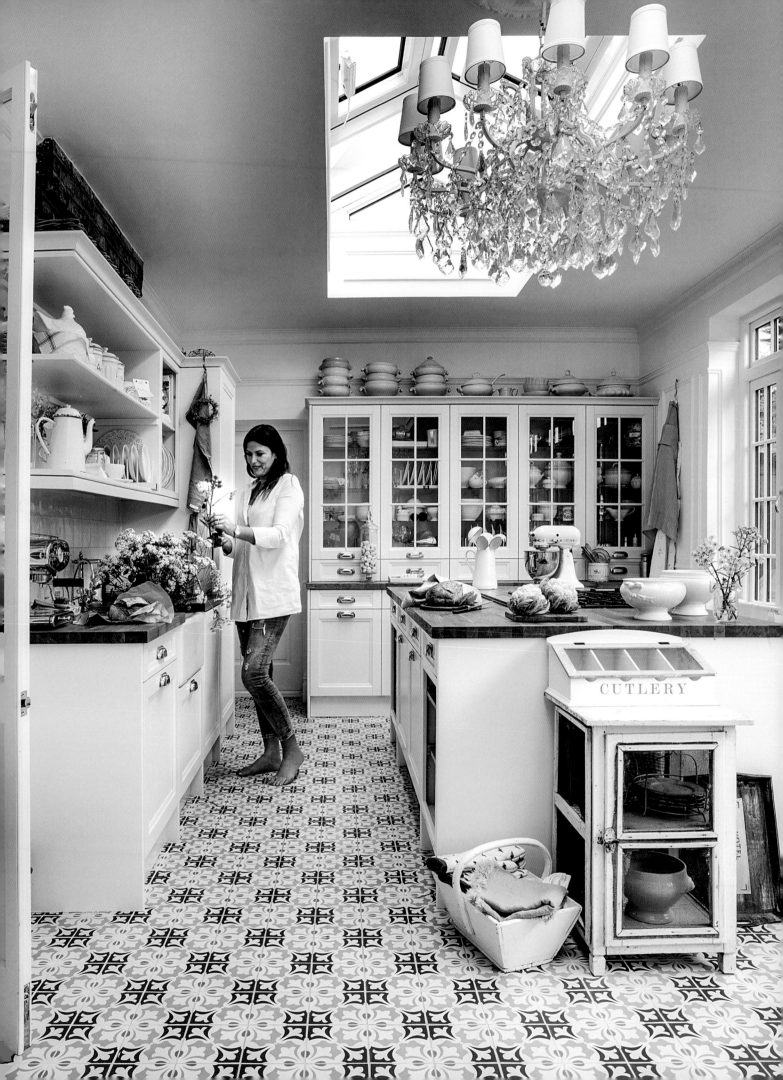

CUTLERY

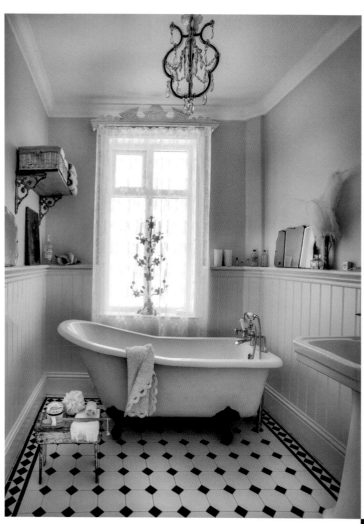

Bathroom

A freestanding, Victorian-style roll top bath, antique chandelier, and lace curtains take pride of place in the bathroom with its black-and-white tiled floor. This room was originally two smaller rooms, which Janet knocked through to make a larger space.

Badezimmer

Eine freistehende viktorianische Badewanne, ein antiker Kronleuchter und Spitzengardinen dominieren diesen Raum mit schwarzweiß gefliestem Boden. Janet vereinte die ursprünglichen zwei Zimmer zu einem größeren.

Bedroom

This large replica French half-tester bed was painted
to match the rest of the scheme. A 19th-century crystal
chandelier softens the look, along with an antique
French chair in the bay window. "The bedroom is one
of my favorite rooms," says Janet. "I love to wake up in
the morning and look at all the beautiful things."

Schlafzimmer

Das große nachgebildete französische Himmelbett
wurde passend zur restlichen Einrichtung lackiert.
Ein Kristallleuchter aus dem 19. Jahrhundert sowie
ein antiker französischer Sessel vor dem Erkerfenster
machen den Look weicher. „Das Schlafzimmer ist
einer meiner Lieblingsräume", sagt Janet. „Ich liebe es,
morgens aufzuwachen und mir all die schönen Dinge
anzuschauen."

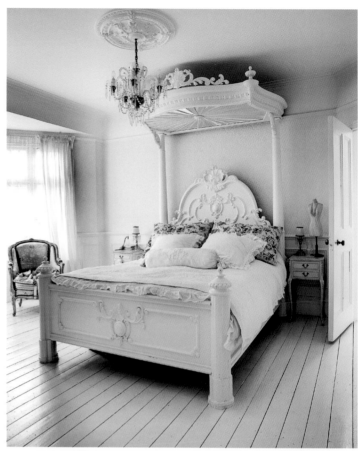

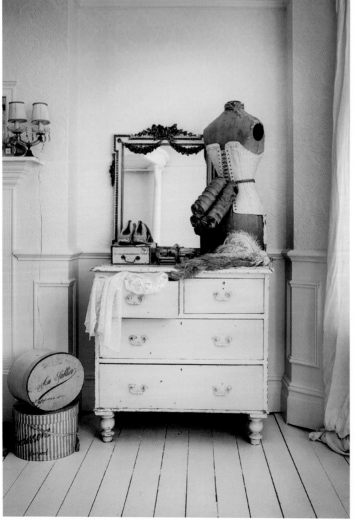

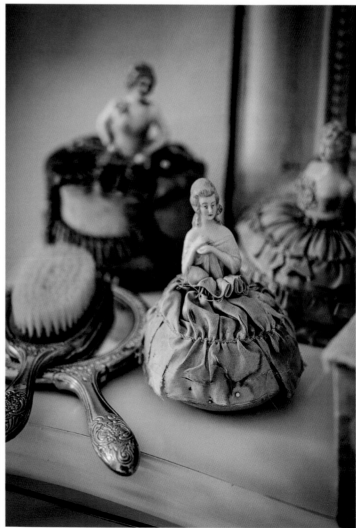

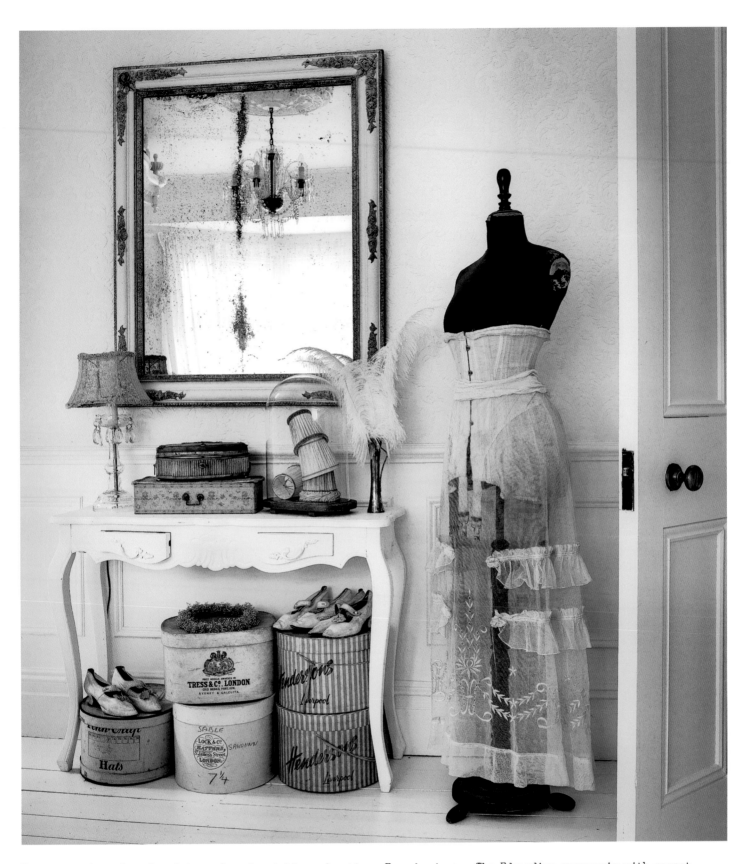

Hat boxes sit under the vintage dressing table and antique French mirror. The Edwardian mannequin with corset and underskirt are another of Janet's passions. "I collect mannequins," says Janet. "They are my obsession. When I love something, I can't have one item. I need to have two, three or four. Luckily, the house never feels that full because everything is white."

--

Unter dem alten Schminktisch und französischem Spiegel sind Hutschachteln verstaut. Die Ankleidepuppe aus der Zeit um 1900 mit Korsett und Unterrock steht für eine weitere Leidenschaft von Janet. "Ich sammele Ankleidepuppen", verrät sie. "Sie sind eine Obsession von mir. Wenn ich etwas liebe, reicht mir nicht ein Exemplar, sondern ich brauche gleich zwei, drei oder vier. Glücklicherweise fühlt sich das Haus nie überladen an, weil alles weiß ist."

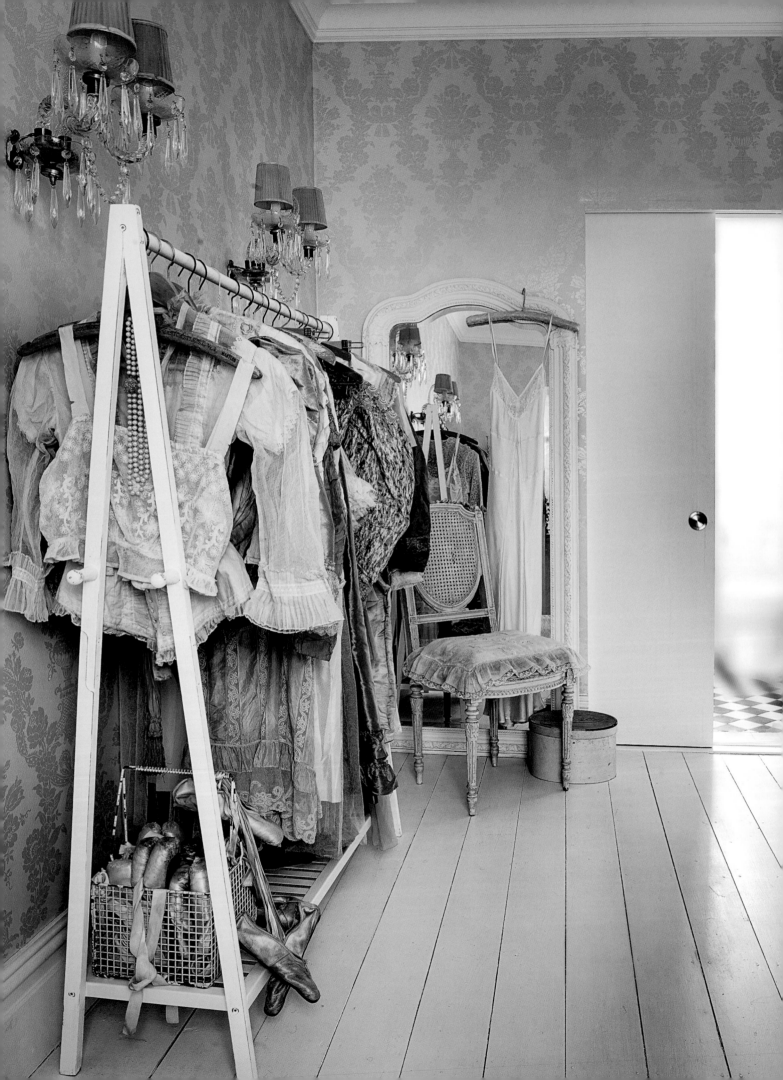

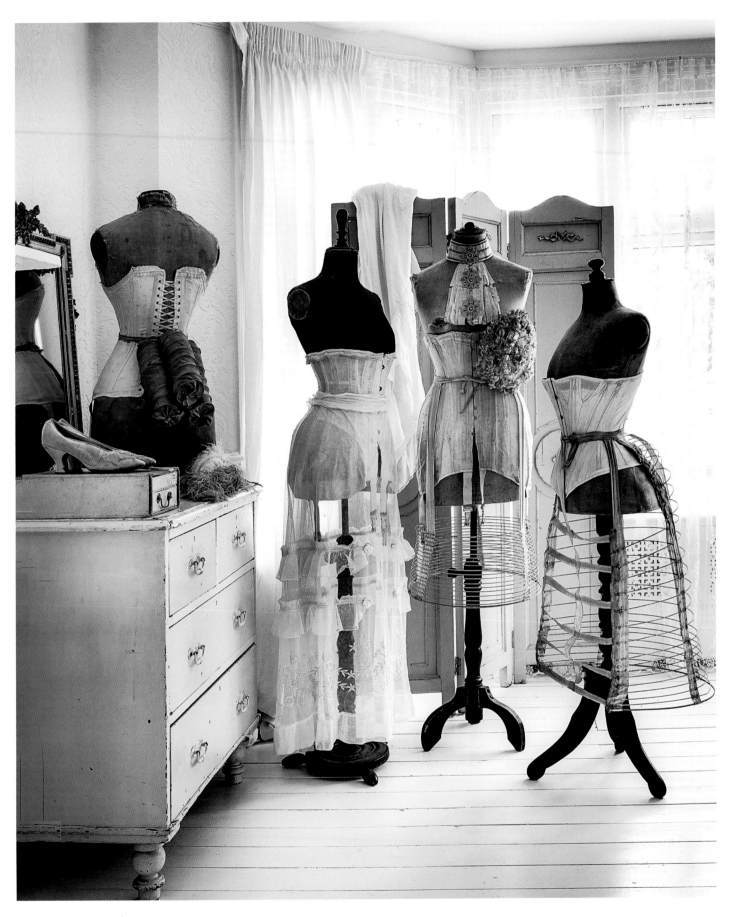

Looking into the bedroom with its antique French mirror, vintage chest of drawers, and Victorian mannequins in front of a screen.
--
Der Blick ins Schlafzimmer mit einem antiken französischen Spiegel, einer Vintage-Kommode und viktorianischen Ankleidepuppen vor einem Paravent.

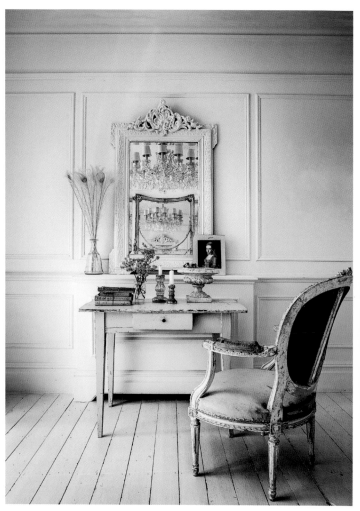

Janet's tips on adding
WARMTH WITH WHITE

1. Add texture with pillows and quilts. It may be white, but in your mind you feel warmth.

2. Stick to matte paint as the chalky finish gives a softer, more diffused light than gloss.

3. Learn to embrace the scuffs and scratches on white-painted floorboards. They give the floor life.

4. From pale grays to creams, mix different shades of white in a room. The perfect white for me is Dulux Light & Space. It's warm, but not too yellow and adapts to the atmosphere outside. For woodwork, Little Greene Paint's Shirting matches perfectly.

5. Use wood paneling on a plain wall to give extra depth. If walls were plain, they would be far less interesting.

Janets Tipps, wie
WEISS WARM WIRKT

1. Fügen Sie mit Kissen und Quilts eine stoffliche Komponente hinzu. Auch wenn die Textilien weiß sind, fühlen sie sich in der Vorstellung warm an.

2. Wählen Sie matte Farbe, da ein kalkiger Anstrich ein weicheres Licht erzeugt als glänzende Oberflächen.

3. Lernen Sie, die Kratzer und Abschürfungen auf weiß lackierten Dielen zu lieben. Sie machen Böden lebendig.

4. Von blassen Grautönen bis hin zu Cremeweiß: Mischen Sie verschiedene Weißschattierungen in einem Raum. Das perfekte Weiß für mich ist Dulux Light & Space. Es ist warm, aber nicht zu gelbstichig, und passt sich der Atmosphäre draußen an. Für Holzanstriche passt die Farbe Shirting von der Firma Little Greene perfekt.

5. Verleihen Sie einer schlichten Wand mit Holzpaneelen zusätzliche Tiefe. Eine schlichte Wand ist weniger interessant.

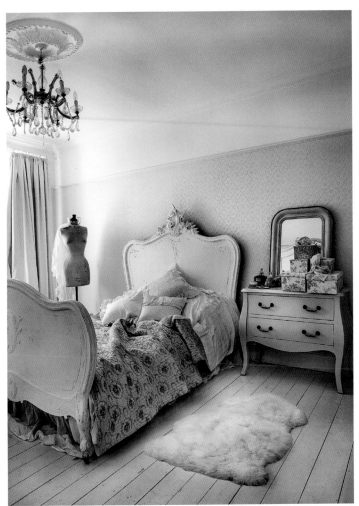
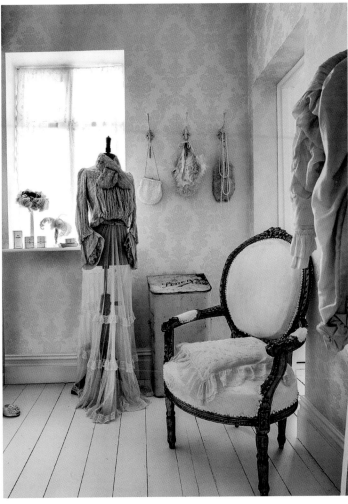

MY HOME TRUTHS

MEINE WOHN-WEISHEITEN

I describe my style as relaxed elegance. It is glamorous, but with a casual feel.

My home reflects my personality in that I know what I want. Dutch people are known for being very honest and precise. This comes across with all the detail in the house. Likewise, I'm easygoing and this is apparent with the relaxed mood.

Meinen Stil würde ich als entspannte Eleganz bezeichnen. Glamourös, aber gleichzeitig leger.

Mein Zuhause spiegelt meine Persönlichkeit wider. Ich weiß, was ich will. Holländer sind bekannt für ihre Ehrlichkeit und Genauigkeit. Das zeigt sich in allen Details des Hauses. Andererseits bin ich aber auch ziemlich locker, was sich in der Atmosphäre niederschlägt.

LIVING TO
THE MAX

Fans of the flamboyant will love this sumptuous Italian home, which showcases vibrant color alongside cutting-edge furniture and art.

"My whole house is a series of ideas on how to break the rules!" That's how Stefano Seletti describes his dazzling home in Lombardy that he shares with his wife Adriana, daughters Petra and Marià, and Jack Russell, Rio. From the moment you walk in you can see this is a great place full of character and inspiration: open and extrovert, it makes a bold statement with color. The contrast of decoration, collection of hyper-kitsch and modern, edgy furniture makes this a playground—but a very grown-up kind. A bit mad, a tad over-the-top, you get a sense that this family knows how to have fun.

In the small village near Mantua, about 25 miles (40 km) south of Verona, Stefano's countryside home is a testimony to his life-long infatuation with extreme art and design. On every available wall and surface there are books, paintings, sculptures, and ceramics, yet he manages to embrace a cluttered feel and make the whole thing work. One man's mess is another man's treasure; surrounding yourself with things you love doesn't have to equal chaos. "The mix is a consequence of time and my ongoing personal style evolution," says Stefano. "I prefer not to match things as I do not like perfection. For me, a precious plate looks much more interesting on a plastic tablecloth."

Creative director of the family design brand, Seletti, Stefano bought his home in his twenties and has spent the better part of two decades making his mark on the interior wonderland. "I used to look at the house from the bedroom window of my childhood home. An old lady used to live here, and she kept chickens and cows. When I moved here I thought it would be for just a few years, but yet, we remain."

Taking an intuitive approach to the decoration, Stefano has been seduced by pieces that he's found as he's gone along. "My daily life, my family—a lot of things have inspired me over the years," explains Stefano. "I've always had a curiosity for discovering new things and have always learned from experience. For example, I have only recently begun to appreciate Memphis design; likewise, the colors that Nathalie Du Pasquier combines are like no other. Also, Barolo wine is a current favorite, too."

"Nowadays I rather look inside myself, and I get inspiration from daily life from my daughters and nieces," Stefano continues. "They are my benchmark. I pay attention to what they eat, how they sit, how they interact with technology, how they play with our dog. I like to see what they are curious about, and I always try to surprise them."

Be it an old piece of furniture or something genius and new, in his home Stefano favors objects that tell a story. Scuffed floors or glossy tabletops—the beauty is in the unforeseen. And thanks to his inquisitive mind, the house is crammed full of the old, the unexpected, and the amazing making it a laid-back and an inspiring place to be.

MAXIMALES WOHNEN

Fans des Spektakulären werden dieses üppig dekorierte italienische
Zuhause lieben, in dem leuchtend-grelle Farben und ungewöhnliche Möbel
und Kunstobjekte den Ton angeben.

„Mein ganzes Haus besteht aus Einfällen, die die Regeln brechen!" So beschreibt Eigentümer Stefano Seletti sein schillerndes Domizil in der Lombardei, das er zusammen mit seiner Frau Adriana, den Töchtern Petra und Marià und dem Jack-Russell-Terrier Rio bewohnt. Sobald man eintritt, erkennt man sofort, dass in diesen Räumlichkeiten jede Menge Persönlichkeit und Inspiration steckt: Sie sind offen und extrovertiert und geizen nicht mit Farbe. Auf dieser Spielwiese für Erwachsene wird die Spannung zwischen hyperkitschigen Elementen und ausgefallen-modernen Möbeln ausgetragen. Das Ganze ist ein bisschen verrückt, ein Stück weit überkandidelt – man spürt, dass diese Familie Spaß hat.

Stefanos in einem Dorf bei Mantua (40 km südlich von Verona) gelegenes ländliches Zuhause spiegelt seine lebenslange Begeisterung für radikale Kunst und extremes Design wider. Auf jeder Wand oder Ablagefläche finden sich Bücher, Bilder, Skulpturen und Keramikobjekte. Stefano macht die Anhäufung von Krimskrams zum Konzept und siehe da, es funktioniert! Der Krempel des einen ist eben der Schatz des anderen; sich mit Dingen zu umgeben, die man

liebt, muss nicht gleich Chaos bedeuten. „Der Mix hat sich im Laufe der Zeit ergeben und beruht auf meiner ganz persönlichen fortlaufenden Stil-Evolution", sagt Stefano. „Ich stimme Dekorelemente nicht aufeinander ab, da ich Perfektion nicht mag. Für mich sieht ein wertvoller Teller auf einer Plastiktischdecke viel interessanter aus."

Stefano ist Kreativdirektor der Designmarke Seletti, einem Familienbetrieb. Er kaufte das Haus, als er in den Zwanzigern war, und verbrachte die nächsten zwei Jahrzehnte damit, dem Interieur seinen Stempel aufzudrücken. „Ich konnte das Haus als Kind von meinem Fenster aus sehen. Eine alte Frau lebte früher dort; sie hielt Hühner und Kühe. Als ich hier herzog, dachte ich, es wäre nur für ein paar Jahre, aber wir sind immer noch da."

Stefano geht beim Einrichten intuitiv vor. Er wird von Objekten verführt, auf die er unterwegs stößt. „Mein Alltag, meine Familie – viele Dinge haben mich im Laufe der Jahre inspiriert", erklärt er. „Ich war schon immer neugierig und habe aus Erfahrungen gelernt. Zum Beispiel habe ich erst kürzlich das Design

von Memphis zu schätzen gelernt; oder auch die Farben, die Nathalie Du Pasquier auf so unvergleichliche Weise kombiniert. Barolo-Wein ist derzeit auch einer meiner Favoriten."

„Heutzutage blicke ich eher in mich hinein und schöpfe meine Inspiration aus dem Alltag oder von meinen Töchtern und Nichten", fährt Stefano fort. „Sie sind mein Maßstab. Ich beobachte, was sie essen, wie sie sitzen, wie sie mit Technologie umgehen, wie sie mit unserem Hund spielen. Ich möchte wissen, was ihre Neugier weckt, und ich versuche immer wieder, sie zu überraschen."

Ob es sich um ein altes Möbelstück handelt oder etwas geniales Neues: Bei sich daheim bevorzugt Stefano Objekte, die eine eigene Geschichte erzählen. Abgenutzte Böden oder glänzende Tischplatten – die Schönheit liegt im Unvorhersehbaren. Und Dank seiner Neugier und Entdeckerlust ist Stefanos Haus vollgestopft mit alten, überraschenden und erstaunlichen Dingen – ein wahrhaft entspannter und inspirierender Ort.

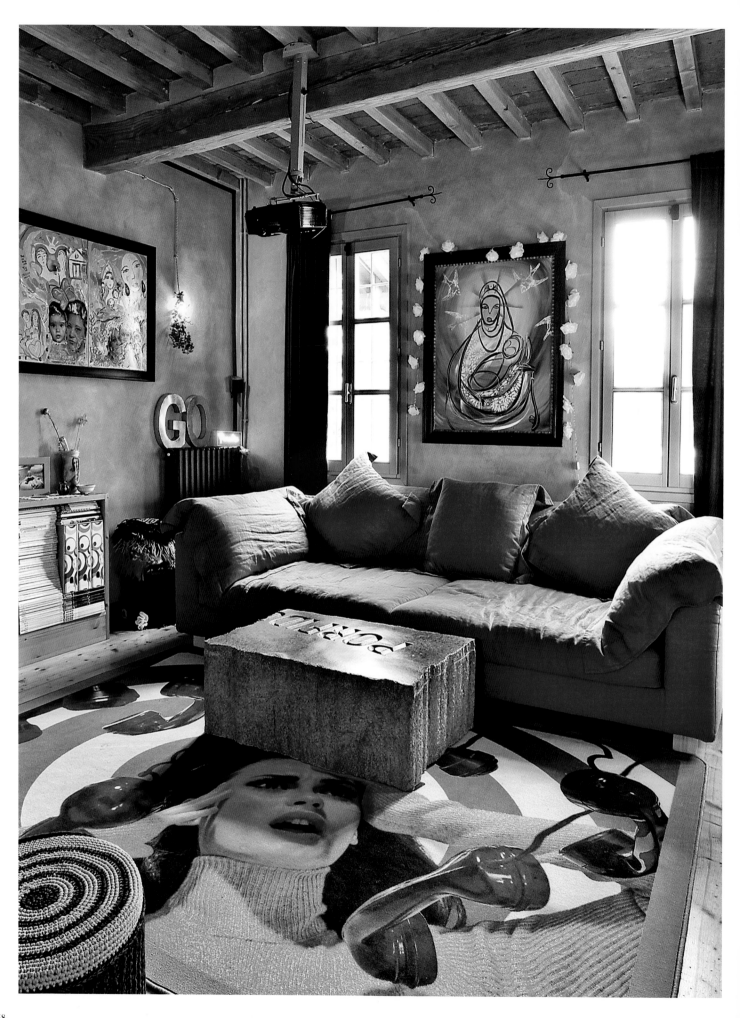

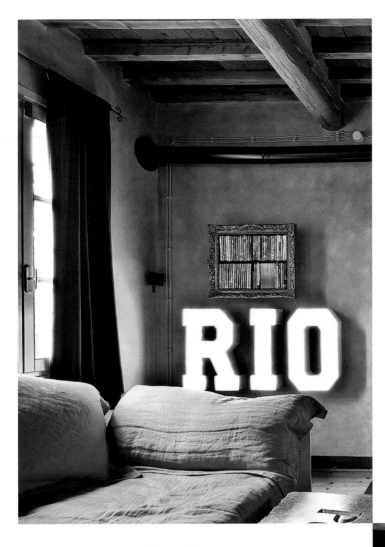

Living Room

"This is one of my favorite spaces for its mix of colors and pieces. I love the blue Nebula Nine sofa—by Moroso for Diesel Living—because it is so wide. The way we use a sofa today is very different from a generation ago. Whereas our parents would sit on a sofa to chat, we use the sofa to watch TV, read, or look at our smartphone screens. The alphabet lights are from Seletti. 'Rio' is the name of our dog, so this is in homage to him. 'Play' is because my daughters keep their toys in that cabinet and it is also where they usually play."

Wohnzimmer

„Dieser Raum ist wegen seiner wilden Farb- und Möbel-Mischung einer meiner Lieblingsorte im Haus. Ich liebe das blaue Sofa Nebula Nine von Moroso für Diesel Living, weil es so schön tief ist. Heute benutzen wir Sofas ganz anders als noch vor einer Generation. Unsere Eltern saßen auf dem Sofa, um sich zu unterhalten. Wir gucken darauf fern, lesen oder blicken auf unsere Smartphones. Die Buchstaben-Leuchten sind von Seletti. Unser Hund heißt Rio, die eine Leuchte ist also eine Hommage an ihn. ‚Play' steht da, weil meine Töchter ihre Spielsachen in dieser Kommode aufbewahren und an diesem Platz normalerweise spielen."

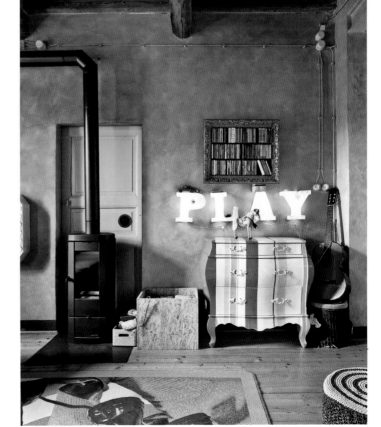

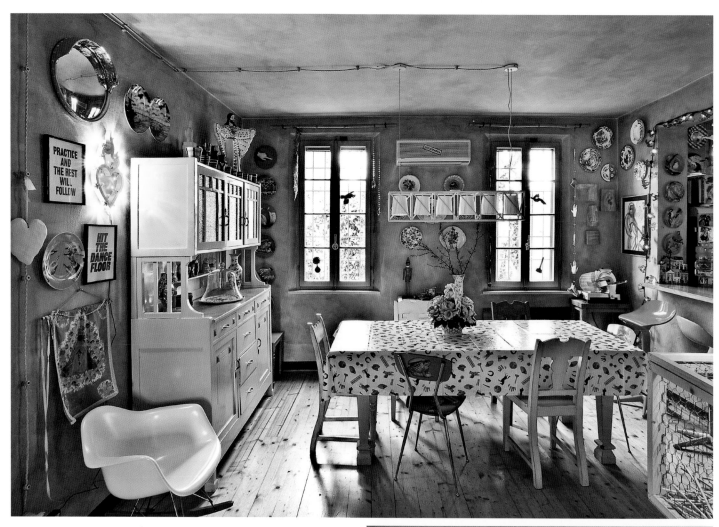

Kitchen

"I love the kitchen because it's totally improvised and wrong! In Italian homes the kitchen is usually the part that is the most expensive. Here, it is made with things that were supposed to be temporary but are still here 20 years on. If you think about it, the only essential items in a kitchen are the stove, fridge, and a few shelves—and that's what you get here."

Küche

„Ich liebe die Küche, weil sie total improvisiert und verkehrt ist! In italienischen Häusern ist die Küche normalerweise der teuerste Teil der Einrichtung. Diese hier besteht aus Elementen, die eigentlich provisorisch sein sollten, aber heute – zwanzig Jahre später – noch immer da sind. Das einzige, was man in einer Küche wirklich braucht, sind ja Herd, Kühlschrank und ein paar Regale. Und genau das findet man hier vor."

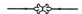

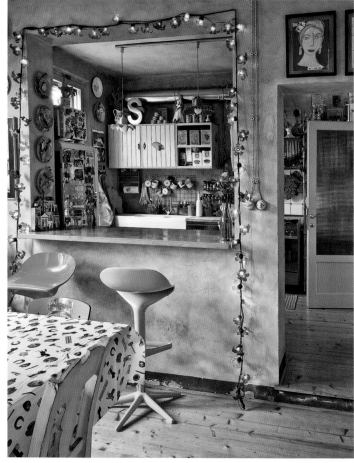

"The green palette in the kitchen is typical to country homes in this area. These days, the rooms tend to be painted pale and 'dirty.' I prefer richer, heritage colors because they feel more authentic to the space."

"I collect a lot of things; travel souvenirs mainly and things that belonged to my parents. The dining chairs and the cabinet used to belong to them. The multilamp pendant light is by Emanuele Magini for Seletti."

--

"Die grüne Farbpalette ist typische für die Häuser auf dem Land. Heutzutage geht die Tendenz aber mehr zu blassen, 'dreckigen' Farben. Ich bevorzuge die kräftigeren traditionellen Farbtöne, weil sie sich authentischer anfühlen."

"Ich sammele viel, hauptsächlich Reiseandenken und Sachen, die von meinen Eltern stammen, wie die Esstischstühle und die Anrichte. Die von der Decke hängende Mehrfachleuchte hat Emanuele Magini für Seletti entworfen."

Conservatory

"The conservatory is on the ground floor in the new part of the house. It used to be the stables. My daughter's play the piano here, and there is also a sauna in the space. It is very important to get a sauna at least once a week."

Konservatorium

„Das Konservatorium befindet sich im Erdgeschoss des neueren Trakts. Das waren früher die Ställe. Meine Töchter spielen hier Klavier und es gibt auch eine Sauna. Es ist sehr wichtig, mindestens einmal die Woche in die Sauna zu gehen."

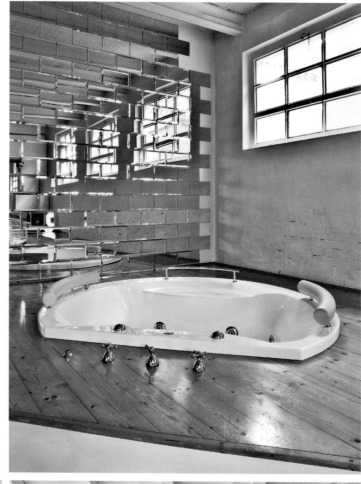

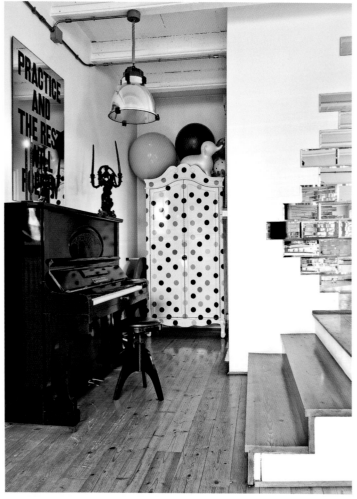

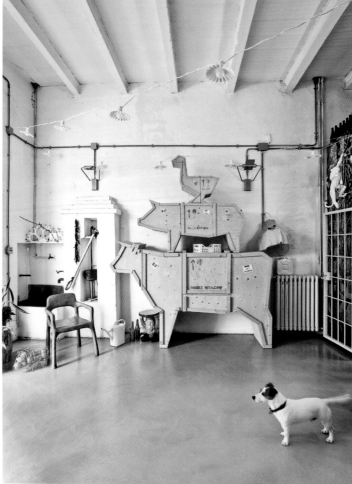

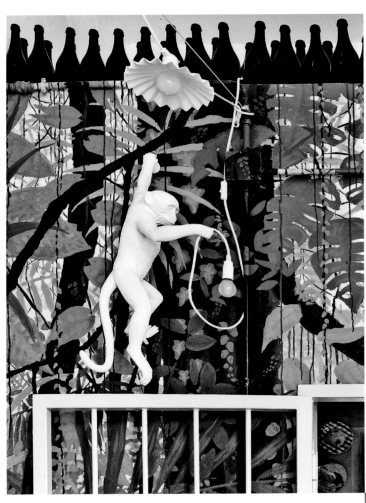

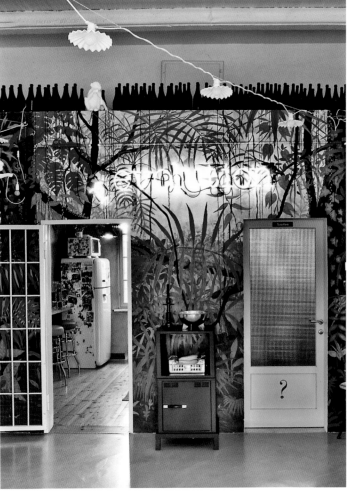

"The mural is a painting by Marcantonio Raimondi
Malerba, which he painted in exchange for accommodation
and food," says Stefano. "It is the Brazilian jungle,
in honor of my wife." The brilliant Monkey lamp is also
by Marcantonio and is one of the current best-selling
designs at Seletti.

--

"Das Wandbild stammt von Marcantonio Raimondi Malerba",
erzählt Stefano. "Er hat es für Kost und Logis gemalt.
Es stellt den brasilianischen Urwald dar, zu Ehren
meiner Frau." Die fantastische Leuchte Monkey wurde auch
von Marcantonio entworfen und ist einer der Bestseller
von Seletti.

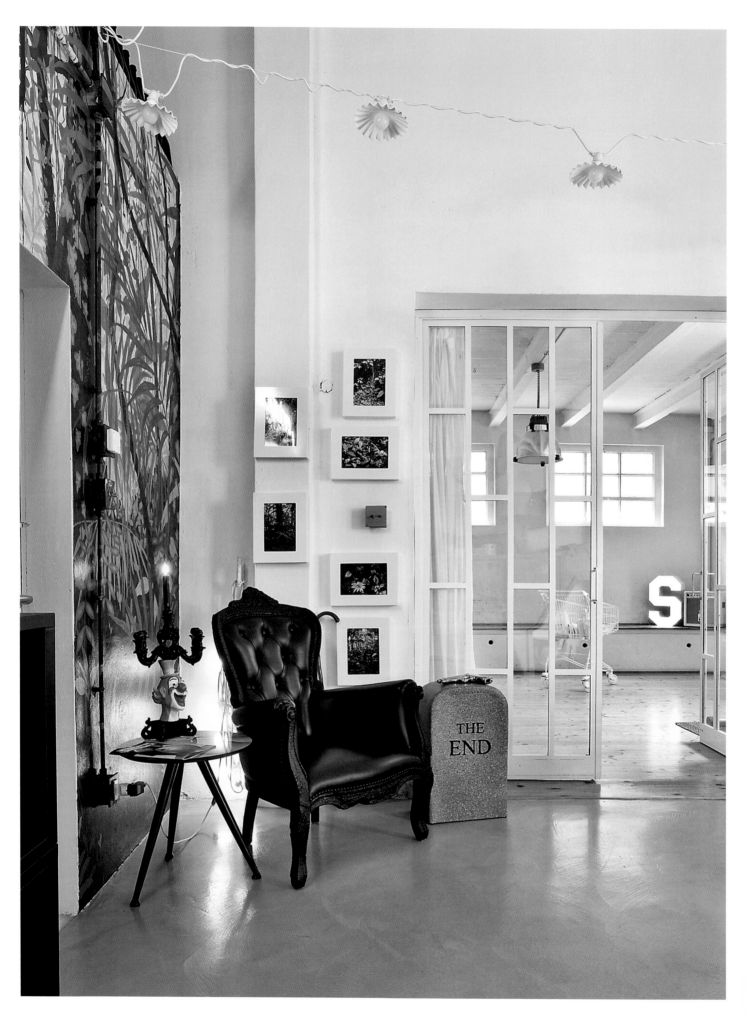

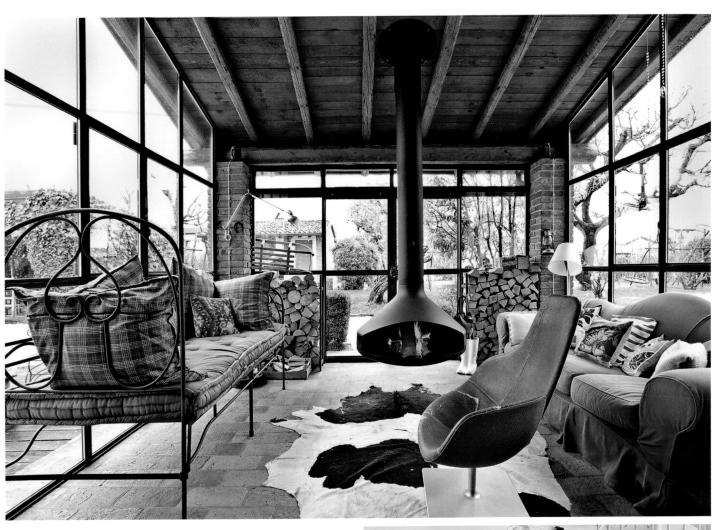

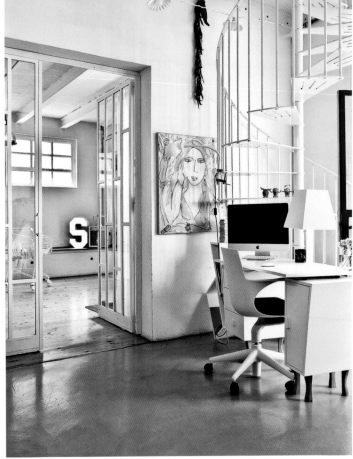

165

Loft

"The white-painted loft is in a different part of the house. It was built in the 1950s and originally intended to be a barn. The atmosphere here is more minimal than the rest of the house. Being more recent to the rest of the house, which dates from 1900, we wanted to keep the two separate. We use the space for guests who do not want to be drawn into the 'maximalism' of the main home."

Loft

„Das weißgestrichene Loft befindet sich in einem anderen Trakt. Es wurde in den 1950er-Jahren errichtet und war ursprünglich als Scheune gedacht. Die Atmosphäre hier ist minimalistischer als im Rest des Hauses. Da dieser Anbau neuer ist als das um 1900 erbaute Haupthaus, wollten wir die beiden Teile auch unterschiedlich einrichten. Hier quartieren wir Gäste ein, die nicht in den ‚Maximalismus' des Haupthauses hineingezogen werden wollen."

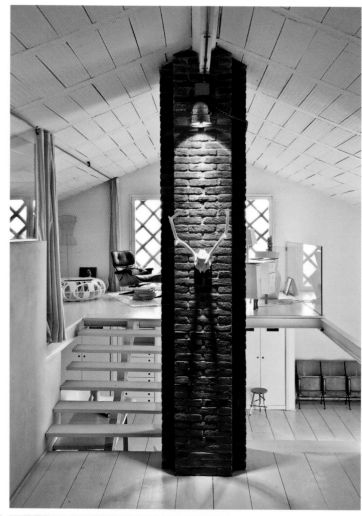

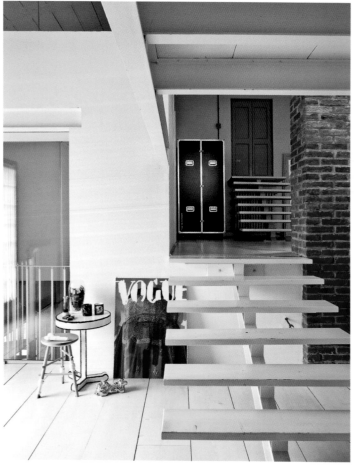

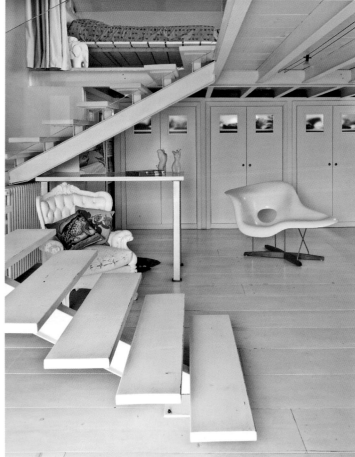

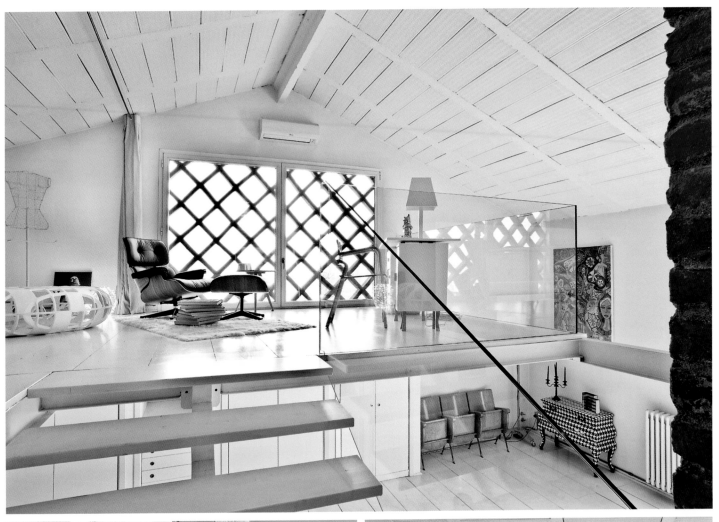

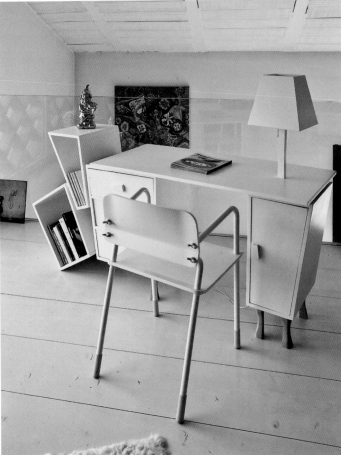

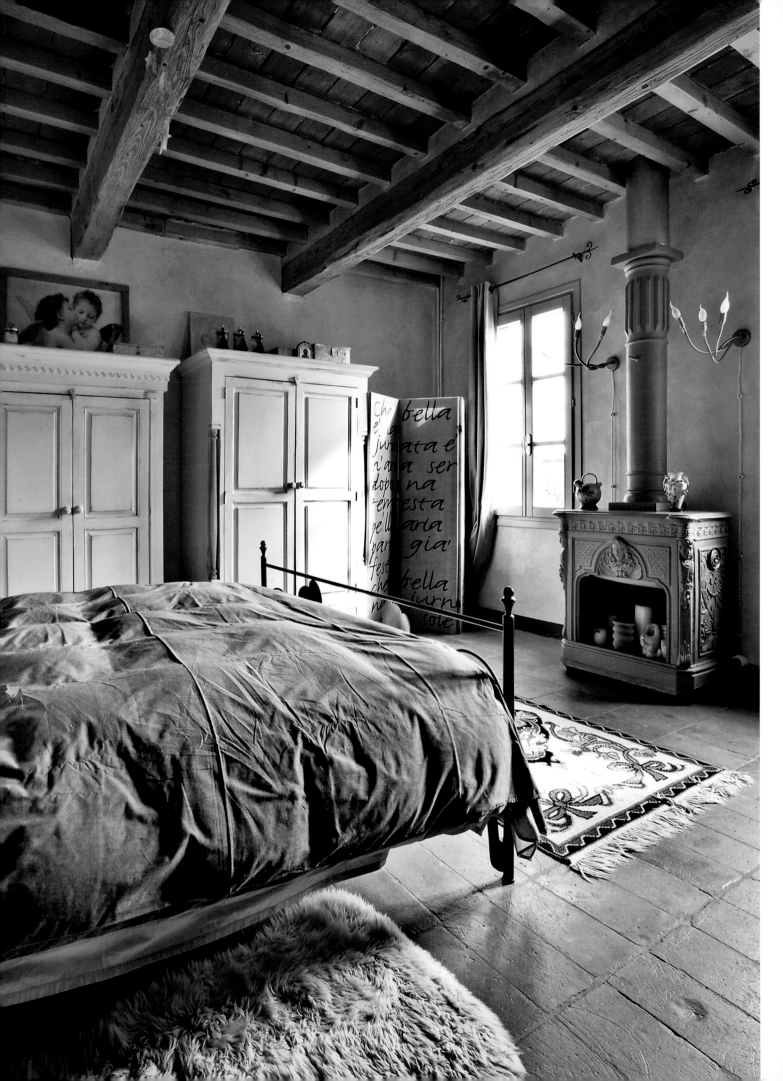

Bathroom

In this room, Stefano allows himself free rein to do whatever he wants. "I have total freedom," he says. "I can stick posters on the wall. I can accumulate stuff. Here, the attention is not on a single element but on the overall idea. It is a sort of pop *wunderkammer*."

Badezimmer

In diesem Zimmer macht Stefano, was er will. „Ich habe totale Freiheit", sagt er. „Ich kann Poster an die Wand heften. Ich kann Krempel ansammeln. Hier stehen keine einzelnen Objekte im Fokus, sondern das Gesamtkonzept. Es handelt sich um eine Art Pop-Wunderkammer."

Bedroom: "I wanted to achieve a cozy environment in this room. Everything here is original to the building and the color is the same as it always was."

--

Schlafzimmer: "In diesem Raum wollte ich eine gemütliche Atmosphäre schaffen. Alle architektonischen Elemente hier gehören original zum Gebäude und auch die Farbe ist die gleiche wie früher."

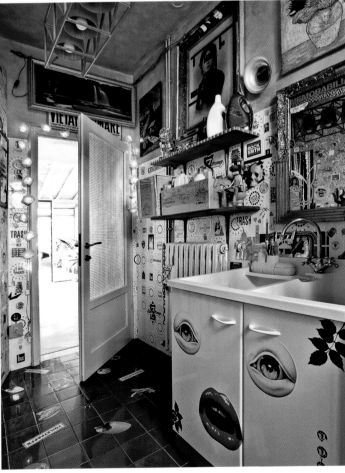

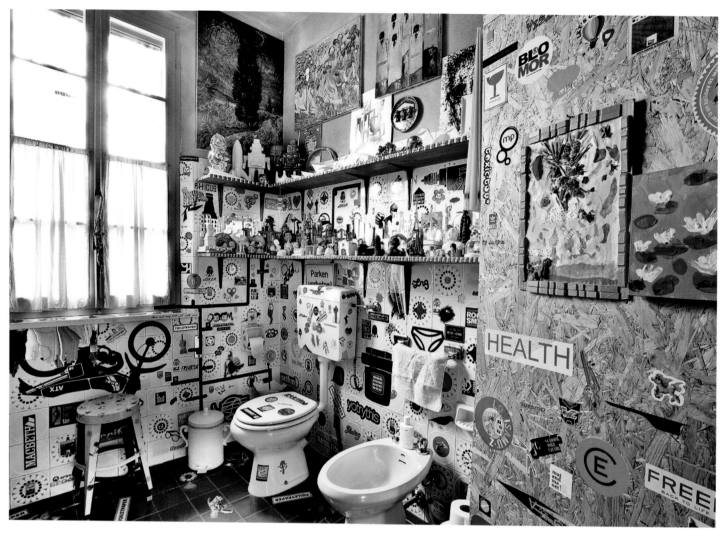

Stefano's guide to
BREAKING THE RULES

1. Allow yourself one room where you can do whatever you want. Here, kids can play with stickers and draw on the walls.

2. Green and blue DO rule! We paired our blue sofa in the living room with a green curtain behind.

3. Don't get hung up on an expensive kitchen. A good stove, fridge, and shelves are all you really need.

4. Mix objects that compete for attention. Things often look better as a whole, rather than in isolation.

5. REVOLUTION IS THE ONLY SOLUTION!
That's the way I live.

Stefanos
REGELN GEGEN DEKOREGELN

1. Gönnen Sie sich ein Zimmer, in dem Sie machen können, was Sie wollen. In einem solchen Raum können die Kinder zum Beispiel die Wände bemalen.

2. Grün und Blau sind TOPP! Wir kombinieren unser blaues Sofa im Wohnzimmer mit einem grünen Vorhang.

3. Versteifen Sie sich nicht auf eine teure Küche. Ein guter Herd, ein Kühlschrank und Regale sind alles, was man wirklich braucht.

4. Gruppieren Sie Objekte, die um die Aufmerksamkeit des Betrachters wetteifern, so sehen sie oft besser aus.

5. REVOLUTION IST DIE EINZIGE LÖSUNG!
Das ist mein Lebensmotto.

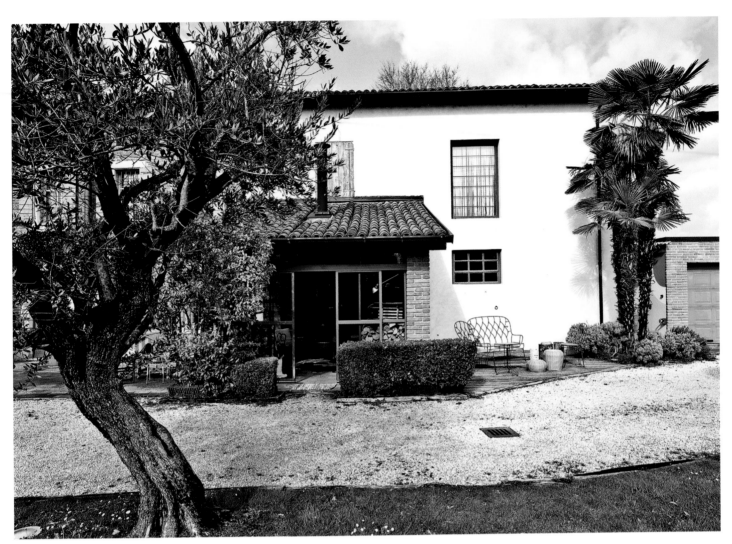

MY HOME TRUTHS

<u>My house is a mix of styles</u> ruled by time. I don't really like to change the furniture and accessories but they constantly evolve with a new color or covered in something else.

<u>I always look for new things.</u> I like to collaborate with artists, which allows the company to move in different directions to other design brands.

MEINE WOHN-WEISHEITEN

<u>Mein Haus ist ein vom Lauf der Zeit bestimmter Stilmix.</u> Ich wechsele Möbel und Accessoires nicht gerne aus, aber sie mutieren durch eine neue Farbe oder Polsterung ständig zu etwas Neuem.

<u>Ich halte immer nach neuen Sachen Ausschau.</u> Ich arbeite gern mit Künstlern zusammen, die die Firma in andere Richtungen führen als die, die andere Designmarken einschlagen.

ESCAPE TO THE
CHÂTEAU

A passion for vintage furniture and a clever blend of styles offers a perfect mix of comfort and edginess in this striking French home.

Antiques dealer Steinar Berg-Olsen describes his home as "French but with a dash of Scandi." For the French side, check out the fairy tale château exterior, the neo-classical details, and the supersized fireplaces indoors. As for the Scandi, take a tour upstairs to the attic, where the vast 1,380-square-feet (128-square-meter) space is painted head-to-toe in white and kitted out with Carlo Colombo and Alvar Aalto designs.

Refined, expressive, eccentric, even a bit quirky—all in a historical context—it's fair to say it is a beguiling mix. Much like the Norwegian-born creative himself. "I wouldn't describe myself as a minimalist, but I like simple shapes that are easy on the eye. I also love vintage but nothing overly flowery. To my mind, if you have to stuff a sofa full of cushions, then there must be something wrong with the design."

Steinar and his husband Mark Slaney, who works in PR, decided to decamp to the French countryside from their beloved, semi-detached house in Rye in 2004. "It was at the height of housing market," explains Steinar. "We thought that if we sold our house in England, we could literally buy a castle in France. We looked into it and realized that we actually could."

Following their château fantasies—Steinar's favorite TV program at the time was *Monarch of the Glen*—the couple fell for the faded grandeur of the 1910 property in the Pays de la Loire region of western France and its large garden which allows them to live the country life with their mini schnauzer, Jo. "Where we live is very rural," says Steinar. "Sometimes you can go here for days without seeing anyone. It's such a big house, there's always something to do— and you can't just buy a ready meal—it doesn't exist. Needless to say, everything is cooked from scratch."

Steinar's background is in antiques and his fine eye for color, contrast, and tactility is evident throughout the interior. Starting with the kitchen and working their way up through the house, the moody blue interior sets the tone. Despite the wow factor of the color palette, it demonstrates how warm and inviting dark shades can be. It also shows how a taste for edgy, modern design can put an original spin on a traditional property.

"When we bought the house, it was like all French interiors—wallpaper everywhere and the smallest room was the kitchen. We knocked down walls and moved the kitchen to the back of the house. Now, when you park up the car, it is much easier to unload the shopping." Steinar opened up the kitchen to create a huge 540-square-feet (50-square-meter) space. "We always wanted to have a big kitchen but this is almost too big," he says. "To make the space feel more relaxed, we introduced the island, which is made from MDF and covered with gray tiles, then added sofas and chairs. Because the whole look is quite hard, it is softened with giant velvet curtains."

As you move through the house, the balance of color shifts, changing the mood from dark and intimate to light and airy. In the indigo-painted living room on the ground floor— Steinar's favorite place to be—tactile materials and contemporary accessories inject warmth, glamour, and cool. Here, a Danish 1940s sofa mixes with Christofle vases and a table by Merve Kahraman. "In this room, there is also the giant fireplace, which is basically the same size as me," says Steinar. "I could sit for hours in front of it. The small library is next to the living room, so I can quickly run and grab a book."

Tearing at the French château cliché, Steinar enjoys living between the old and new. Today the home's interior is a mix of European furniture, Persian rugs, and eye-catching photography the couple have picked up throughout their careers. "If I had another profession, I would have been a photographer," says Steinar. "When the iPhone came in and I first discovered Instagram, it was amazing. I was suddenly Sarah Moon." This is something Steinar says he would love to be in his next life. For the present, however, there is a lot more gardening to be done.

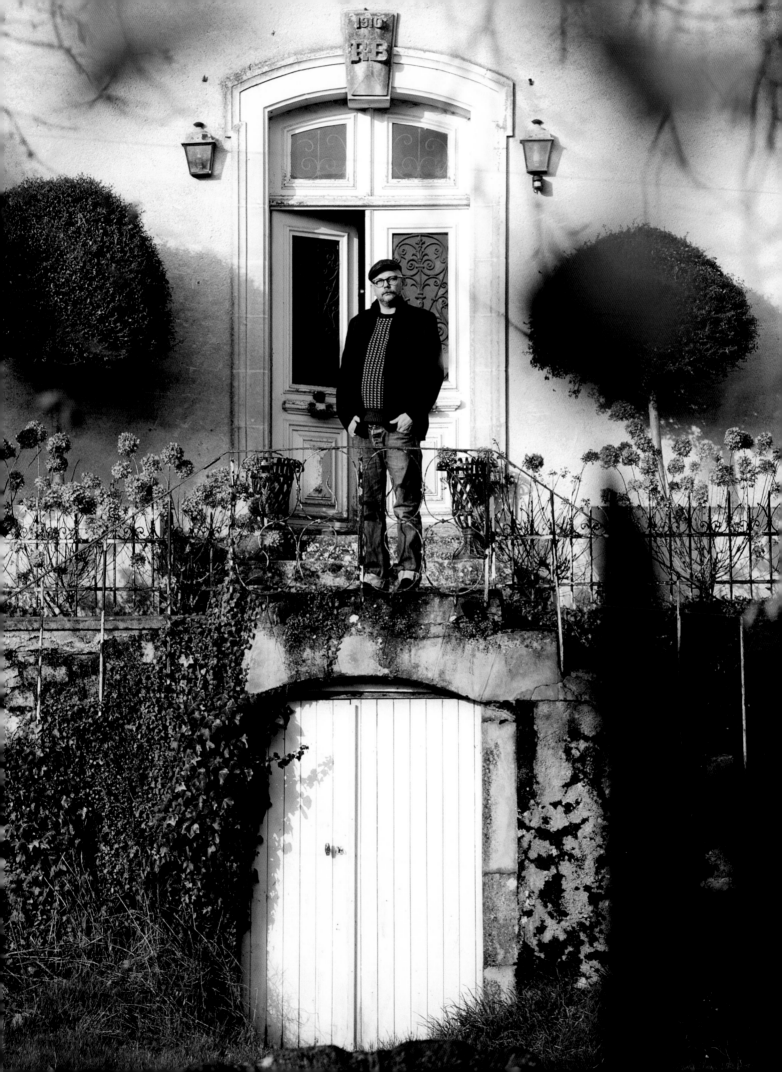

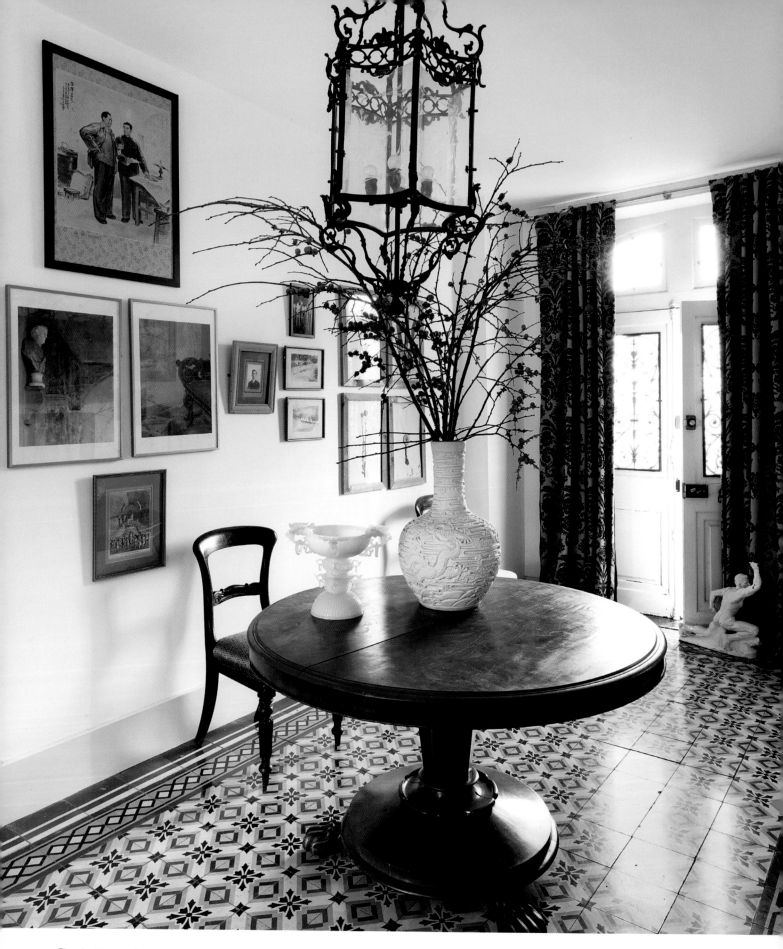

The hallway features original tiled floors, which inspired the color palette of the house. The stairs are kept white so it all blends together.

--

Im Flur liegen die Original-Bodenfliesen, die die Farbpalette des gesamten Hauses inspirierten. Die Treppen sind in Weiß gehalten, damit sich alles harmonisch zusammenfügt.

CHÂTEAU DER TRÄUME

Eine Leidenschaft für Vintage-Möbel und ein cleverer Stilmix ergeben in dieser exquisiten französischen Residenz die perfekte Balance zwischen Behaglichkeit und Innovation.

Der Antiquitätenhändler Steinar Berg-Olsen beschreibt sein Zuhause als „französisch mit einem Schuss Scandi". Auf der französischen Seite stehen die märchenhafte Château-Fassade, die neoklassizistischen Details und die Kamine im XXL-Format zu Buche. Der Scandi-Look findet sich oben auf dem Dachboden, dessen 128 Quadratmeter große Fläche komplett weiß gestrichen ist und mit Designs von Carlo Colombo und Alvar Aalto möbliert wurde.

Elegant, expressiv, exzentrisch – und das alles in einem historischen Kontext: Diese Mischung ist ausgesprochen attraktiv. „Ich würde mich nicht als Minimalisten beschreiben", so der aus Norwegen stammende Kreative über seinen Stil, „aber ich mag einfache Formen, die gefällig sind. Ich liebe auch Vintage, aber nichts zu Blumiges. Wenn man ein Sofa mit Kissen vollstopfen muss, stimmt meiner Meinung nach etwas nicht mit dem Design."

Steinar und sein Mann Mark Slaney, der in der PR-Branche arbeitet, beschlossen 2004, ihr geliebtes Reihenhaus im englischen Rye zu verlassen und nach Frankreich aufs Land zu ziehen. „Da hatte der Immobilienhype in England gerade seinen Höhepunkt erreicht", erklärt Steinar. „Wir dachten, wenn wir unser Haus verkaufen, könnten wir uns womöglich ein richtiges Schloss in Frankreich leisten. Und genau so war es dann auch."

Das Paar war fest entschlossen, seine Château-Fantasien voll auszuleben – Steinars Lieblingsfernsehsendung war nicht umsonst *Monarch of the Glen*. Spontan verliebten sie sich in die verblichene Pracht und den großen Garten des Anwesens von 1910 in der Region Pays de la Loire im Westen Frankreichs. Hier können die beiden mit ihrem Zwergschnauzer Jo das Landleben genießen. „Wir leben sehr abgeschieden", sagt Steinar. „Manchmal sieht man tagelang keine Menschenseele. Das Haus ist so groß, dass es immer etwas zu tun gibt. Und man kann sich nicht einfach eine fertige Mahlzeit kaufen. Also kochen wir alles von Grund auf selbst."

Steinar ist Experte für Antiquitäten und sein gutes Auge für Farben, Kontraste und Haptik macht sich in jedem Raum bemerkbar. Ein melancholisches Blau gibt den Ton an und zieht sich durchs ganze Haus. Das Interieur demonstriert, wie warm und einladend dunkle Töne sein können und wie man ein altehrwürdiges Haus mit ausgefallenem, modernem Design originell und behutsam in die Neuzeit führen kann.

„Als wir das Haus kauften, war das Interieur vollkommen französisch – überall Tapeten und die Küche im kleinsten Raum. Wir rissen Wände ein und versetzten die Küche in den hinteren Teil des Hauses. Jetzt ist der Weg vom Parkplatz zur Küche beim Ausladen der Einkäufe viel kürzer." Die Küche ist nun ein riesiger Bereich von 50 Quadratmetern. „Wir wollten zwar eine große Küche, aber diese ist schon fast zu groß", sagt Steinar. Um ein entspanntes Ambiente zu kreieren, haben wir die mit grauen Fliesen bedeckte Kochinsel aus MDF installiert und dann noch Sofas und Sessel hinzugefügt. Weil der Look ziemlich hart ist, haben wir uns auch für die schweren Samtvorhänge entschieden, die alles weicher wirken lassen."

Beim Gang durch das Haus verändert sich die Farbbalance, die Stimmung schwingt von dunkel und intim zu hell und luftig. Im indigoblau gestrichenen Wohnzimmer im Erdgeschoss – Steinars Lieblingsort – verströmen haptische Materialien und zeitgenössische Accessoires Wärme, Glamour und Eleganz. Hier trifft ein dänisches Sofa aus den 1940er-Jahren auf Christofle-Vasen und einen Tisch von Merve Kahraman. „In diesem Zimmer gibt es auch einen gewaltigen Kamin, der ungefähr so groß ist wie ich", sagt Steinar. „Ich könnte stundenlang davor sitzen. Die kleine Bibliothek liegt gleich daneben, ich kann also schnell hinlaufen und mir ein Buch holen."

Steinar genießt es sehr, das Klischee vom französischen Château aufzubrechen und sich mit alten und neuen Dingen zu umgeben. Das aktuelle Interieur des Schlosses ist ein Mix aus europäischen Möbeln, persischen Teppichen und markanten Fotografien, die die beiden im Laufe ihrer Karrieren zusammengetragen haben. „In meinem nächsten Leben wäre ich gern Fotograf", sagt Steinar. „Als das iPhone auf den Markt kam und ich Instagram entdeckte, war ich begeistert. Plötzlich war ich Sarah Moon." In diesem Leben gibt es jedoch noch viel Arbeit im Garten.

Living Room

"I love to have shiny black floorboards but I didn't think about the practicalities of living in the countryside and coming in with muddy boots and paws. It's impossible to get clean. This is one of the reasons we have so many rugs. We always use a lot of rugs in Norway. We layer them up and drag them outside. The walls are painted in Dulux Venetian Crystal, and there are several pieces of designer furniture such as the marble Diplopia coffee table by Merve Kahraman. The large portraits are by Dale Grant."

Wohnzimmer

„Ich liebe glänzende schwarze Holzdielen, habe aber nicht daran gedacht, dass man auf dem Lande ständig mit matschigen Stiefeln und Pfoten reinlatscht. Sie sind unmöglich sauber zu halten. Unter anderem deshalb haben wir so viele Teppiche. In Norwegen verwendet man generell viele Teppiche, die man übereinander schichtet. Die Wände des Wohnzimmers sind in der Farbe Dulux Venetian Crystal gestrichen. Es gibt hier mehrere Designerteile, darunter das marmorne Beistelltischchen Diplopia von Merve Kahraman. Die großen Porträts stammen von Dale Grant."

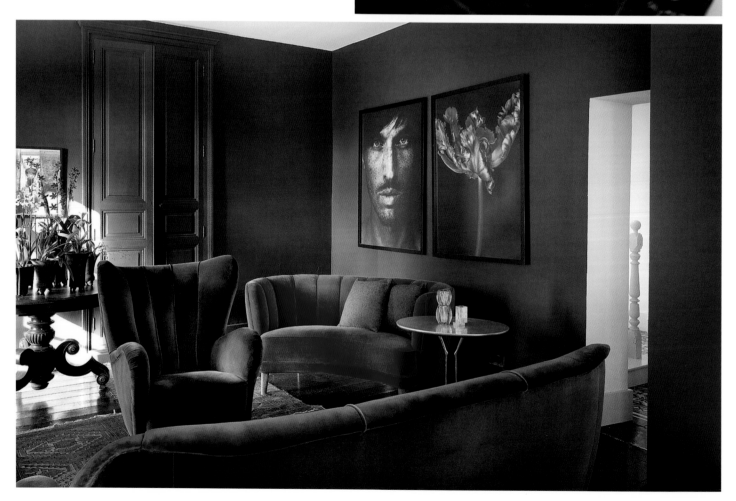

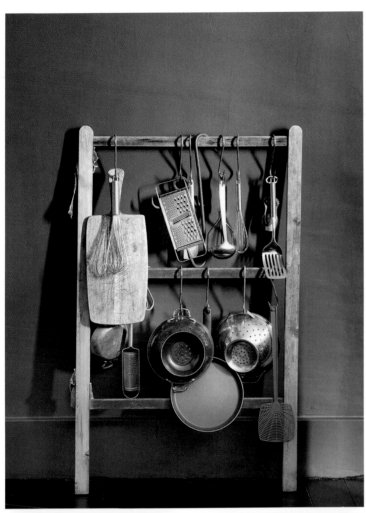

Kitchen

"When I decorated my first house over 30 years ago, I painted my kitchen in the exact same shade of blue. It is normal to be influenced by trends, but blue and green has always been a constant. In general, I like colors that are inspired by nature. If a color combination exists outside, then it is likely to work indoors too.'

Küche

„Als ich vor über dreißig Jahren mein erstes Haus einrichtete, strich ich die Küche in exakt diesem Blauton. Es ist normal, von Trends beeinflusst zu werden, aber Blau und Grün bilden bei mir eine Konstante. Generell gefallen mir natürliche Farben. Wenn eine Farbkombination draußen in der Natur existiert, dann funktioniert sie höchstwahrscheinlich auch drinnen."

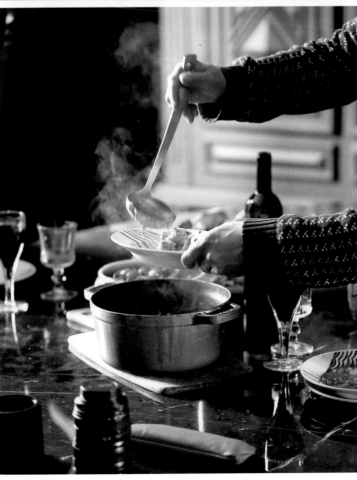

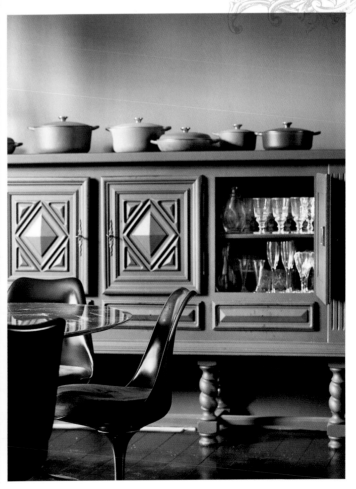

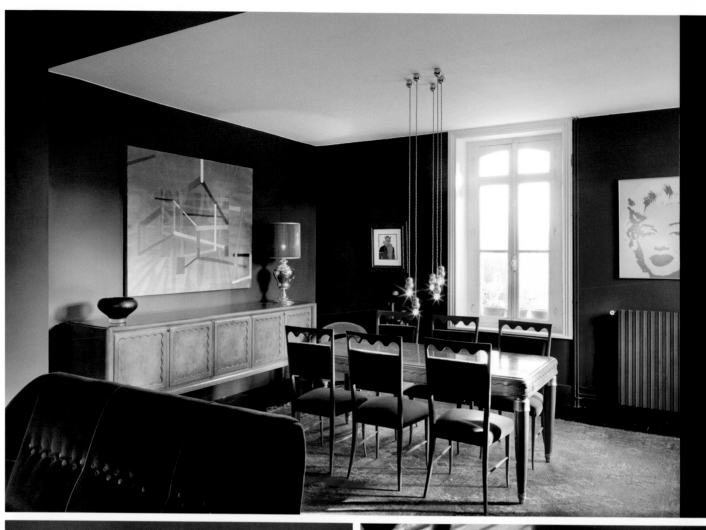

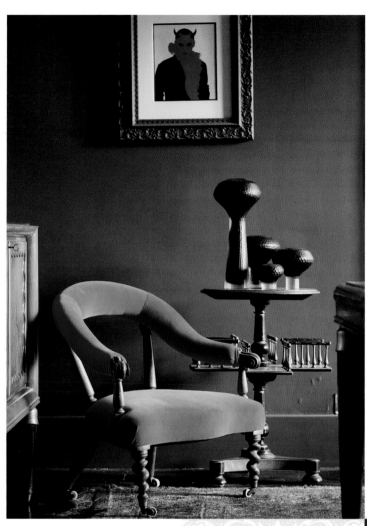

Dining Room

Above the 1940s marble-topped dining table by
the Italian architect Paolo Buffa, are a collection
of Ball lights by lighting designer Michael
Anastassiades. Then there is a sofa by the
Italian architect Nino Zoncada, black glass vases
designed by Steinar, and above the sideboard,
a large artwork by the British artist
Shane Bradford.

Esszimmer

Über dem Esstisch mit Marmorplatte vom
italienischen Designer Paolo Buffa hängt eine
Gruppe Ball-Lampen von Lichtdesigner Michael
Anastassiades. Das Sofa wurde vom italienischen
Designer Nino Zoncada entworfen und die
schwarzen Glasvasen hat Steinar designt. Über
der Anrichte hängt ein großes Gemälde des
britischen Künstlers Shane Bradford.

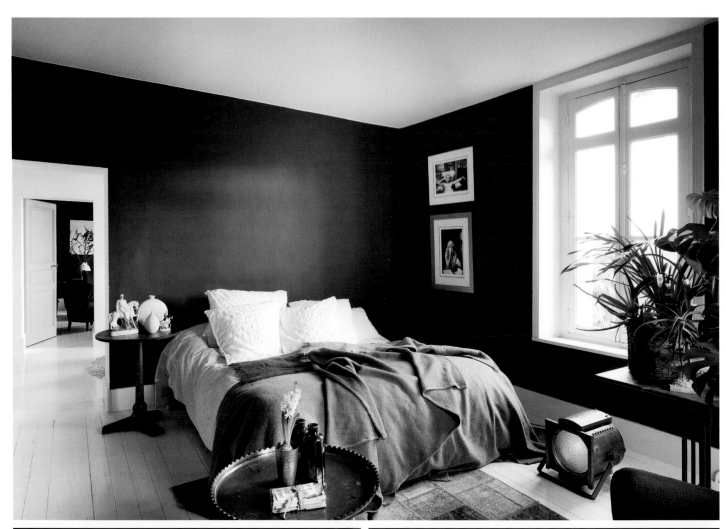

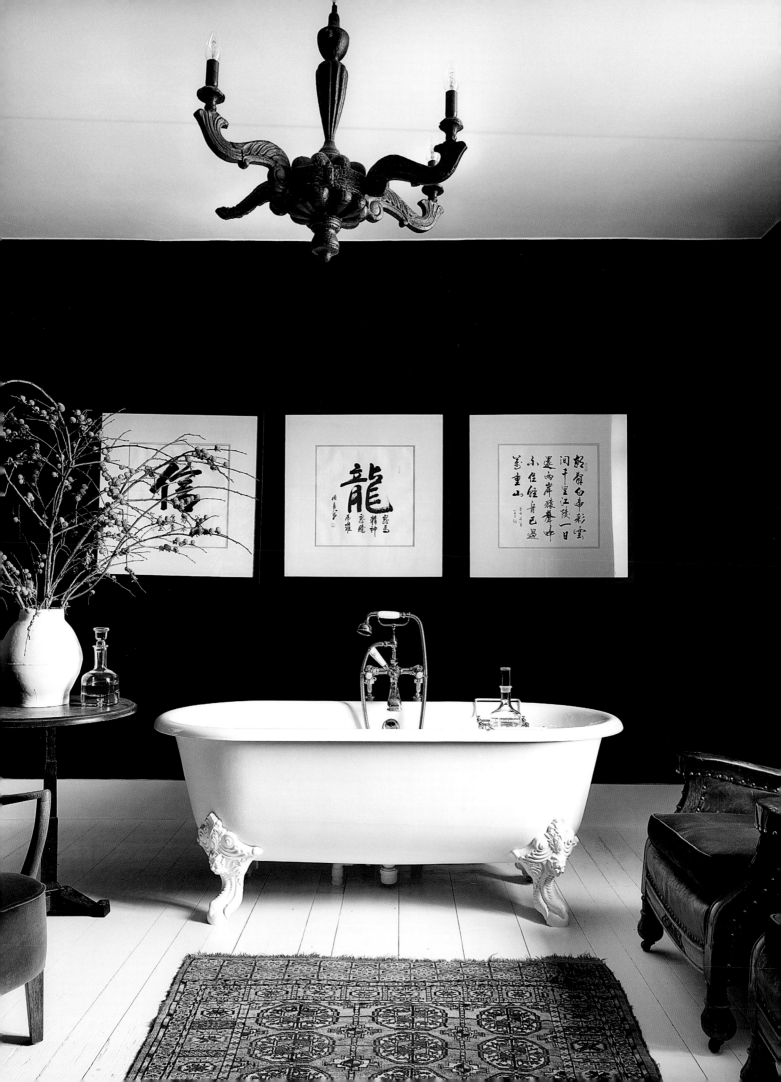

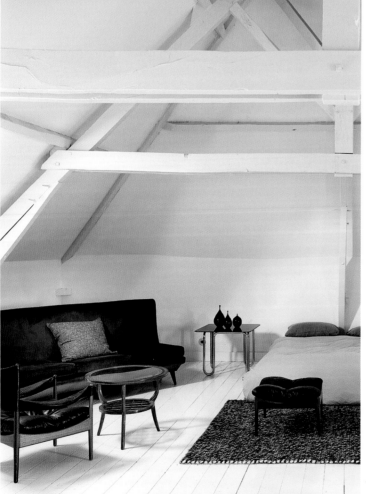

Loft

"The attic is an enormous space. It's a bit 1970s Scandi lounge—white and bright. I can't imagine painting an attic in dark colors. It would feel wrong. As I rearrange furniture around so much, flexibility is a must. All of my floor and table lamps, including the giant Anglepoise lamps, can be used anywhere. In this space I love my Alvar Aalto stools. I also love the more unknown TH9 table, designed in 1931 by Oliver Bernard."

Loft

„Der Dachboden ist riesig. Das Ganze hat etwas von einer Scandi-Lounge aus den 1970er-Jahren – alles ist weiß und hell. Ich kann mir nicht vorstellen, einen Dachboden in dunklen Farben zu streichen. Das würde sich einfach falsch anfühlen. Da ich die Möbel so oft umstelle, ist Flexibilität ein Muss. Alle meine Steh- und Deckenlampen, darunter die riesigen von Anglepoise, können überall zum Einsatz kommen. In diesem Wohnbereich liebe ich besonders meine Alvar-Aalto-Hocker. Sehr mag ich auch den unbekannteren Tisch TH9, der 1931 von Oliver Bernard entworfen wurde."

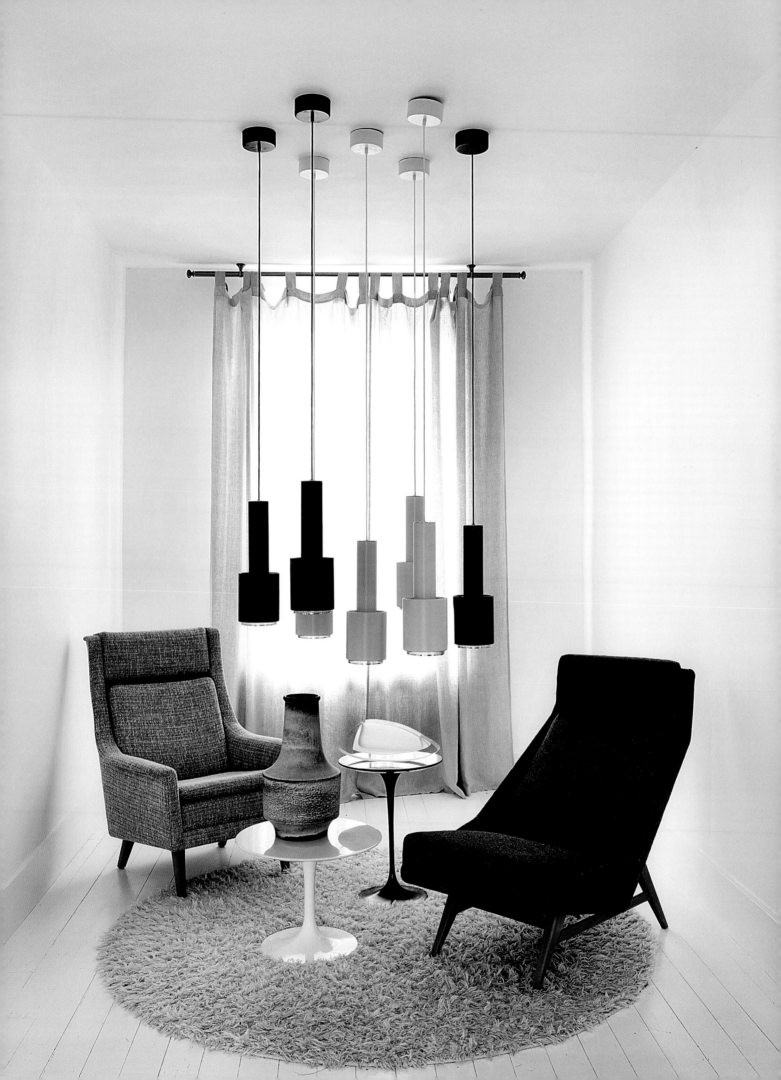

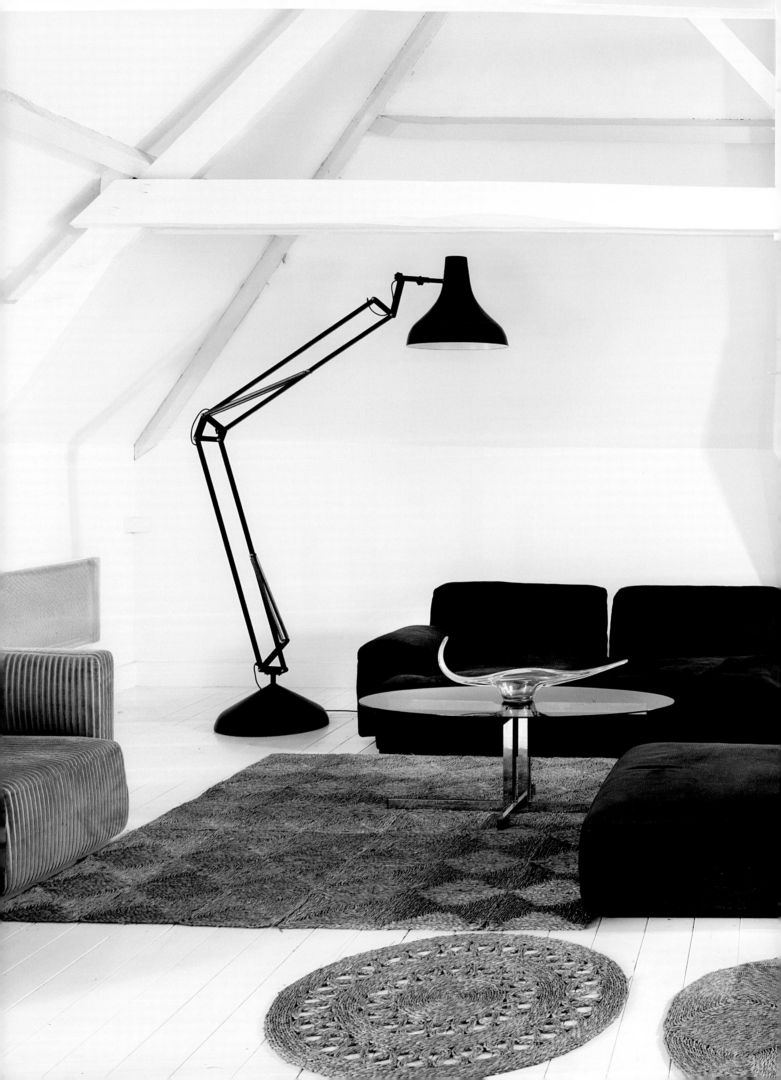

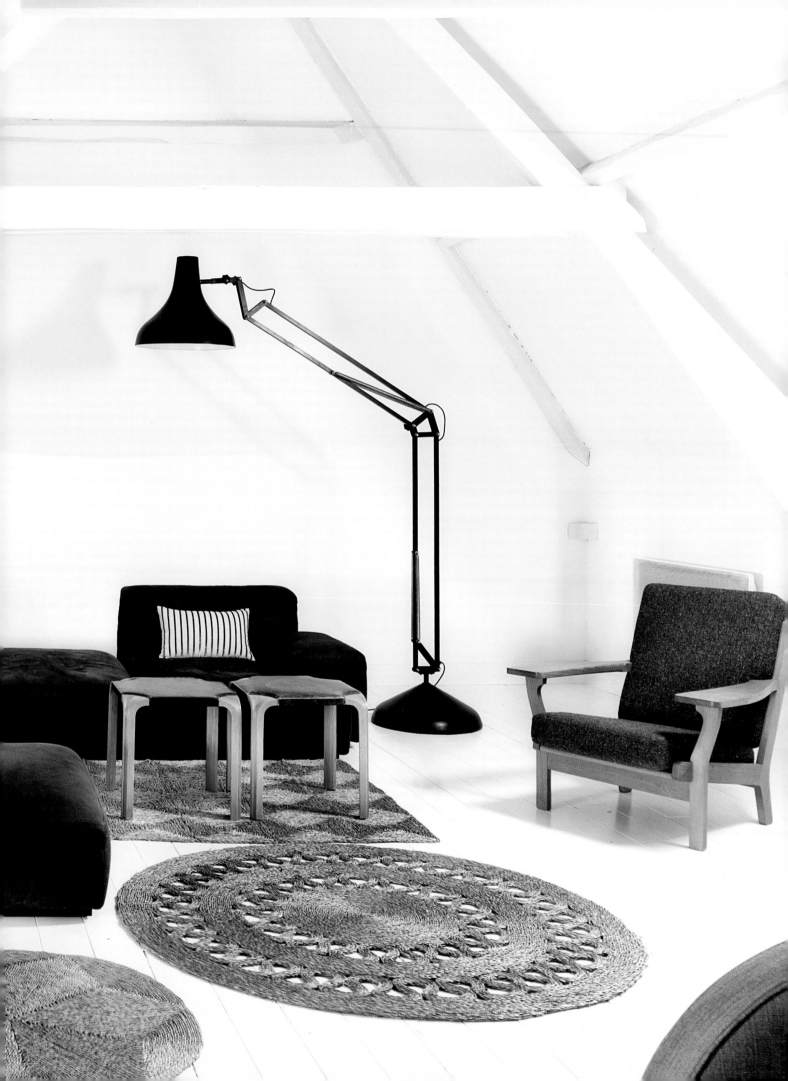

When Steinar and Mark moved here, the garden was
completely overgrown. "It was like being in a jungle,"
says Steinar. "We cut away almost all of the trees. Our
neighbor said she hadn't seen the blue sky for 30 years.
The garden is far from finished. The idea is that it
will become a series of 'rooms'. We've planted hedges
with walls to try and make it more intimate. That's our
project for the future."

--

Als Steinar und Mark einzogen, war der Garten völlig
überwuchert. "Es war wie in einem Urwald", erinnert
sich Steinar. "Wir ließen fast alle Bäume beschneiden.
Unsere Nachbarin sagte, sie hätte seit dreißig Jahren
nicht mehr den Himmel gesehen. Der Garten ist noch
lange nicht fertig. Wir wollen darin eine Reihe von
'Räumen' anlegen, die Intimität vermitteln. Als 'Wände'
haben wir Hecken angepflanzt. Das ist unser Projekt für
die Zukunft."

Steinar's rules for
DECORATING WITH A DARK PALETTE

1. Everyone has a built-in color palette. You can see it from the way you dress. My advice would be to use colors that you love and that are part of you.

2. I always start planning a new scheme by standing in front of the Dulux color cards in a DIY store.

3. I like matte walls and ceilings, but prefer floorboards that are as glossy as a mirror.

4. To keep a room looking smart, I tend to paint the baseboards and radiators in the same color as the wall.

5. I don't have a motto as such, but I love rooms to be a place where you can hang out and enjoy.

Steinars Regeln für das
EINRICHTEN MIT DUNKLEN FARBEN

1. Jeder hat eine natürlich eingebaute Farbpalette. Das erkennt man daran, wie man sich anzieht. Mein Rat lautet: Verwenden Sie Farben, die Sie lieben und die zu Ihnen gehören.

2. Ich beginne die Planung eines neuen Projekts immer damit, dass ich im Baumarkt die Dulux-Farben anschaue.

3. Ich mag matte Wände und Decken, bevorzuge aber Bodendielen, die so glatt und glänzend wie Spiegel sind.

4. Um einen Raum schick und aufgeräumt aussehen zu lassen, streiche ich die Fußleisten und Heizkörper oft in derselben Farbe wie die Wände.

5. Ein richtiges Motto habe ich nicht, aber ich möchte, dass Zimmer Orte sind, an denen man sich wohlfühlen kann.

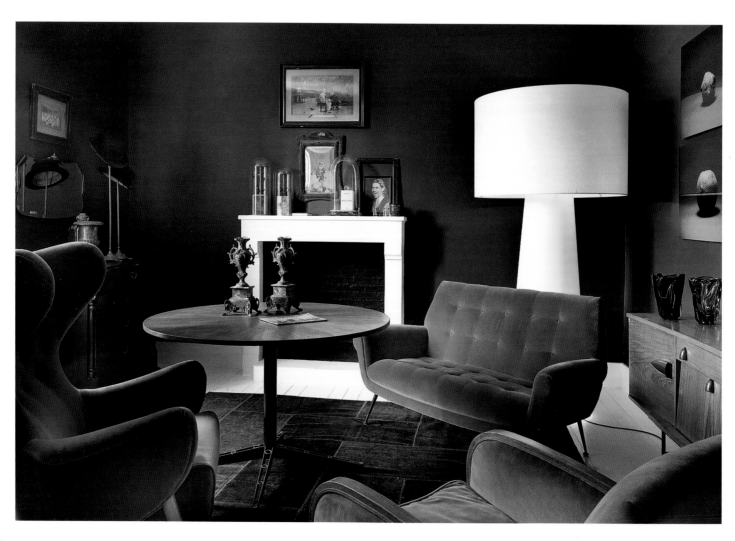

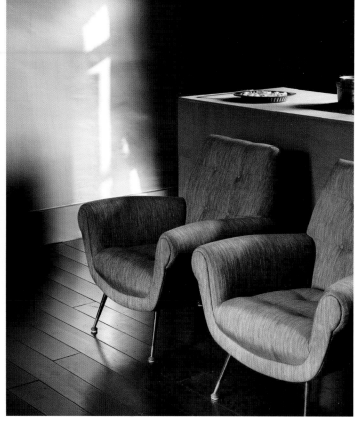

MY HOME TRUTHS

I would describe my style as soft-edged and round.
I never sit in a chair—I like to mold myself into it.
For me, comfort and coziness are chosen over Scandi stick
furniture. I like things soft and curvy—nothing hard.

My dream buy would be a Jean Royère sofa. The French
auction house Artcurial has a sale coming up where they
have the dreamiest Royère sofa. I would like to die in a
chair like that.

MEINE WOHN-WEISHEITEN

Ich würde meinen Stil als weichkantig und rund
bezeichnen. Ich sitze nie einfach in einem Stuhl,
sondern schmiege mich regelrecht hinein. Komfort und
Behaglichkeit sind mir wichtiger als strenge Scandi-
Möbel. Ich mag weiche, kurvige Möbel — nichts Hartes.

Mein Traumkauf wäre ein Sofa von Jean Royère. Das
französische Auktionshaus Artcurial versteigert in Kürze
ein traumhaftes Exemplar. Auf so einem Möbelstück würde
ich gerne sterben.

PHOTO CREDITS / BILDNACHWEISE:

Cover photo © Michael Paul / Livinginside; Back cover photo © Chris Tubbs Photography
Author's portrait (jacket) © Ellie Cotton, Dandelion Photography

pp 04–19 (A New Vintage) © Lisa Cohen / Livinginside; pp 20–37 (Bohemian Rhapsody) © Gaelle Le Boulicaut;
pp 38–53 (Ahead of the Curve) © Gianni Basso / VegaMG; pp 54–71 (Studio Moves) © Chris Tubbs Photography;
pp 72–85 (Color Vision) © Barbara Corsico / Livinginside; pp 86–103 (Dans le Salon) © Michael Paul / Livinginside; pp 104–119
(Couture Revival) © Fabrizio Cicconi / Livinginside; pp 120–137 (House of Fun) © Jenny Brandt Grönberg / JennyoJens(.com);
pp 138–153 (Pretty Cool) © Michael Paul / Livinginside; pp 154–171 (Living to the Max) © Gianni Basso / VegaMG;
pp 172–191 (Escape to the Château) © Chris Tubbs Photography

Icons & Illustrations / Icons & Illustrationen:
© designed by freepik.com, except / außer p 11, p 14, p 16, p 120, p 125, p 130, p 132 © retrovectors.com

TEXT CREDITS / TEXTNACHWEISE:
Words for "Dans le Salon" & "Pretty Cool" partially adapted from original texts by / „Der magische Garten" & „Ganz in Weiß"
teilweise adaptiert aus Texten von: Michael Paul

Words/Texte: Claire Bingham
Copy editing/Lektorat: Maria Regina Madarang (English)
Proofreading/Schlusslektorat: Nadine Weinhold
Translation/Übersetzung (German/Deutsch):
Ronit Jariv, derschönstesatz
Editorial management/Projektmanagement: Nadine Weinhold
Design & Layout: Christin Steirat
Production/Herstellung: Alwine Krebber
Imaging & proofing/Bildbearbeitung & Proofing: Jens Grundei

Published by teNeues Publishing Group

teNeues Media GmbH & Co. KG
Am Selder 37, 47906 Kempen, Germany
Phone: +49 (0)2152 916 0
Fax: +49 (0)2152 916 111
e-mail: books@teneues.com

Press department: Andrea Rehn
Phone: +49 (0)2152 916 202
e-mail: arehn@teneues.com

teNeues Publishing Company
7 West 18th Street, New York, NY 10011, USA
Phone: +1 212 627 9090
Fax: +1 212 627 9511

teNeues Publishing UK Ltd.
12 Ferndene Road, London SE24 0AQ, UK
Phone: +44 (0)20 3542 8997

teNeues France S.A.R.L.
39, rue des Billets, 18250 Henrichemont, France
Phone: +33 (0)2 48 26 93 48
Fax: +33 (0)1 70 72 34 82

www.teneues.com

English Edition
ISBN 978-3-8327-3498-5
Library of Congress Control Number: 2016957910

Deutsche Ausgabe
ISBN 978-3-8327-3499-2

Printed in the Czech Republic